To Stephen Mullan

I hope you
enjoy this book

Im MAD about you

Frecks

Practical Sculpture

Practical Sculpture

A WORKSHOP MANUAL

Sally Hersh

Robert Hale • London

© Sally Hersh 2011
First published in Great Britain 2011

ISBN 978-0-7090-8836-3

Robert Hale Limited
Clerkenwell House
Clerkenwell Green
London EC1R 0HT

www.halebooks.com

A catalogue record for this book is available from the British Library

2 4 6 8 10 9 7 5 3 1

Typeset by Eurodesign
Printed in China

Contents

Illustrations

Foreword

This manual acts as a one-to-one tutorial and follows the work of a professional sculptor, graphically demonstrating how she approaches her own work and passing this information on to the reader.

Why is this sculpture manual different from many other similar books? Because every step of producing a stone carving and portrait head is described in detail – with nothing left out! Excellent photographs illustrate and clarify the various techniques. For this reason, students can work alone with this book beside them on the workbench and be able to produce an excellent piece of work. Every likely problem is clarified in the troubleshooting sections where there is also advice on how to avoid problems. There are comprehensive lists of the specific tools and materials required and information on where to purchase them. And readers are shown how to make items that are useful, or even essential, in the workshop.

This book is a must-have for the student sculptor.

Acknowledgements

My very special thanks to Tony Brooks, my patient husband, for his endless support, advice and encouragement and for giving up so much time to make himself constantly available to take the many photographs covering all my work for this book – and especially for sorting out the technicalities of my computer that are quite beyond me!

My sincere thanks to the British Geological Survey and in particular Graham Lott for his assistance in confirming and enhancing all the geological information in this book and preparing the maps.

Huge thanks to my lovely model, Mary (Diggy) Rodber, for her unending patience and happy disposition that made the modelling of this portrait such a pleasure for me – I am so pleased that aniseed balls turned out to be her favourites! She could not have been a more perfect model.

Tim Hook for his time and advice in researching archive photos.

I want to thank my readers, Patricia Mackay, Andrew Ransford (stone section), Barbara Southcott MB, BS, FRCR and Dr Eileen Pankhurst (portrait section) for their helpful literary and technical observations, diligence and time spent on my behalf to bring my manuscript up to scratch.

To my dear children and many good friends who have encouraged me throughout; and particularly to the consultants and staff of St Richard's Hospital Haematology Department, Chichester, without whom I would not have finished this book.

Image Credits

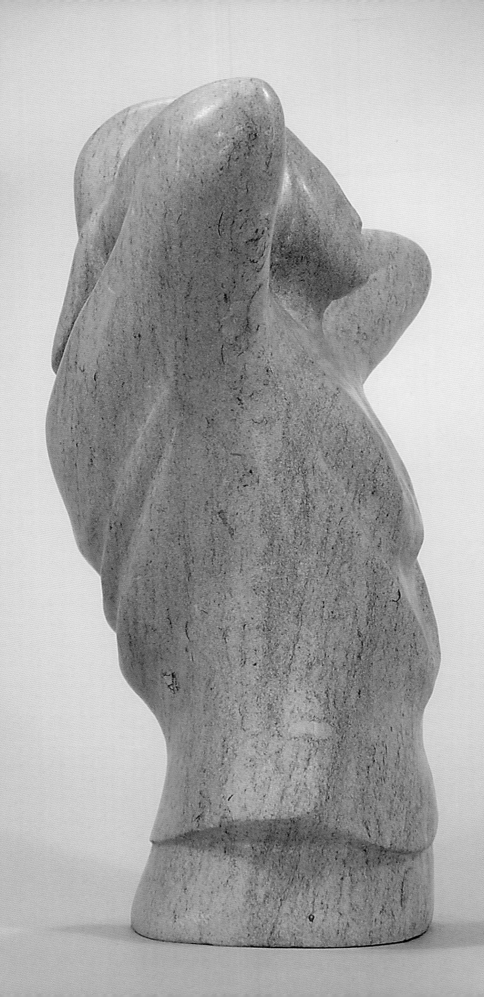

PART 1
STONE CARVING

Girl with her Hands Behind her Head, Sally Hersh, 2009

Carving and the Workshop

1 Introduction: The Excitement of Stone Carving

"I've always wanted to carve stone but never thought I could."

This engaging, practical workshop manual will provide all the essential information you need, as well as the confidence and inspiration you have been seeking.

Making stone sculpture is a passion. The metamorphosis from rough stone to a tactile, sensuous sculpture that reflects and bends the light has always been a fascination for me. Watching someone being drawn to a smoothly finished piece is also enthralling. No one should be dissuaded from stroking a sculpture if they need to do so for this, surely, is the ultimate sign of success.

Stone carving is an exhilarating, physical art form that anyone can take up. You really don't have to be very experienced to produce quite complex sculptural forms. It appeals to all those who want to feel the excitement of chisel striking stone and the appearance of something beautiful or unusual from a raw material.

If you tried stone carving before and did not succeed, try again, as this manual includes all the information and inspiration you need to succeed. Comprehensive information is given about suitable carving stones and where to find them. The process of beginning and putting your ideas into maquette form is explained. It teaches the many stone-carving techniques, detailing the tools and equipment required for the beginner as well as the more experienced sculptor; photographs throughout the manual assist readers in the purchase of the correct items for their own particular needs. Finishing and polishing and advice on

essential health and safety issues are also included.

Five hundred years ago the great sculptor Michelangelo carved with point and claw tools similar to those used today. The meaningful tool marks on his masterpieces are just like those you will create on yours! It's conceivable that your carving won't be *quite* as epic as his, but it's astonishing to think that there will be similarities – and your work of art could last just as long.

The wide-ranging information here will enable you to work alone if you choose to do so and explains any likely anxieties or problems you might experience as well as how to resolve them. For those wanting to set up their own workshop, advice is offered on every aspect, from workbench and storage to lighting, ventilation and useful equipment. A range of lifting gear is suggested and how it should be used.

A series of photographs follows the progress of carving a demonstration sculpture and illustrates the gradual evolution of a stone sculpture such as you might expect to experience yourself.

This wide-ranging workshop manual is a must for all sculptors interested in exploring the traditional methods of stone carving and enhancing their knowledge as well as for complete beginners who will find full instructions and clearly explained advice on all aspects of stone carving.

2 Your Workshop

You will spend a lot of time in your workshop so it is worth giving some thought to the content and layout in advance, so that the space available will contain everything you need and be arranged in such a way as to make your work pleasurable and efficient.

Everyone who carves stone needs a place to work, ideally a place where it is not necessary to clear up after each session! There are many sculptors who have little access to ideal carving conditions but who work successfully in a small area with few facilities. Some working space is better than none and a simple workbench can be set up anywhere.

The information in this section covers a full range of workshop equipment, from the very simple to the professional. Whether you have a large old barn, the corner of a kitchen or an area outdoors in which to work it is worth thinking about good light, heating and ventilation; your health and safety is paramount and you will need to have the most appropriate tools at your fingertips.

Smaller spaces have simpler requirements. You can manage quite well with a strong wooden bench or table to work on, three basic carving tools and a mallet. You will also need strong shoes, protective spectacles and a facemask or visor. With these few things you can begin carving.

Some people enjoy working outdoors using an old wooden table or viable alternative, such as a bench simply constructed from building blocks and a strong plywood board across

the top, covered with a square of carpet. So long as the construction is stable, this is a perfectly acceptable and robust system that can also be used to make additional bench space in the corner of a workshop. It is great to work outside, especially if you can protect yourself from bad weather and hot sun under an awning or gazebo. You will experience fewer dust problems outdoors and can enjoy the *al fresco* life. If you have workshop space available you need to decide what equipment is essential to set yourself up and what you can leave until your requirements become greater or more complex. The following are suggestions and ideas I have found useful over the years.

WALL AND FLOOR STORAGE

Cupboards are essential, especially for items that must be kept dry, such as stone resins, abrasive papers *ciment fondu* and plaster (used for casting), which quickly deteriorates if at all damp.

Glass-fronted eye-level cupboards are useful for reference books etc. as they provide protection from dust whilst enabling you to find what you are looking for quickly and easily. They are also particularly recommended as maquette cupboards, as they keep your embryonic ideas in view.

A wall-mounted shelf unit for storing and displaying mallets, hammers, chisels and day-to-day equipment is invaluable for quick access to your tools when working.

Shelves are worth installing in otherwise free wall space for small finished or plaster copies of work, as well as hooks for assorted small items to keep readily to hand.

STORAGE FOR TOOLS

Tools can be kept in wheeled, metal tool-boxes with several shallow drawers. These are now widely available from DIY and car-parts stores. The boxes are mobile, enabling you to move them close to the work. However, I find that a simple rack, fixed to a wall near the workbench and part of the general-purpose shelving unit previously mentioned, is an excellent arrangement for carving tools, especially if space is limited.

The angled storage shelf shown in Fig. 2 is constructed with a raised retaining batten across the front, to prevent tools from falling out, and divided into separate sections in the style of a cutlery drawer. Once you have

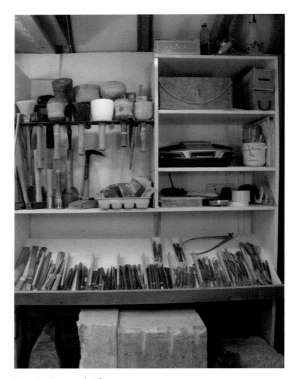

Fig. 1 Open shelf storage

amassed a good selection, it is a convenient way to set out your carving tools; they will be readily to hand and, if displayed in types (chisels, claws, rasps, etc.), quickly and easily located.

STORAGE FOR STONE

Once you begin carving, exploring quarries and stone suppliers can become something of an obsession; you are likely to be captivated by all sorts of blocks and will thereby quickly build up a collection. Strong shelving or metal racking for displaying your spare blocks of stone ensures that each one is visible and accessible. This is far preferable to piling one block on top of the other in a corner of the workshop floor where they can be a hazard and take up useful space. By seeing your stone collection as you pass by it, you will become familiar with the visual proportions and colour of blocks you have and quickly remember whether there is something suitable for a carving you may wish to make. Metal racking, which is frequently offered second-hand from offices and warehouses at a low cost, is ideal for this purpose

WATER

Plumbed in water and a butler sink should be considered seriously as they will be used frequently. A large, heavy-duty, working sink is invaluable for polishing stone carvings under running water. Clay can be stored under the sink where it will stay cool. Water is

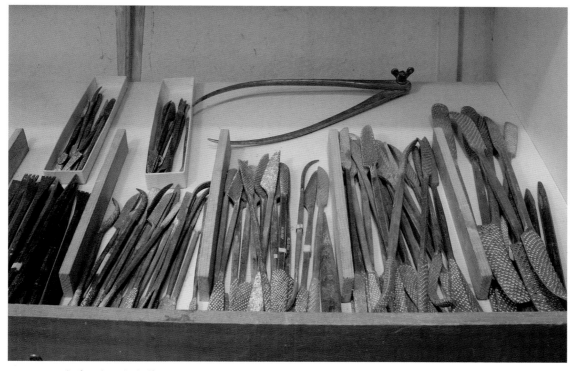

Fig. 2 Detail of tool rack shelf

necessary for sharpening tools, mixing plaster for plaster maquettes, casting portrait heads, keeping clay moist and making cups of tea! So do fit one if you possibly can.

You can even set up a butler sink outdoors by constructing a support from building blocks (like the bench mentioned previously, see page 19) using it in conjunction with a hosepipe.

FLOOR SPACE

It is essential when creating a sculpture to be able to stand back from it and view your work objectively from a distance, so space is an important consideration for your workplace. Consider adding versatility to your workshop area by giving yourself the option of recon-figuring benches for a particular job, for example, to set up a model for a portrait or life figure or carve something larger than usual. Wheeled benches with braked tyres are available that can help you to do this easily.

The workshop floor needs to be strong and flat to safely take account of this type of movement and be robust enough to support the heavy weights of the stones that you will inevitably accumulate. A sealed concrete floor is best, enabling you to sweep away dust and debris and to wash it down, if necessary, without worrying about damaging a more sophis-ticated surface. If you are concerned about the hardness of the floor or it being cold to stand on, rubber fatigue mats in your working area give warmth in winter and comfort to the feet at all times and are now recommended in many places of work.

Fig. 3 Rubber fatigue mat

LIGHTING

Good light is vital. Whether you have tradi-tional windows or VELUX-style roof lights, natural daylight is essential. VELUX windows give the additional benefit of providing additional ventilation as well as top light. Sometimes it is possible to install them so that you have north light, which is always the best in a workshop – although some people like to have both north and south light in order to have the best of all worlds!

Strip lights are only appropriate for general light in the workshop, as they provide no shadows; consequently they are useless for illuminating your sculpture critically.

More specifically located spotlights give essential harder light and shade to accen-

tuate the detail and overall shapes of three-dimensional work. Several spotlights spaced along one or two overhead bars are readily adaptable and will enable you to adjust the lighting to be effective for your needs in different parts of the workshop.

I like a harsh light at times, specifically to expose irregularities in a carved surface or to draw attention to a particular shape that might need adjusting to relate better to an adjacent one. It can demonstrate in good time critical alterations necessary to the design and often shows up areas that are far too big. A strong light is a particularly useful tool for examining linear work with hard-edged shapes or a relief carving where there are important details at different levels requiring emphasis or clarity. Strong light definitely clarifies areas where 'straight' lines are not straight!

THE WORKBENCH

A sculpture workbench needs to have an even, flat top made of wood and be robust enough to support the heavy weight of stone. Wood usefully absorbs some of the vibration caused by the impact of the mallet and tool on stone which, in the wrong circumstances, can cause stone to break.

A bench must be at a comfortable working height. One approximately 31 in high x 47 in wide x 24 in deep (79 x 119 x 61 cm) will provide a sufficiently large surface to display a good-sized block of stone with room to turn it about and still leave enough space for your tools. If you have a choice of wood thickness or you are making the bench yourself, a depth of 3-4 in (7.5–10 cm) is recommended, to absorb vibration.

An alternative to the conventional workbench is a banker, a square, strong unit designed to support one specific sculpture for carving. It normally houses an integral turntable so the carver can rotate the work frequently and without effort and progress can be easily appraised 'in the round'. Bankers are very useful and some sculptors like to have them available in addition to the larger benches. There are low, off-the-floor versions available, designed for tall carvings that could not sensibly be placed at normal bench height and which can be turned easily despite the size and weight of the work.

Fig. 4 Bankers

WORKSHOP ACCESS

Although this is not often considered in advance, there are times when stone,

cement, clay or other heavy or bulky items are delivered to your workshop or a completed sculpture needs to be removed. Double-door access makes the movement of work and materials in and out of the workshop much more straightforward, both for your own convenience and for any van or lorry drivers, especially if there is a hard-standing area beyond the doors. Lack of easy access to a workshop can be a problem, especially across bumpy grass in wet weather! A hard-standing area outside the workshop, with a ramp, if necessary, extends your working space; you will probably use it more often than you think, particularly for carving outside in good weather. Have a sack trolley available to move stone in and out. If the exterior ground surface is soft or uneven, a trolley with broad pneumatic tyres will make the movement of stone and other materials far easier.

ELECTRICS

When you are considering the installation of power points, put in more than you think you will need and, most usefully, at bench-top height. It will not be long before you will be using a variety of electric tools, from a drill to a vacuum cleaner or a hairdryer, and therefore pleased to have sufficient sockets.

There are some excellent, heavy-duty workshop vacuum cleaners available that pick up quite large stone chips as well as fine dust that I would highly recommend. Unlike a broom, they ingest the dust cleanly and do not raise it and are an efficient clearing medium for the debris around your carving and under your feet.

Fig. 5 Tungsten masonry saw

An extractor fan will remove dust as you work. If you are installing one in your workshop, consider fitting it close to floor level to draw the dust down and away from your face. Since the weight of stone dust tends to make it drop, a floor-level extractor fan makes sense.

I would always recommend the use of modern night-storage heating for workshop use. This ensures that the workshop is warm throughout the day in winter and into the evening when required, then is fully re-charged during the night ready for the next morning. It is possible to take advantage of cheaper electricity night rates, making them considerably less expensive than electric fan heaters that, incidentally, would certainly raise the dust. Mobile gas heaters are not recommended in the workshop as they give off a damp vapour that rusts metal tools.

SMALLER WORKSHOP TOOLS AND KIT

From time to time you may need some of the following: electric drills with a good selection of masonry bits, clamps, squares, steel metre rules, extending rules, a hairdryer and a free-standing pottery turntable to view small sculptures (and maquettes) in the round. A particularly useful item is a wooden dolly, a stout, wooden platform with corner wheels that enables the free movement of stone or other heavy items placed upon it. Another highly recommended item is a tungsten masonry saw manufactured specifically for stone. With their specially shaped tungsten teeth, they are the only saw that will cut stone effectively and save you hours of carving time (see Fig. 5).

A collection of sandbags is useful for propping up and stabilizing irregular shaped pieces of stone. You can easily make your own by sealing well-dried sharp sand into plastic sacks (not too full) and then sewing them into fairly tightly woven bags made from any cotton fabric (I used unwanted heavy cotton curtains!) or sacking. Small sandbags are often more versatile than large ones. Cat litter can also be purchased as an alternative to sand.

Woodcarvers' chops are a wooden form of vice that sits on the top of the bench in any chosen direction to suit the work being done. The vice is fixed with a big bench screw that slots through the vice and bench and is bolted and tightened from underneath with a large wing nut. The insides of the jaws of the vice are covered with leather to avoid damage to items being held within them. The vice is ideal for small sculpture; it is used to hold the work tightly, leaving both hands free to carve without worrying about having to prevent

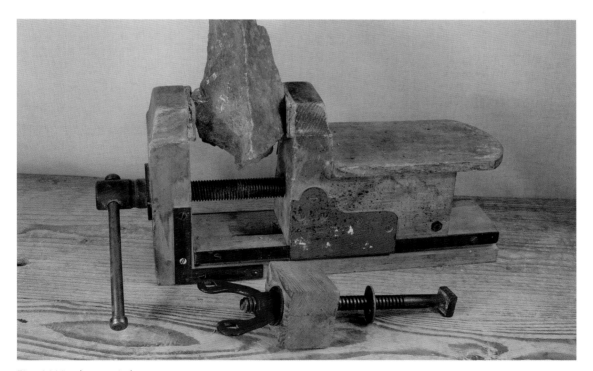

Fig. 6 Woodcarvers' chops

the stone from moving around because of its comparatively light weight. It is important to change the position of the sculpture within the chops regularly so that you carve all around the stone evenly. These chops are designed to be used as required and stored away from the bench whilst not in use.

A strong plywood box to stand on, approximately 18 x 10 x 6 in (46 x 25 x 15 cm) is another invaluable item in the workshop. It will give you additional height, so that you can look down on work or reach high shelves, and is also good to squat on when viewing work from low levels. It can also be used for raising work on the bench.

LIFTING EQUIPMENT

In due course there is the chance that your work will get larger and heavier, until it becomes difficult and dangerous to try to move it without help. This is probably the time to consider having a workshop gantry installed, consisting of a steel beam or rolled steel joist (RSJ) supported by two A-frames with a chain hoist and trolley running along the beam. Unless very large work is planned, a safe working load of 500 kg (approx. ½ ton) is recommended for all the workshop lifting and moving equipment you purchase so that it is compatible. This equipment needs to be installed across a central area of the workshop to make it possible to lift and move your work onto your bench or a mobile platform. Safety shoes or boots with protective toe caps should always be worn whenever such equipment is in use.

Soft, strong nylon strops that wrap closely around the stone and hook onto the lifting gear will need to be purchased for these tasks. Advice on their safe use usually comes with the strops but you should acquaint yourself with all safety measures surrounding the use of strops and lifting equipment. A wrongly tied strop around a heavy weight can very quickly become a 'granny' knot that neither you, nor your Granny, will ever undo. With careful forethought and planning you will soon learn how best to lift and relocate stone in a safe, orderly fashion. A chain hoist brings great peace of mind and independence to the user, and, with one in the workshop, you will quickly opt to use lifting equipment rather than your own strength to move a block.

I will just briefly mention other forms of workshop lifting gear so that you are aware of their uses. A hydraulic scissor lift can be of enormous help when working on large sculptures and enables you to deal with very heavy and bulky blocks. One of the problems with working on a large sculpture is that you are obliged to reach up and, more awkwardly, bend down or sit on the floor to reach the lowest areas of the piece. Over a long period this can cause back pain. I installed a scissor lift in my workshop for a large commission and, when not in use, it is stored away in its own space beneath the floor, covered with two steel trap doors that can be lifted away with the chain hoist. It rises up to height of about 3 ft (91 cm) above floor level and incorporates a large turntable on top to support and rotate very heavy stone sculpture. It is quite an impressive item to see and use! The lift is activated by switches on a simple electric hand pad, which means no effort whatsoever is needed to

Fig. 7 Stone and letter carving rig. Sundial mounted on ledge, being carved

use it. In my own small workshop the turntable has allowed me to revolve a 2 ton (2,032 kg) block, so that every part of the sculpture could be accessed without effort and at a comfortable height. When such a sculpture is completed the lift is lowered and the steel trap doors become floor space again.

Another device that I use myself is a steel lifting rig. It is designed to raise heavy pieces of stone, headstones or stone plaques from the floor to a convenient and comfortable working height for carving or letter cutting. The ½ ton (500 kg) capacity, purpose-designed lifting rig is made from box-section steel for strength and comprises a rectangular structure with its front face angled backwards a few degrees, as illustrated in Fig. 7. A sliding frame attached to its front face has a narrow protruding ledge, 3 in (7.5 cm) wide, to support headstones and plaques for letter cutting.

To make the lifting rig more versatile it has a removable steel 'table' (30 x 18 in/76 x 46 cm) that slots easily into the front of the sliding frame. This can be used as an additional carving surface for sculpture and has an optional small turntable (see Fig. 8). The sliding frame is raised or lowered using an integral chain hoist system and work is brought to the lifting rig by an overhead travelling chain hoist mounted on an 'A' frame and RSJ. The lifting rig is a very versatile accessory in the workshop.

However, for hundreds of years stone masons have stood on blocks and boxes to reach the upper levels of headstones, or in a hole cut into the workshop floor to reach the bottom lines to carve, and these methods are still used to this day in some monumental masons'

Fig. 8 Stone and letter carving rig with added table and turntable plus stone awaiting carving

workshops, so don't worry if you can't initially afford expensive lifting gear. I have described a wide range of lifting equipment to consider and use as appropriate for your own needs but, whatever you ultimately choose, do not stint on the safety requirements for all lifting gear. This cannot be over-emphasised.

3 Health and Safety in the Workshop

It is easy to get so involved with your carving as soon as you enter the workshop that you forget all the rules about health and safety and the need to guard against potential hazards. It is best to develop a routine so that you are constantly aware of how you should protect yourself and make sure you are properly equipped before you start work. It is rare that a piece of stone falls from a bench, but it is the simplest thing to wear strong shoes, preferably with protective toe caps, so that if one ever did, your toes and feet would be protected. Beware, also, of the lump of stone that rolls from a sack trolley or from equipment you are moving without having bothered to secure the load safely, which could result in damage to your feet, ankle or shin.

PROTECTION FROM STONE DUST AND DEBRIS

One of the main hazards in the carving workshop is that of dust and debris. When carving stone, fine dust and large, sharp shards of stone are thrown up, and these are a danger both to lungs and eyes. Dust hazards to the lungs, particularly silica (which is found in various carving stones including sandstone and slates), can be lessened quite simply by routinely wearing a suitable facemask to cover your nose and mouth. A variety of these can be purchased from specialist companies who offer health and safety equipment. A mask with an integral valve in front will tend to vent more efficiently than plain masks, which means such masks stay drier, are less likely to mist and, consequently, tend to be more comfortable to use.

A facemask alone is not sufficient because, without protection, your eyes are vulnerable to extreme damage from flying pieces of stone. Proper eye protection should always be worn – ordinary spectacles are not adequate. I recommend, at the very least, using a visor that wraps around the whole face, giving you a clear, wide field of vision. Facemasks can

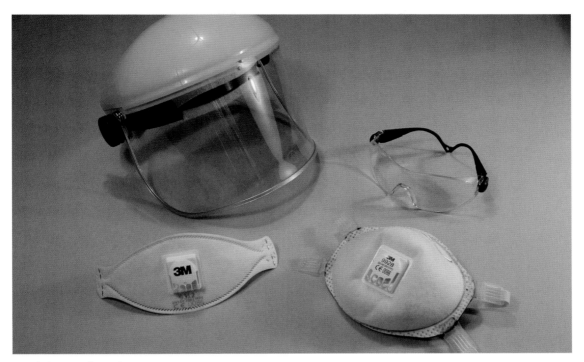

Fig. 9 Facemasks and visor

be purchased from most DIY stores or builders' merchants as well as companies offering health and safety workshop wear.

Wearing a visor together with a facemask is effective, too, ensuring plenty of protection from dust, and the valve of the facemask deterring the visor from steaming up. There are goggles available with wrap-around sides, giving greater protection to the eyes, but they tend to get hot inside and steam up. I find they are not popular in use although they seem tempting initially.

My favourite and most recommended form of protection is a respiration unit. This comprises a visor and an integral dust filter unit that propels clean air to your lungs and gives you total face and lung protection. It is light in weight and you very quickly become accustomed to wearing it and slip it on as routine.

The power comes from a small, rechargeable-battery-operated waist pack containing special filters suitable for workshop dust; this pushes filtered air from the waist pack, up a hose to the top of the visor, and then blows it gently down over your face, keeping the visor (and your spectacles) free from misting and allowing you to work safely in your own, totally dust-free micro-environment. It is marvellous although, inevitably, quite expensive, but it will last for many years and is a good investment for the peace of mind it gives.

Specialist industrial sundries companies generally offer a good range of health and safety equipment, including packs of masks, so you may prefer to start with face masks and a visor until such time as you choose to invest in a respirator.

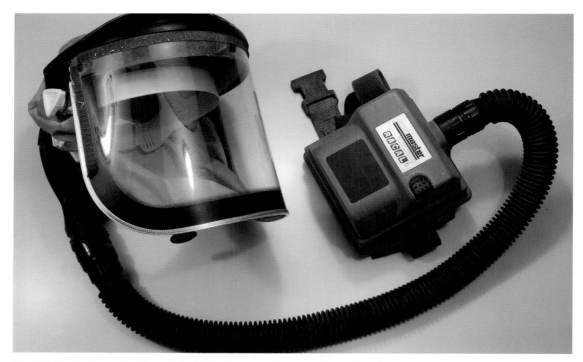

Fig. 10 Respiration unit with waist-belt filter, hose and visor with complete face protection

Keep yourself informed of the latest stone dust research and advice by checking the website of the Health and Safety Executive: www.hse.gov.uk.

MOVING STONE

The other most common hazard in the sculpture workshop is back damage from lifting and moving heavy weights. If you do not have a chain hoist or other simple mobile lifting gear readily to hand, it is always prudent to get help when lifting lumps of stone.

To move stone from the floor and onto a bench, place a strong crate or table at an interim height close to your bench; this is to support the stone partway between the floor and the bench, so that you avoid lifting the weight all in one go. It is not worth taking chances or enduring the pain that results from moving stone which is too heavy for one person. There are companies that offer small-load lifting equipment to help you when removing stone from your car boot and up onto the bench (see the directory, page 202).

If you acquire large and heavy blocks of stone that need to be stored on the floor and are likely to be difficult to move, it is wise to prepare 2 in (5 cm) square lengths of timber the same depth as the stone; place these on the floor on either side and to the front and back of the stone, so that the blade of a sack trolley will fit in the space below for subsequent moves. It is worth storing some wooden battening in your workshop for this purpose.

A useful tip for turning heavy stone safely is to tilt it onto one edge and place a small pebble under the middle of the block, lowering the stone down onto it. You will be able to

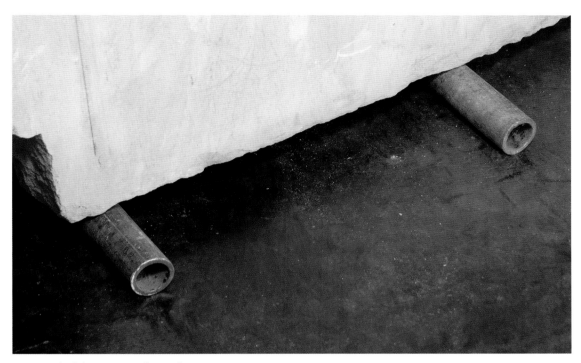

Fig. 11 Block being moved on rollers

spin the block easily to the aspect you need before removing the pebble, again by tilting.

Similarly, a heavy block of stone can be moved across the floor, Egyptian style, with the use of three wooden or metal rollers. By tipping the stone on one edge, a roller can be placed as far back as possible under the stone and another near the front. Once the stone is lowered it can be pushed on the rollers, which are replaced under the front of the stone as they emerge at the back.

HAZARDS FROM MECHANICAL TOOLS

This manual is generally concerned with the use of traditional hand tools for carving. However, it is important to comment briefly on health and safety issues that apply to power tools for stone carving, for those who might be tempted to use them. There are times when speed of production can be of the essence or it may be that this style of working appeals to you; whatever the reason, potential users of mechanical tools should be aware of the dangers of using them, be equipped properly and follow the rules.

Pneumatic tools and diamond saws are quite commonly employed nowadays in the making of sculpture, although these methods are generally used by experienced sculptors creating large works for large spaces. Some sculptors use pneumatic tools in conjunction with hand tools for roughing out so as to avoid the heavy initial work and move the sculpture on more quickly. Diamond saws cut stone at a remarkable speed, and are particularly useful for linear designs.

Before you invest in the necessary equipment it is worth considering that diamond saws create huge amounts of dust and noise, so you would need to be set up in a work space well away from neighbours, who will not appreciate these hazards. In a large, outdoor space, this type of carving can be an exhilarating experience. But, whether working in or outdoors, the operator must be well-masked and wear ear defenders at all times. Masks, visors and respiration units are particularly important in these circumstances. Similarly, both pneumatic tools and the compressor they require to power them also create considerable noise and ear defenders and visors, facemasks or a respiration unit are necessary again.

The mechanics of the hand piece that holds pneumatic tools are such that they create continuous vibration on the hands and upper body; users always need the protection of heavy anti-vibration gloves to prevent the unpleasant condition known as 'white finger'. This also applies to diamond saw use.

Should you be tempted to try working with any of these tools it is recommended that you visit a stone masons' yard or a sculptor who uses them regularly; have a look at the equipment you would require to set up and chat with the operator to assess whether you feel this is a route you wish to take.

Visiting Carrara in Italy during a marble symposium some time ago I was fascinated to watch some twenty sculptors working away with diamond saws in the town square, creating their linear designs in earnest. All the surrounding shop owners had covered their door-ways with heavy plastic sheeting as pure white dust was swirling everywhere. Each sculptor had a good-sized workspace, a large block of Carrara marble and a connection to electricity. The noise was deafening. At 12.30 on the dot, complete silence fell as the electricity was switched off for a lunch break, stopping the bewildered sculptors in mid-cut. After a pause of about five seconds, a lone Polish sculptor could be heard, mallet striking chisel on stone – the only participant not using a diamond saw, he continued his curvaceous work with a large smile on his face.

Stones and Tools

1 History of Stone

The stones of the Earth have formed over hundreds of millions of years. They have been analysed, described and then placed by scientists into a sequence of geological systems, ranging from the oldest rocks of the Pre-Cambrian System, approximately 4,500 million years ago, through Ordovician, Silurian, Devonian, Carboniferous, Triassic, Jurassic and Cretaceous to the youngest rocks of the Tertiary System, which were formed a mere 24 million years ago. Most rocks are composed of a wide variety of different minerals that began to form as the earth evolved from its original gaseous, fluid state into the hard stone crust that we know today. Different minerals and rocks exhibit many different properties, varying in hardness, crystal shape and colour.

Man soon realized that some stone was soft enough to carve and shape with the implements of his time. An amazing, very early carving is the *Willendorf Venus*, a small, voluptuous female figure, almost certainly a fertility symbol, made from limestone and discovered in Willendorf, Austria. It dates from some 25,000 years ago (the Upper Palaeolithic Period).

There are many examples of such fascinating ancient sculptures in existence in museums around the world. It would appear, therefore, that carving stone is an art form that man has used to portray himself – or herself – almost since human life began, and the search for suitable stone for carving has been going on ever since!

From the point of view of the stone carver and which stones he/she can find to work, all stone falls into one of three main geological divisions forming the igneous, sedimentary and metamorphic groups.

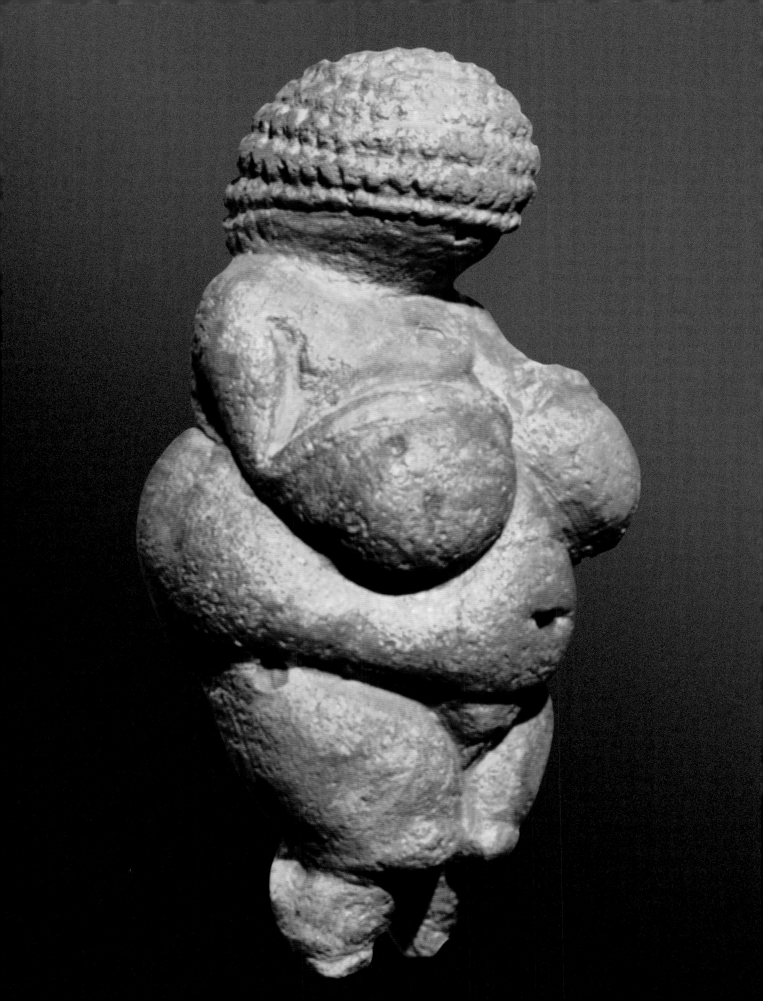

IGNEOUS, SEDIMENTARY AND METAMORPHIC ROCKS
Igneous

Igneous rocks are formed deep inside the earth as magma. As this intensely hot and molten magma rises to the earth's surface it slowly cools and crystallizes to form some of our hardest stones, such as basalt, diorite, obsidian and granite, all of which are crystalline igneous rocks. In the nineteenth century, many of these igneous rock varieties, but primarily granite found in Scotland, Cumbria, North Wales, Devon and Cornwall, were widely employed for building and decorative use because of their durability and the wide colour varieties available.

Sedimentary

Sedimentary rocks, such as sandstone, siltstone and mudstone, are formed as a result of the weathering and breakdown of all rock types into fragments of mineral. Other sedimentary rocks, such as limestone and coal, are accumulations of organic detritus from marine animals (shells, corals, ooids etc.) and plants. This debris or sediment is transported by wind, wave or weather to collect in layers in deserts, at the bottom of rivers or lakes or on sea beds. Gradually, over geological time, the build up of these sediment layers or beds, eventually leads to the consolidation and formation of sedimentary rocks, the limestones and sandstones that are particularly sought by sculptors.

Limestone

Limestone is a good stone to carve and typically has a fine, granular surface. It varies in colour, hardness and even detail, and is to be found in huge quantities throughout the world.

There are two principal types of limestone: those dominated by calcium carbonate and those dominated by magnesium carbonate (dolomitic limestones). These are both commonly composed of coarse bioclastic grains (shells, coral fragments etc.), very fine carbonate crystals or a mixture of both. Both types of limestone are good for carving but the coarser-grained varieties are harder to work and more resistant to weathering.

There is a useful selection of active limestone quarries peppered around the UK, which sculptors can approach for stone. Most quarry men are pleased to share their knowledge when they understand you are interested in carving and will always clarify whether or not their stone is appropriate for that purpose, so always ask.

Sandstone

As sandstones are principally composed of grains formed by the breakdown of all pre-existing rock types they can have a very variable composition; they may contain quartz,

Fig. 12 *Willendorf Venus*

feldspar, clay minerals, rock fragments, carbonate grains or a range of other grain types in various proportions, all held together by natural cements such as silica, carbonate or clay minerals. This variety of constituent components can mean that the sandstone will suffer decay more easily, as not all the grains are equally resistant to the elements.

Sandstones preferred for carving tend to be the more even-grained types with a limited range of grain varieties, for example quartz and feldspar. Some sandstones can suffer from splitting and cleaving along weaker mud-rich or micaceous layers.

Coarser sandstones are often chosen for large outdoor carvings, particularly as they can be fairly soft to carve when freshly quarried but harden as the surface weathers. Sandstone sculptures can be especially effective with textured finishes. Be aware that sandstone dust contains silica, so a mask is essential when working.

Metamorphic

Metamorphic rocks evolve as a result of increased temperatures and pressures generated by movements deep within the Earth's crust. These conditions can transform the original minerals within igneous and sedimentary rocks into new minerals, completely changing the character of a rock. For example, marble is metamorphic limestone. Serpentine stone, which is hard and attractive with beautiful markings, and soapstone, which is closely related to it, although much softer, are both metamorphic rocks popular with sculptors.

In geological terms, slates are fine-grained metamorphic rocks, formed by the alteration of mudstones and siltstones. They are unusual in that they display a characteristic splitting quality (cleavage), which makes them ideal for making thin roofing slates and using as interior and exterior architectural cladding. From the sculptor's perspective, slate is one of the best stones to use for lettering and decorative inscription because of the clarity, precision and crispness of the cut letter within it. It is, consequently, a popular material for memorials, plaques and sundials. A visit to a churchyard in any Cornish or Welsh village will demonstrate the amazing longevity of the locally quarried slate memorials and the legibility of the inscriptions. In Cornwall, the complex decorated borders carved upon them are virtually as crisp as the day they were cut, and in the Charnwood area of Leicestershire the local Swithland slates (from the Cambrian Period) also show particularly ornate lettering and decorative inscriptions still in pristine condition after more than 200 years.

There are few true metamorphic marbles in the UK and often imported marbles are selected in their place. However, it is possible to find some excellent hard limestones, such as those from the Purbeck and Hopton Wood quarries, which resemble marble and are often used in place of imported stone.

GEOLOGICAL AND STONE AND QUARRY MAPS OF THE UK

The following map and diagram illustrate the geology of the UK, with information on the whereabouts of specific types of stone suitable for carving as well as building purposes.

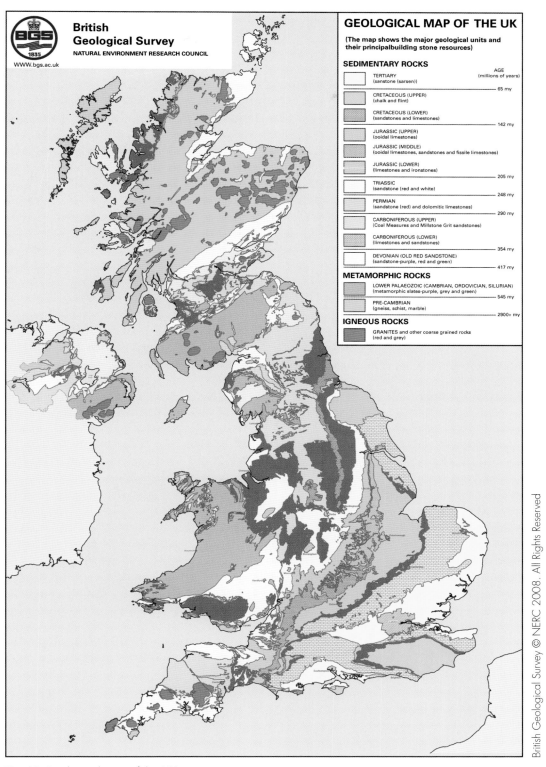

British Geological Survey
NATURAL ENVIRONMENT RESEARCH COUNCIL
WWW.bgs.ac.uk

GEOLOGICAL MAP OF THE UK

(The map shows the major geological units and their principal building stone resources)

SEDIMENTARY ROCKS

	AGE (millions of years)
TERTIARY (sanstone (sarsen))	
	65 my
CRETACEOUS (UPPER) (chalk and flint)	
CRETACEOUS (LOWER) (sandstones and limestones)	
	142 my
JURASSIC (UPPER) (ooidal limestones)	
JURASSIC (MIDDLE) (ooidal limestones, sandstones and fissile limestones)	
JURASSIC (LOWER) (limestones and ironstones)	
	205 my
TRIASSIC (sandstone (red and white)	
	248 my
PERMIAN (sandstone (red) and dolomitic limestones)	
	290 my
CARBONIFEROUS (UPPER) (Coal Measures and Millstone Grit sandstones)	
CARBONIFEROUS (LOWER) (limestones and sandstones)	
	354 my
DEVONIAN (OLD RED SANDSTONE) (sandstone-purple, red and green)	
	417 my

METAMORPHIC ROCKS

LOWER PALAEOZOIC (CAMBRIAN, ORDOVICIAN, SILURIAN) (metamorphic slates-purple, grey and green)	
	545 my
PRE-CAMBRIAN (gneiss, schist, marble)	
	2900+ my

IGNEOUS ROCKS

GRANITES and other coarse grained rocks (red and grey)	

Fig. 13 Geological map of the UK

Building and Decorative Stones of the UK

British Geological Survey

Geological age of some currently available building stones
Estimated age in millions of years
(*italics* indicates limestones, red igneous and metamorphic, black sandstones)

Age (m years)

CAINOZOIC

PLEISTOCENE, PLIOCENE, MIOCENE — *Tufa*

— 24 —

OLIGOCENE

— 38 —

EOCENE (including **PALEOCENE**) — *Bembridge Limestone/Quarr*

— 65 —

MESOZOIC

CRETACEOUS

UPPER: Beer, *Cambridge Clunch*, *Totternhoe*

LOWER: Carstone, Hurtwood, Kentish Rag, Midhurst, *Purbeck*, Salcombe, Sussex Sandstone, 'Wealden Marbles'

— 142 —

JURASSIC

UPPER: Abbotsbury, Chilmark, Headington, Hildenley, *Hovingham*, *Melbury*, *Portland*, *Purbeck*, *Wheatley*

MIDDLE: *Aislaby Ancaster*, *Alwalton* *Barnack*, *Box Ground* *Casterton* *Combe Down*, *Clipsham* *Cotswold* *Dundry*, *Guiting* *Hackness*, *Ketton* *Monks Park* *Nailsworth*, *Painswick* *Stamford* *Stoke Ground*, *Taynton* *Weldon* *Westwood Ground*

LOWER: *Banbury*, *Blue Lias*, *Ham Hill*, *Hornton*, *Marlstone*, *Marston*, *Stowey*, *Sutton*, *Tout*, *Wroxton*

— 206 —

TRIASSIC

Alabaster (Chellaston & Fauld), Corsehill, Draycott, Grinshill, Hollington, Myddle, Newton, Red St Bees, Rosebrae, Spynie, *White Lias*

— 248 —

PALAEOZOIC

PERMIAN

Anston, Bolsover Moor, Cadeby, Corncockle, Copley Lane, Gatelawbridge, *Gebdykes*, *Lazonby Red*, *Locharbriggs*, *Mansfield*, *Park Nook*, *Plumpton Road*, Roche, Steetley, Tadcaster, Warmsworth

Permo-Triassic

Capton, Clashach, Greenbrae

— 290 —

CARBONIFEROUS (DINANTIAN, NAMURIAN, WESTPHALIAN)

Alston, Bearl, Birchover, Black Pasture, Blaxter, Blue Pennant, Bolton Woods, Bramley Fall, Carlow, Cat Castle, Chatsworth, Chinley Moor, Clevedon, Graigleith, Crosland Hill, *Derby Fossil*, Doddington, Dukes, Dunhouse, Elland, Forest of Dean, Frosterley, Grange Mill, Greenmore Blue, Greenmore Rock, *Hades*, Hall Dale, *Hopton Wood*, Kerridge, Kilkenny, Ladycross, Liscannor, Moelfre, Moorside, *Nidderdale*, *Orton Scar*, *Penmon*, PlasGwilym, Revidge Grit, Ridgeway, Ringby, Roach Bluff, Scout Moor, *Salterwath*, *Sheldon*, Shipley, Springwell, Stainton, Stanton Moor, Stancliffe, Darley Dale, Stoke Hall, Stoney Brow, Ulverston, Waddington Fell, Waterholes Grit, Watts Cliff, Wellfield, Westmorland Waterworn, Wimberry Moss, Windy Hill, Whitworth Blue, Woodkirk Brown

— 354 —

DEVONIAN

Ashburton, *Caithness*, Delabole, Dunmore, Merryfield, Mill Hill, Monmouth, Red Wilderness, Trecarne, Tredinnick, Trevillet

— 417 —

SILURIAN

Berwyn, Burlington, Grennan

— 443 —

ORDOVICIAN

Aberllefeni, Brandy Cragg, Broughton Moor, Buttermere, Croes-y-Ddwy Afon, Cumbria Green, Cwt-y-Bugail, Elterwater, Gloddfa Ganol, High Fell, Hodge Close, Kirkstone, Lakeland Green, Portmadoc/Ffestiniog, Prescelly, Spoutcrag

— 495 —

CAMBRIAN

Nantlle, Penrhyn, *Swithland*, Twll Coed, Vronlog

— 545 —

PRE-CAMBRIAN

Achill Quartzite, *Connemara Marble*, Donegal Quartzite

— 4500 + —

GRANITES AND OTHER IGNEOUS & METAMORPHIC ROCKS (AGE UNSPECIFIED)

Bearah Tor, Blackingstone, Cataclews, Dalbeattie, De Lank, Hantergantick, Hurdwick, Iona Marble, Kemnay, Luxuillianite, Merrivale, Mountsorrel, Peterhead, Pentewan, Polyphant, Ross of Mull, Rubislaw, Shap

Fig. 14 Stones and quarries of the UK

SUITABLE CARVING STONES

Before starting a carving it is advisable to know something of the qualities of the stone to ensure that it is compatible with your sculpture design and its proposed location. It could be that you want to carve a white cat, in which case your options may be limited to marble, alabaster or Portland stone, but what more should you know about the specific characteristics of the stone itself and what you can expect from it?

Bear in mind the geological descriptions above, as well as the diagrams displaying the geological ages of the stones, where many of them can be found in the UK and the detailed explanations about recommended carving stone below. From these you should be able to make an informed decision about which stone will be most reliable and suitable for your particular sculpture.

Alabaster

Once readily available in England, alabaster (from the Triassic Period) has now become almost impossible to purchase for carving purposes and most is imported. Italian alabaster is proving to be of good quality and currently can be obtained in pure white and light 'donkey' brown, with new varieties still appearing. This stone is soft gypsum (hydrated calcium sulphate) that can appear quite hard to carve, especially in the early stages, because of its crystalline qualities and the effect of cutting through crystals. However, as work proceeds, it becomes more evident that alabaster is, in fact, a soft stone that can quite easily be worked to the smooth and refined finish required to expose the characteristic translucency that gives it another dimension.

Alabaster is unusual in that it can be worked very thinly in selected areas without support, if carefully fashioned. This characteristic was used to great effect to make translucent windows in early-Christian and fifth- and sixth-century Byzantine churches, for example, in the Basilica di San Vitale in Ravenna, Italy. In the twenty-first century the windows of the Cathedral of Our Lady of the Angels in Los Angeles, USA, were made from sheets of alabaster in warm earth tones, measuring 27,000 sq. ft (2,508 sq. m) in total!

Alabaster is quarried around the world in colours ranging from pure white, through ivory, grey, brown and orange to pink, frequently with darker veining within it. The stone has cloud-like markings throughout that might give the impression that it is unevenly cracked. In fact, these markings are typical of the stone, which is actually strong and will not break apart unless you deliberately choose to put a chisel along the line of the marking and strike the stone for this purpose.

Alabaster is a very popular carving material and lovely to look at in its own right. It takes a high polish if required although a matt finish is attractive too, closely resembling Lalique glass. However, alabaster should be considered carefully before being chosen for a projected sculpture. Some designs need a solid colour, not a translucent material. As a really beautiful stone it is often admired just for its own features; its colour and markings deep within, exposed by the translucency as it evolves with polishing. This means that the more

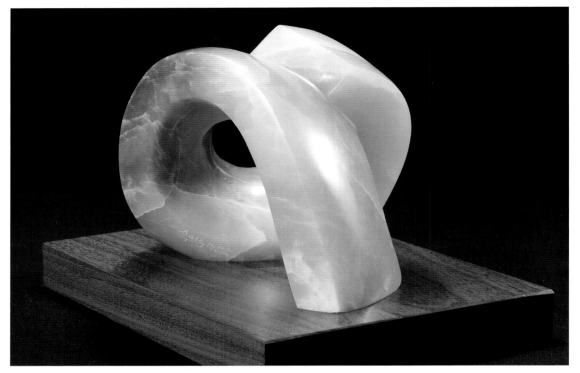

Fig. 15 Virages (alabaster, 10 x 8 in/25 x 20 cm)

delicate details of a complicated design can be lost amongst these characteristics. Therefore, it is advisable to create an uncomplicated design for an alabaster sculpture, or the stone might be admired more than your sculpture!

Be aware that alabaster can bruise, so as your carving develops you will need to take care not to strike the tools too hard perpendicularly into the stone. The resulting stun mark, in the form of an opaque white bruise, can penetrate alabaster ½ in (1.25 cm) into the stone. When the carving is finely finished and ready to polish, these marks become very obtrusive, as they are the only areas of opaque stone within the translucency. Unless they are superficial it can be impossible to remove them without reducing the surface level of the sculpture and consequently the shape of the carving. Try to ensure that the cutting angle of your tool is kept oblique to the surface to minimize any bruising.

When purchasing alabaster, choose a block that has been cut rather than a random boulder, as boulders tend to have shallow bruising over most of their surface from being rolled around in storage. Should you acquire such a boulder you would need to remove these marks first, which could alter the proportions of the stone.

To judge the colour, markings and translucency of alabaster before you start work, try pouring water over the surface; this will give some indication of what lies within.

Alabaster is a stone affected badly by frost and rain and should only be stored and displayed indoors.

Ancaster Hard White

This is an ooidal limestone and is quarried in Lincolnshire (Middle Jurassic, Lincolnshire Limestone Formation). It is an ideal stone for carving as it is generally of even texture and cuts cleanly and predictably. It contains small shells and fragmented minerals, is an attractive warm, cream colour and typically has honey-coloured lines running discreetly horizontally through it. These lines show the bed of the stone. This dual colouring is very pleasing when the stone is polished and provides an interesting feature in a sculpture. It often has cobweb and mica-like patches that appear on the surface as the stone is being refined. Hard White is more commonly chosen to display indoors where its colour can be appreciated at close quarters, especially when polished and the honey-coloured striations are enhanced. For aesthetic reasons, sculptors sometimes choose to carve Ancaster Hard

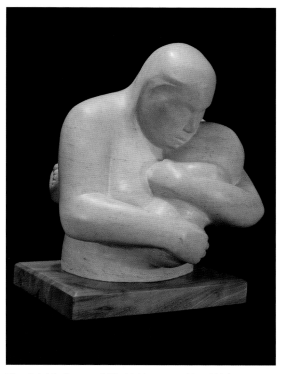

Fig. 16 Mother and Child (Ancaster Hard White, 18½ x 13 in/47 x 33 cm)

White with the striations running vertically. In the long term, these carvings are only appropriate for display indoors to avoid the ingress of rain into the striations.

A related stone is Ancaster Weatherbed, which is creamy white, often with clearly defined, large patches of blue stone within it (known as blue-hearted) containing shells and minerals. This blue stone manifests itself in the quarry in the form of a 'sandwich' of colour within the cream stone and is often wide enough to be selected as a single-coloured blue block. At other times, when the blue layer is narrower, the characteristics of the dual-coloured stone can be used to good effect for sculpture for outdoor display. Carvers should be aware that the blue stone is much harder than the cream.

Bearing in mind the comments above about the bed of the stone, Ancaster Hard White and Weatherbed can be used both for indoor and outdoor sculptures as they develop a harder 'skin' as they weather.

Clipsham

From south Lincolnshire, this is also a Middle Jurassic limestone (from the Inferior Oolite Group). It is not always regarded as a carving stone, but it is so attractive and unusual to use that I mention it here. It is very hard and therefore recommended to more experienced carvers and those who like a challenge and are prepared to spend time developing the

work. It is a stone full of minerals and fossils that give it separate and vibrant colours of yellow, beige, brown, blue and grey, which are particularly strong and beautiful when polished. The markings are generally circular and coarse. Clipsham is similar to some marbles in style. It might be a choice worth considering for a focal point piece which, because of the markings, needs to be of fairly simple design.

Granite

Granite is still selected in some areas for memorial stone because of its long-term durability, particularly in south-west England, Scotland and Ireland. However, in other areas it is positively discouraged for memorial use because of its very long life, and there are some church incumbents who will not sanction the use of this material, particularly if it is not indigenous to their area.

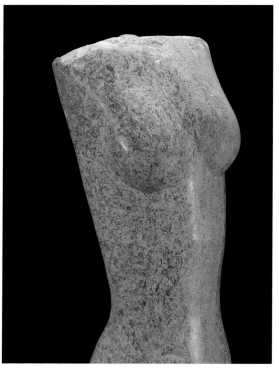

Fig. 17 Detail of Tall Torso of Woman (Clipsham, 15 in/38 cm)

Granite has a coarse crystalline and granular appearance and is primarily made of quartz and feldspar. Its colours include red, black and grey mixtures. The extremely hard quality of the stone responds well to being pulverized with pneumatic hammers as a means of reducing it and to fashion and cut decoration and lettering into it. Although this is now the accepted method of dealing with such hard material there are still those who love to use the stone as a sculpture medium and choose to carve granite by hand.

Hopton Wood

This Carboniferous limestone is a hard, crisp stone. It is quarried in Derbyshire and is warm white in colour, peppered with beige flecks (fossil fragments) throughout. Despite its hardness and similarity to marble (though not crystalline), it is responsive to carving, and attractive to look at, so suitable for the beginner who is not in too much of a hurry. It suits most sculptural ideas, whether abstract or figurative, as well as being suitable for lettering or relief carving with fine detail because of its evenness and clarity of cut. It has been popular with many well-known sculptors over a considerable number of years and is excellent for indoor or outdoor display.

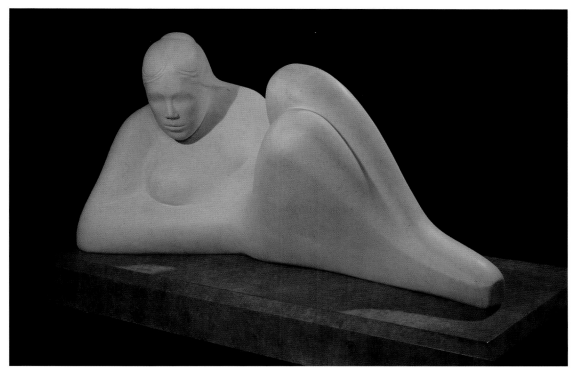

Fig. 18 Reclining Woman (Hopton Wood stone on bronze base, 49 x 24 x 27 in/125 x 61 x 68 cm)

Marble

Marble consists of fine to coarse crystalline mosaics of interlocking calcium and/or magnesium carbonate crystals and has been carved for centuries. It is much softer freshly cut from the quarry than after storage.

It has been popular as a sculptural medium since the Ancient Greeks and Romans and it has been used for architectural purposes all over the world. Carrara marble was extensively chosen during the Italian Renaissance for its amazing, pure-white quality. Famous sculptors, particularly Michelangelo, Bernini, Canova, Rodin and Brancusi, are amongst the many sculptors who made the quarries at Carrara the most famed in the world. They chose the clean, white stone to emphasize the purity of their subject and emotional significance of their message. The Taj Mahal is notable for the magnificence of the marble used for this beautiful edifice, both architecturally and calligraphically.

In the twenty-first century, marble is often treated as power-tool material, but it is still chosen by the stalwart hand carver who finds it a challenging but rewarding stone. And Carrara marble is still probably the most sought after marble of them all.

The complexity of many of the colours and markings in some marbles can very easily overwhelm a sculpture so that it loses its identity and forms become lost within them. White, grey, black or cream marble or finely flecked single colours can be an ideal choice for some sculpture, but consider carefully whether a colourful or multi-figured marble or

onyx would be right for your work. Belgian black marble is very beautiful because of its pure colour. It does smell of sulphur as you carve, but it is worth the discomfort to see the finished result!

Portland stone (Whitbed and Basebed varieties)

Cropping out only in Portland Bill in Dorset, white Portland stone is an ooidal and bioclastic limestone from the Upper Jurassic (Portland Limestone Group) and comes into the Jurassic, oolitic limestone category. The two varieties of stone are cut from the same quarry but, as the name suggests, the Basebed is quarried from a lower stratum than the Whitbed.

This well-known and much-used stone has historically been chosen for large memorials and prominent buildings in a number of cities across the UK and is particularly apparent in London; St Paul's Cathedral, the Cenotaph, Waterloo Bridge, the British Museum and the former offices of the *Daily Telegraph* in Fleet Street are particularly notable for the use of this stone. Portland is characteristically a shelly stone, with a good, firm texture for sculpture. It is pale cream or white in colour, tending towards light grey because of the shells within it. Although both these Portland stones are good for carving, the Whitbed is perhaps slightly preferred for its marginally warmer colour.

The rather coarse texture of Portland stone precludes it from being polished but it can be finely finished and is ideal when used for crisp, drawn shapes, similar to masonry. The reflective qualities of this stone and the darkness of the shadows created within it mean that a relief design carved into Portland stands out well and looks at its best when linear shapes are accurately cut within it.

It is interesting to note that the soft, fine-grained Caen stone (Middle Jurassic bioclastic limestone) which is quarried in Northern France is part of the same Jurassic geological stone basin as Portland stone, which extends between France and the UK under the Channel. Caen stone was previously also popularly used for sculptural, architectural and building material in south-east England. Today, Caen stone is still found in northern France but it tends to be too soft for sculptural purposes. Portland stone has more character, with its fossils, and is generally of a harder quality.

Purbeck

This is a Lower Cretaceous limestone (Purbeck Limestone Group), from Dorset, of hard marble-like quality and can be a mottled, pale or dark cream in colour with very attractive, small pale shells (mainly freshwater gastropods and shell fragments depending upon which variety you choose).

As there are various qualities available it is worth a visit to a Purbeck mine to select stone. Purbeck mines are currently open-cast. Traditionally, an angled shaft (an adit) was dug to the desired layer of stone, which was removed underground by hand (bars and wedges), thus avoiding the mammoth task of removing the over-burden or surface stone. Hydraulic excavators have made light work of that and since the Second World War not many people

have returned to that method of quarrying (although, perhaps surprisingly, the last-known activity was as late as the 1980s).

Purbeck cuts cleanly and is excellent for linear designs and lettering as well as for sculpture. It can be carved for interior use and polished very finely to reveal the lovely markings if required. It is not considered a long-lasting stone for outdoor sculpture as it can decay badly in the elements. Because of its hardness, I would generally only recommend Purbeck to those who have some experience in carving.

Slate

Slate can be a delightful stone to use for sculpture, bearing in mind its liability to laminate. If carved carefully it is possible to produce quite impressive three-dimensional images or relief carvings. It is very good for lettering and so is commonly used for memorials and architectural purposes.

If a slate slab is finely rubbed, so that the surface is really smooth, scratched drawings made with a scribe are easily seen, and by cutting carefully along the drawn lines a shallow relief can be created. I have seen a lovely, icon-like drawing on slate which was remarkable for its detail and clarity and which, years later, was still as clear as when it was first created.

There are still Welsh grey slates available in some quarries, although the best unblemished stone has apparently been worked out. Some grey slate contains curious pyrites and most have swirling, cloud-like smoky markings. Delabole slate from Cornwall has an unusual, pearly-grey sheen. The colour of slate from Cumbria ranges from finely flecked green-grey to grey to nearly black.

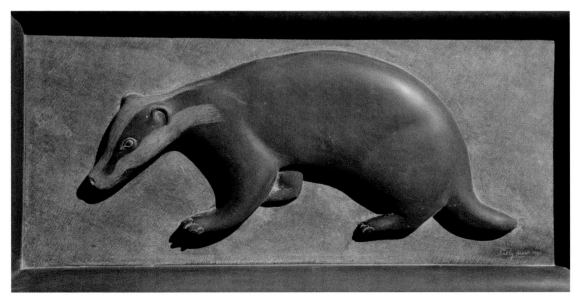

Fig. 19 Slate badger plaque (31½ x 18 in/80 x 46 cm)

The stone can be obtained in slab form and sourced direct from quarries or sometimes memorial masons.

Soapstone (Polyphant Stone from Cornwall)

This stone is a metamorphic steatite (serpentanite) and is an ideal medium for sculpture. It is found worldwide, and was the preferred stone of the Inuits for their naïve carvings. The best stone is freshly quarried and sawn. The fine, mottled colouring of this opaque material seems to enhance sculpture designs whether large or small, abstract or figurative, and whether the stone is polished or not. It is responsive to carving and easily controlled with sharp tools

It is black, green or grey in colour, usually with darker blues mixed in and sometimes with rust from iron ore within the stone which manifests itself as orange speckle marks that can be jewel-like and beautiful in sculpture. Be aware, though, that some tempting and attractive blocks contain a plethora of iron ore marks, appearing in dense patches. Although the presence of a few, fairly widespread but small speckles are ideal within a sculpture, dense patches will be hopelessly soft and friable and liable to crumble badly or even disintegrate when carved, so do avoid them.

Soapstone is a porous stone, unsuitable for outdoor storage and display. I have encountered students who have acquired a soapstone block which looked fine but had been left in the open air. They were disappointed to find it was completely uncarvable; it had become spongy and soft because of being weathered and badly affected by rain and frost.

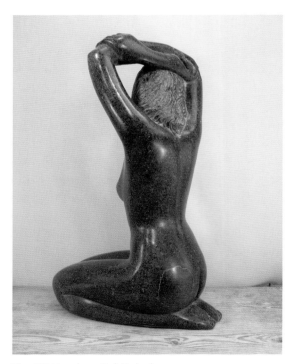

Fig. 20 Kneeling Girl (Polyphant soapstone, 34 x 18½ in / 87 x 47 cm)

Serpentine stone

Serpentine stone is geologically closely related to soapstone and is found in the Lizard Peninsula area in Cornwall. It is, however, much harder and tighter-grained than soapstone. It is black or green in colour with bright markings in different greens, yellow and grey and frequently with strong, straight map-like lines and markings. It is another stone to use for simple designs. I have used it successfully in conjunction with a tungsten tool to incise shapes and designs into the polished surface. In many ways it is similar to carving marble, although not crystalline, and because of the bright and crisp colours it reveals is well

worth the slow carving time. It can be polished to a very high shine which shows up the colours clearly but also is very attractive when textured or tool marked, so that the colours appear more muted.

MORE COMMENTS ON STONE

If a sculpture is planned for the landscape remember to check (or ask when purchasing) that the stone stratification marks (bedding planes or lamination) lie horizontally so that there is less likelihood of the stone splitting through ingress of rain. If the carving is planned for indoor use this is not a consideration and you can choose to design your carving specifically to emphasize these bed marks to good effect.

Although the general descriptions of the colours of the stones mentioned are accurate it has to be appreciated that, being a natural product created with organic and mineral content, there are frequent variations in colour and stone markings, even from one part of the quarry to another. I have not included specific pictures of stone because of these variations but hopefully the descriptions and photographs illustrating various stone mentioned will be sufficiently helpful to enable you to visualize them and decide whether the stone is likely to be of interest. Some stone quarries happily provide stone colour samples and it is always worthwhile contacting them for this purpose. Better still, ring beforehand and visit the quarry and see if you can select pieces of stone to carve on site. To obtain a fairly good idea of the colour of any stone you have selected, pour cold water over it and the wet stone will show up many of the characteristics. All colours and detail you initially see in this way will be enhanced by the refining and polishing of the stone.

When selecting stone, take a carving tool with you and check for cracks or damage. Strike all around the stone with the tool held fairly loosely in the hand. If the stone has a ringing quality, it is sound. If it clunks it almost certainly has a crack or poor-quality material somewhere in that area. Check to see if the dull sound is extensive (e.g. along a particular line) or in a specific location. It could just be that a section of the surface material is soft and can be cut away, leaving the rest sound, but it could indicate a more extensive crack. A stone supplier would certainly be happy to check that the block is sound and you can re-check if you are not certain. It will not offend anyone if you test for cracks. Choose another piece if you are unsure.

DISCOVERING A CRACK (VENT) IN YOUR CARVING

A block which initially appears to be perfectly sound can suddenly reveal a crack whilst you are carving. Should you discover a very fine, dark hairline in the stone that you can trace for any length, there is, unfortunately, a crack. If it runs fairly near the surface of the stone and you can track it away from the main sculpture area it can probably be removed without interference with the carving, but if it seems to move inwards and across the proposed sculpture, you will need to consider what to do.

The vibration from carving will slowly open up a crack, so you can choose to carve on

for a while, checking whether it is lengthening, but you must make a decision quickly as to whether to risk proceeding with your sculpture or to open up the crack immediately and split off that part of the stone.

The most sensible thing to do is to deal with the problem head on by placing a flat chisel along the line of the crack and striking it hard with a mallet, moving the tool along it as you strike, causing it to open up. Gradually you will separate the two pieces.

If the stone is soapstone you will usually find that the crack line is caused by a thin film of iron ore, which can act as a separator between slightly different mineral surfaces within the stone, and that, in fact, the two separate pieces of stone are independently quite sound.

It is better to have made this separation before you are too far into your carving than to discover the problem later on and have to abandon the piece. With luck the crack will not have intruded too far into your work and you can carry on with just a slight adjustment. If you need the separated stone for the sculpture you will need to fix the two parts together with stone resin (see Repairs, Chapter 5, page 102).

WHICH STONE TO SELECT FOR CARVING

My advice would always be to try carving all sorts of stone, including the ones detailed, and get to know their characteristics, their good and not so good points, and, most of all, which of them you personally like. All knowledge comes from experience, and it takes time to accumulate that.

© Richard Edwards

Fig. 21 Detail of Reclining Woman

Any of the soft stones described previously are suitable for the beginner and new carvers can safely choose a stone which appeals to them from those descriptions and current availability.

The stone you select needs to reflect your own temperament as well as the sculpture you plan to make. If you are patient and prepared to spend the time on a carving, harder stones, such as Hopton Wood limestone or marble, are well worthwhile because of their strength and crispness, appropriate for detailed work should you want to make something with fine features, such as noses and fingers on a figurative sculpture.

Soapstone can be cut quite finely but needs to be tested out first on an odd corner to establish how hard the piece you are selecting is likely to be. Softer pieces will not be suitable for very detailed work, but sharp tools should enable you to cut fine detail if required.

2 Tools and their Uses

Choosing stone tools to start your collection is a stimulating but potentially daunting experience as there is such a wide selection from which to choose. Without some advance knowledge it can be confusing, and annoying should you find you have bought incorrect or unnecessary tools.

Firesharp tools are required for stone carving. They are tempered by blacksmiths ready for use but normally require you to give them a final sharpen before cutting stone. There are several different cutting profiles, each with a variety of widths to choose from. Stone carving tools do not have wooden handles but are made entirely from carbon steel with octagonal steel shanks, which are easier to grip than round steel. Some of these tools are designed for roughing out stone (i.e. removing stone which is outside the area of your carving) and others for general shaping, reducing and refining. A hammer or mallet will be required to strike the carving tools and you may be offered another kind of hammer called a 'dummy'.

HAMMER OR MALLET?

Stone tools are used in conjunction with lump hammers with rectangular, malleable iron heads, nylon (or polycarbonate) mallets with rounded heads or wooden mallets with rounded heads – all of which have wooden handles. It is advantageous for the student to know the various characteristics of each and, therefore, which of them might be preferable to use.

Selecting between hammer and mallet can be confusing and, where possible, it is worth doing some stone carving with both in advance, to get used to the feel of them, before making your decision to purchase. Alternatively try to visit the supplier to give yourself the opportunity to handle both kinds of striking tools and evaluate the weight, structure and particularly the balance of the tool to decide whether you could use it over long periods. You will probably be carving for some hours at a time and need a hammer or mallet which

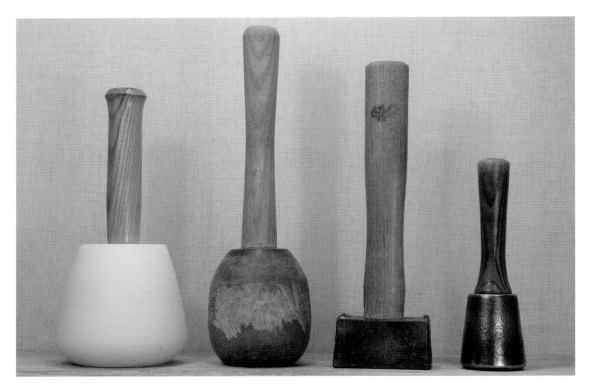

Fig. 22 Nylon and lignum vitae mallets, lump hammer and dummy

is heavy enough to make the tools function efficiently, but not so heavy that your wrists and arms will ache, meaning that you cannot continue.

Traditionally sculptors used lump hammers with their carving tools, but some carvers find that they appear much heavier than mallets as all their weight is concentrated in a comparatively small tool head. If you have strong wrists and prefer the idea of using a metal hammer, choose from a selection of the weights available.

The white nylon mallet has a larger, round head and is very well balanced. My experience has been that most students seem to prefer these, finding them comfortably heavy and a robust tool that can be used over long periods without causing tiredness. The 4 in (10 cm) mallet, in particular, proves to be a good weight for most people, although heavier ones are available.

It is important to appreciate that mallets and hammers are designed to strike the carving tool to bring about the most effective removal of stone in a controlled way and it should be the weight of the mallet, not the use of the shoulder, that transfers the power through the tool to cut the stone.

One advantage of nylon and wooden mallets is that they absorb much of the vibration of carving and thus are not so punishing to wrists and joints. They also have the bonus of being quieter to use than metal hammers on metal tools. Wooden mallets are available in beechwood or lignum vitae and as lignum is the harder and heavier wood of the two,

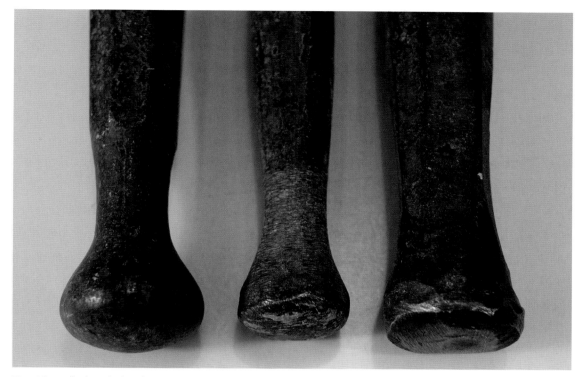

Fig. 23 Mallet-headed tools

size-for-size, they are a better choice. Wooden mallets are more popular with people with weaker wrists and for carving small sculptures. Because of the nature of wood, these mallets are inevitably more easily damaged by the impact of tools than nylon and iron hammers, and tend to splinter in time.

It is important to choose your hammer or mallet before any other tool, as tools vary in shape at the striking end and each style of top is designed to be used specifically with either a mallet or a hammer. Students new to stone carving frequently choose hammer-headed tools for use with mallets or vice versa. You really do need to match the hammer or mallet with the correct tool to avoid inevitable damage to all types of mallet.

If you decide to use a nylon or wooden mallet you will need to purchase mallet-headed tools to partner them. These steel tools have rounded, mushroom-shaped tops that protect the mallet from damage.

An iron hammer requires the use of hammer-headed tools. These have almost pointed tops, designed for use with metal hammers only and, if chosen in error, this is the shape that can damage wooden or nylon mallets. Hammer-headed tools are also used with hammers for marble and granite carving.

A third type of striking tool is a dummy (see Fig. 22). This has a small, cone-shaped iron head, a round wooden handle and is a good mid-weight, comfortable to hold and very tempting to purchase. However, it is actually designed for cutting lettering into stone (for

which it is perfect), not for making stone sculpture. With such a small, light tool, the power to cut the stone tends to come from the shoulder girdle. The dummy itself is of inadequate weight to meet substantial carving requirements, so carving takes longer and eventually becomes tiring. For this reason I would only suggest the use of a dummy for a very small sculpture carving – it is not the best choice for the serious carver. A dummy needs to be used with hammer-headed tools.

STONE CARVING TOOLS

Carving tools have the following names and in practice are used in roughly this order:

Point
Punch
Pitcher
Claw
Chisel
Gouge
Bouchard (or bush hammer)
Tungsten-tipped chisels
Rasp
Riffler

Fig. 24 Hammer-headed tools

The tools you choose will depend on the size and complexity of the carving, with some small works only requiring three or four in total.

A mallet or hammer and a claw, chisel and gouge just ½ in (1.25 cm) wide and one or two rifflers can be sufficient to tackle a carving of up to, say, 18 in (46 cm) cubed, so with this minimum number of purchases you can set yourself up.

However, once you begin working regularly on stone carving, your collection will inevitably grow and you will doubtless want a selection of tools in varying widths – and, in the case of rifflers, several sizes and shapes – so that you can tackle a sculpture of any dimension and be equipped with tools to suit simple or complex shapes.

As a general rule, larger tools should be chosen to carve wider areas of stone and small ones for more detailed work. Too small a tool can leave deep marks in the stone, because you are trying to remove large amounts of stone too quickly, so select a wider one, covering a broader area rather than damaging the stone.

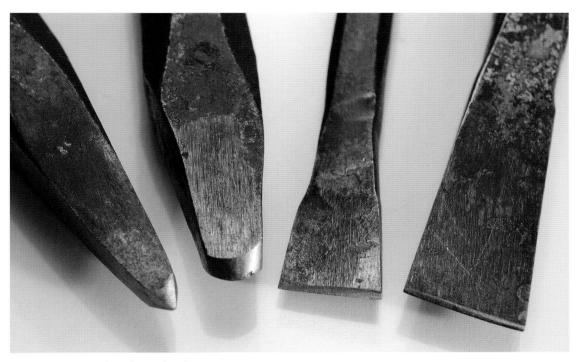

Fig. 25 Point, punch and two chisels

Fig. 26 Creating initial parallel lines with a point

Point

A point is a tool with a sharply pointed tip designed to cut down into the stone to remove large quantities, most frequently in the initial stages of roughing out a sculpture. You can use its weight and piercing shape to burst away any unwanted stone outside the bounds of your sculpture as quickly as possible. For this reason it is often the first tool to be chosen.

The traditional method of carving with the point is to cut a series of deep, parallel score lines in the selected area with heavy blows from the hammer or mallet; by subsequently cutting similar deep lines between them, the blows will burst the central stone away. The point needs considerable force to remove large quantities of stone quickly. This action is repeated until the main roughing out is completed.

Heavier points are used first to dispose of the majority of unwanted material and smaller and lighter ones can be chosen for the early shaping of the emerging sculpture.

A point is usually too aggressive for use with alabaster, which can bruise easily, and, similarly, it is not normally recommended for use on soapstone, a soft stone readily damaged or fragmented by the action of a point. However, it is ideal for limestones, marbles and hard stones in general.

Punch

A punch is a similar tool, used to remove large areas of unwanted stone (see Fig. 25). Its

Fig. 27 Roughing out stone shape with the point

oval cutting edge, about ¼ in (6.5 mm) wide, is sharpened on both sides and slices effectively into stone during the roughing-out process. It does not have any advantages over the point, and is not so commonly used, but it is an alternative that you may prefer or that cuts your current block more effectively.

Pitcher

This tool is specifically designed to cut away large lumps of unwanted stone, mostly from the angles and outer edges of a flat-faced block of hard stone. It is a bulky tool, with a slightly angled head, one flat edge of which is sharp for cutting. The flat edge is laid against a surface of the stone, generally near a corner, and angled upwards and outwards; it is then struck hard to break the stone away. A pitcher is only required when carvings are very large or the stone very hard and need not form part of the beginner's collection.

Claw

The claw is one of the most ancient carving tools and one of the most frequently used. It is a flat-edged, wide-toothed tool, usually used for more specific shaping of a sculpture after the initial roughing out has been completed – it continues the process of reducing the level of the stone but in a more refined way. It can also be used for roughing out, especially for smaller carvings. It is also an effective tool for carving soapstone.

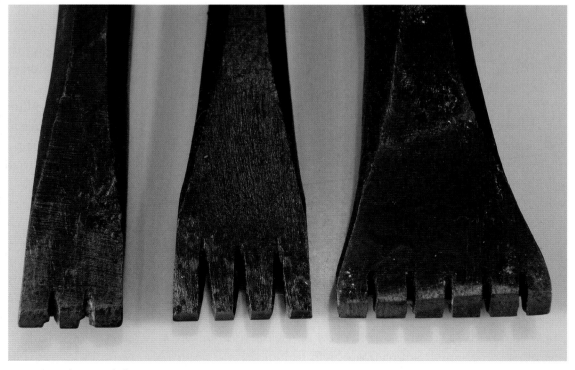

Fig. 28 A selection of claws

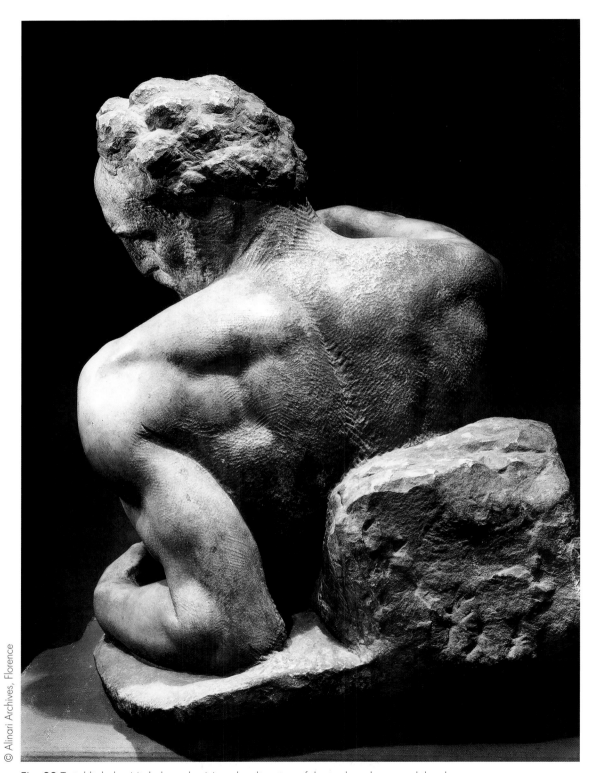

Fig. 29 Twighlight by Michelangelo. Note the direction of the tool marks around the shapes

The teeth of the stone claw have cut off points that leave narrow parallel lines in the stone, although a marble claw has pointed ends. They are produced in various widths with two to eight teeth, but to be efficient the whole surface of the tool should be in contact with the stone during carving. It is rarely necessary to use a claw with more than four or five teeth (under 1 in/2.5 cm) on a sculpture unless it is very big.

On wide, flat surfaces broader claws are used to shape and level the stone parallel to the current surface; similarly, on a curved surface, the claw creates parallel contours, reducing the size and bulk of the stone to gradually release the detailed shapes of the sculpture prior to using a riffler.

The claw may not always be suitable for cutting alabaster as it may rough up the surface of some blocks rather than cutting it cleanly, and sometimes a flat chisel or gouge may be more appropriate.

The claw will produce interesting textured surfaces that the sculptor can use to give a particular effect to part or all of a sculpture. A number of Michelangelo's unfinished works clearly show the marks from the points and claws he had been using to emphasize the powerful contours of his marble carvings as he created them. On other sculptures we can see how he used claw marks, sometimes in criss-cross form, to add texture to shallow shapes. Far from giving these carvings an unfinished look, the markings added softness and romanticism, for example on his carvings of the Madonna. Examining Michelangelo's work can provide us with a useful lesson on the master's techniques and we can all still learn a great deal from his genius. The male figure of *Twighlight* on the tomb of Lorenzo di Medici at San Lorenzo in Florence is a perfect example of these markings, demonstrating the use of the claw and how its marks add strength and masculinity to the form.

Flat chisel

There are those who choose to use the flat chisel (see Fig. 25) rather than the claw, preferring the clean cutting surface it produces from its straight edge to the rougher finish of the claw. Like the claw, the chisel can be used simply to reduce stone where required. However, it is especially good for 'cutting in' shapes at the early stages of a carving to bring out a feature or finer detail. With its precise cut, a thin chisel with a well-sharpened edge is frequently used for lettering in stone and carving in relief.

Gouge

This tool has a U-shaped cutting edge and can be used in conjunction with the flat chisel and claw for shaping and developing a sculpture. As they are hand fashioned, the depths of gouges vary, even within same-width tools, so a selection of these is useful. Gouges cut a clean, curved surface in alabaster and soapstone and do not fragment the stone, which makes them a good choice of tool for them. For these materials, select a width of tool to suit the area to be cut; do not choose one so large that control of the shaping is compromised.

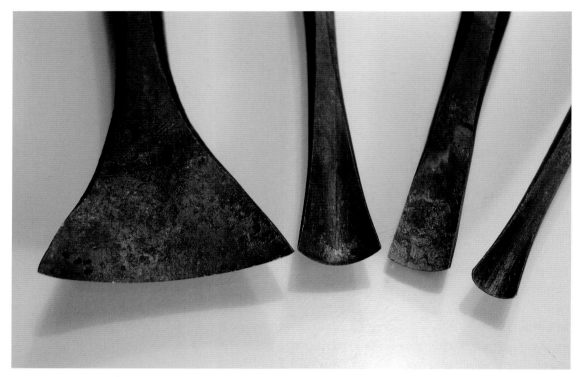

Fig. 30 A selection of gouges

Sculpture tools are usually offered in two or three lengths; the most commonly used is 7 in (18 cm) and the longest normally offered is 9 in (23 cm). Even longer tools are effective to reach awkward places, for example through an aperture, and for large sculptures. A friendly blacksmith can often be persuaded to make tools especially for you to any specified length.

Bouchard (bush hammer)

A bouchard has a wooden handle and resembles a meat tenderizer. It is used on its own, like a hammer, to pulverize and abrade away very hard stone surfaces, such as granite, which cannot easily be cut with traditional carving tools. Its hypnotic action can cause one to dispense with other tools until the final finishing, but it cannot achieve fine detail and close shaping, even though they are available in several sizes. It is a good tool to use for creating a texture on stone.

A bouchard is an effective tool to have in your armoury for the times when you find a particularly hard stone difficult to cut with conventional tools. Ancaster Weatherbed stone is a good example of a popular stone with dual characteristics, where the patches of very hard blue stone within the softer limestone can be abraded with a bouchard hammer to good effect.

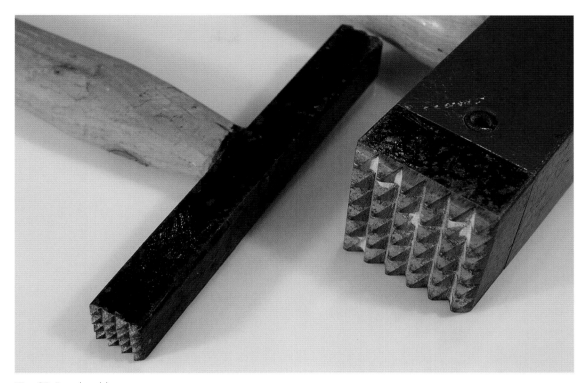

Fig. 31 Bouchard hammers

Marble tools

Marble tools are manufactured in narrow-gauge octagonal steel and are tempered differently from firesharp tools to suit harder stone. The distinctive teeth of marble claws are finely pointed – rather than flat-ended – to penetrate hard, crystalline stone more successfully. Heavy-duty marble tools, such as points, are produced to burst away large amounts of stone in the early roughing-out stages, and finer points, claws and gouges are later employed to give the stone its final shape. All the tools need to be kept sharp to cut well.

Tungsten carbide tipped sculpture tools

Tungsten carbide is an expensive, hard and brittle metal, popular for sculpture tools because of its ability to take and hold a sharp edge. The cutting blade is produced as an insert into the tip of the tools. For general carving they are manufactured in a more robust form and have bulky shanks to protect the tungsten carbide from damage. Tungsten carbide tipped claws and flat chisels are available.

Tungsten carbide chisels for letter carving are generally lighter in weight and provide the hard and very sharp cutting edge needed to produce the fine, crisp detail of lettering in stone. In these tools, the tungsten inserts protrude from the shanks by about $\frac{1}{16}$ in (1.5 mm). This makes them unsuitable for general sculpture, as the brittle metal can chip too easily as it cuts through the surrounding stone. However, they are perfect for cleanly

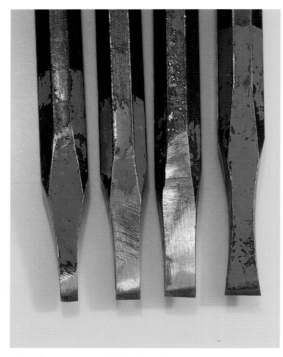

Fig. 32 Tungsten carbide chisels

cutting fine detail into soft stone when the general carving is completed, and are a useful adjunct to your tool collection. Lettering tools are hammer-headed and designed to be used with a metal dummy. They are distinguishable from firesharp tools by being partly painted, usually blue, burgundy red or green (these colours relate to the manufacturer and have no practical significance).

Rasps

Once the cutting tools have done their job and the sculpture is more or less complete, rasps are employed. These have coarse surfaces designed to amalgamate and refine rough, tool-worked areas and achieve a good, consolidated surface on stone.

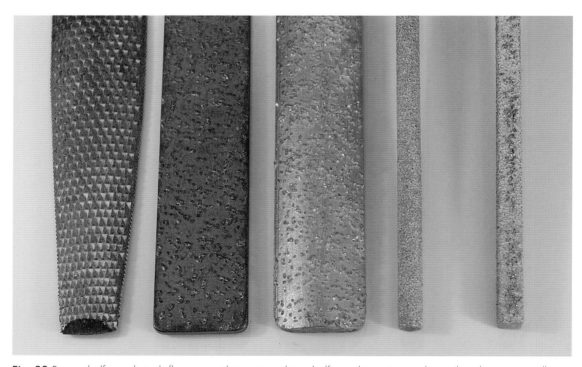

Fig. 33 Rasps: half-round steel, flat rasp with tungsten chips, half-round tungsten and round and square small tungsten bendable files

Half-round and flat, thin rasps are produced with tungsten fragments bonded to them and are good for holding at both ends and effectively smoothing large areas of stone. Narrow round and square 'bendable' rasps are also available, which can be adjusted to suit a particularly awkward angle or curve you need to reduce. The coarseness of a rasp means that a stone surface will be reduced quickly and gives an even but not very fine finish.

Rifflers

Rifflers are small, sophisticated abrading tools, specifically designed to shape and smooth the surface of a stone sculpture in the final stages until it is ready for polishing. Rifflers are individually handmade, the best coming from Italy, and offered in sizes ranging from 6 in (15 cm) to 12 in (30 cm) in length, the largest being the coarsest and the smallest being extremely fine.

They are traditionally made as double-ended tools with similar-sized rifflers at each end. They are available in a very wide range of shapes: flat with curved ends, flat with flat ends, round-ended, square-ended and with wonderful hooks, curves, points and cutting edges. Every contour and curve, hollow and crevice a sculptor can conjure up can be clarified, refined and finally honed in minute detail with these amazing files. So although you can manage with just one or two rifflers in your collection there is always a good reason to acquire just a few more 'essential' shapes and sizes you will find a use for one day!

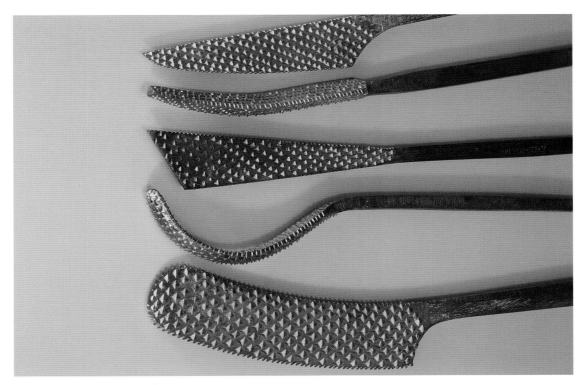

Fig. 34 Selection of large rifflers

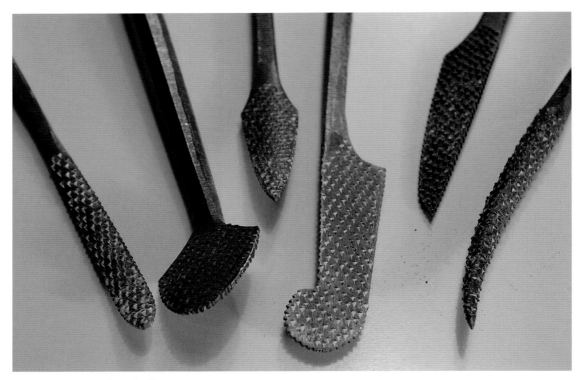

Fig. 35 Selection of small rifflers

Rifflers cannot be sharpened but should always be kept, even when finally blunt, for jobs where a dull riffler is required to remove tiny amounts of stone sensitively or where you need to be particularly careful not to scratch a surface. Alabaster, for example, sometimes needs such a tool for very fine adjustments to the final surface of a carving and to remove scratches. Never use a riffler on wet stone as this will quickly clog it up and causes it to rust and its sharpness to deteriorate.

You know that a sculpture is nearing completion when you are just using rifflers on a carving.

SHARPENING AND MAINTAINING STONE TOOLS

It is always good working practice to start or end your carving day by going through the tools you plan to use next and sharpening them ready for use. Stone naturally has a blunting effect and grit stones in particular dull a tool.

Using blunt tools will only succeed in breaking the stone rather than cutting it, which means you lose control of what stone is removed. New tools are often only partially sharpened and you need to ensure they are honed to a good edge before using them.

There are two surfaces that sharpen steel tools effectively. One is a flat-topped block of York stone, which is worth hunting down at a stone suppliers' or monumental masons' yard. The other is diamond-sharpening blocks, which are now readily available in coarse

and fine grits. These are prepared from man-made industrial diamonds and have a very long life. Both types of sharpening surfaces should be used with water. Please note that oil stones, such as those used for sharpening wood-carving tools, are not suitable for stone-carving tools because of the temper of the steel.

What is unusual about the edge of a stone-carving tool is that it does not come to a long, fine point, like a wood tool, but has a fairly stubby end with a sharpened tip. The thick metal protects the steel from being broken by its heavy impact on the stone. This means that it is only the narrow edge that must be kept sharp.

The angle of sharpening is critical for firesharp tools and should be approximately 40–45°. To sharpen, wet the surface of the sharpening block with water, then hold the tool on the block at this angle with one hand and support it lightly with the other. Make sure you are holding the tool squarely on the sharpening surface. Then with long strokes move the tool backwards and forwards on the block, first on one side of the blade, then the other, keeping the same angle.

The sharpened edges on both sides will gradually meet, forming a fine, shiny edge which you can see clearly. Assess for sharpness with your thumb, as one would a knife, until the tool feels really keen. If the tool does not 'drag' on the skin it is not sharp enough. The same sharpening angle should be applied to claws and chisels. Dry the tools when you have finished to avoid them rusting.

Gouges need the same angle of cut on the underside (back) of the tool and the

Fig. 36 Sharpening using York stone

Fig. 37 Diamond block, showing correct sharpening angle

inside of the curve will occasionally need the use of an abrasive slip stone to remove the fine steel burr which will develop over time and make the tool feel blunt, even when it has been sharpened. The slip stone should be flat to the inside face of the curve as you abrade the metal. If the burr is not removed the gouge will tend to break the stone rather than cut it in a controlled way, or be damaged itself.

When sharpening a gouge it should be held in the same way as the flat tools, with one hand guiding the direction and the other resting lightly on the tool to stop it wandering. Then swing from the wrist from side to side on the sharpening block at the same angle as before, so that the curved edge is abraded evenly. With the curved tool, take care not to move beyond the side of the tool, causing the loss of its corner.

A point should also be held rigid at a 45° angle and, using the facets of the steel shank as a guide, rotated, abrading the tool with a sideways to-and-fro action across the sharpening block until the point is sharp again.

When using York stone for sharpening, make sure the surface is used evenly so that the centre of the stone is not worn more than the rest, especially in ridges caused by the point. It is not possible to sharpen flat tools properly if the centre of the stone is worn away, so move the tools to different areas of the block. Consider using the vertical sides of the stone for your points or punches as they will tend to leave channels in the surface. Even a diamond block will lose its edge if you only sharpen tools in the middle, so be aware that the whole surface of the block is for sharpening.

Dry all tools after sharpening and occasionally brush them with a wire brush to remove any stone debris that might attract damp. To avoid rusting, an occasional wipe with a small amount of linseed oil on a cloth is worthwhile, although not rifflers. Do not get oil on the stone you are carving as it will stain.

Maquettes

1 Creating Ideas

There are always individuals whose minds are teeming with great ideas and, in a sculptural context, have designs for a collection of carvings they are itching to create in large blocks of stone bursting from within them. You may, or may not, be one of those people. The questions I am most frequently asked when teaching are: 'How do I get ideas?', 'Would I be capable of making sculpture?' and 'How do I begin'? If you have never done any stone carving before it can be a bit daunting and difficult to know where to begin. However, the fact that you have made the decision to make a stone carving at all means that you are halfway there already.

You simply need to want to do it, to think broadly about possible pieces and be prepared to sit quietly and sketch out any inspirational ideas that may emerge. However obscure these ideas may seem to be they can fire your imagination and set the process in motion. Everyone approaching an art form new to them faces similar uncertainties. With the enthusiasm to carve and the germ of an idea, inspiration grows and often develops from a simple or unexpected source. With someone to guide you with the technical information you need, you should be able to move forward successfully.

Are there any artists you particularly admire? Are your favourite sculptors people who made complex pieces, like Bernini, or did they make simple, tactile, refined ones, like Brancusi? What type of sculpture do you find yourself drawn to and what do you tend to reject? Do you ever think to yourself – I'd really love to have made that! Is it the subject, the texture or the technique that you are attracted to? Is it a style of work you would like to attempt yourself?

I do not approve of carvers copying other sculptors' work (which is, in fact, their copyright), using illustrations they may have found by surfing the Internet, picking up postcards or cutting sculpture photographs from magazines. However, there is nothing wrong with using the basic concept of another piece of work and developing that concept yourself, resulting in your own, original piece of sculpture. There are many examples of famous sculptors basing their work on other artists' ideas.

There is, however, great satisfaction in creating something totally original. You could be inspired by a specific sculpture or just a small part of it, an unusual shape amongst the branches of a tree, pictures you can 'see' in the swirls of your vinyl floor covering or perhaps an object, such as an animal or bird, whose contours you admire. Alternatively, you can find that the shape of a piece of rough stone suggests an idea to you.

You should, however, be aware of the intrinsic qualities as well as the limitations of your material. Stone cannot support heavy weights when it is too thin. It is not possible, for example, to carve an animal's tail without an integral stone base to support it. Similarly, one cannot carve a ballerina standing on one foot or a standing horse, even with its four legs, without support from additional stone, as the legs simply cannot support the weight of stone above it; this is why you frequently see large marble figures standing with a tree trunk or drapery conveniently placed against them, enabling the carving to be buttressed and thus safe. So some designs are inappropriate for stone and ideas must be tempered with this in mind before any work can begin.

It is quite common for certain shapes to keep recurring in your designs, round, undulating motifs or long, thin, seated figures, for example, that you return to again and again. Some sculptors make a study of a particular form, reworking it in different ways to explore and develop the idea. Elizabeth Frink, for example, was renowned (amongst other things) for producing many large male heads wearing sunglasses.

Collect and retain your initial ideas in a simple sketch or a doodle. Setting them down in some form gives you an invaluable *aide memoire* before the ideas elusively slip away. A fine-quality drawing is unnecessary at this stage, as the sketch is just for your creative vision. If and when you decide to take the idea forward it can be helpful to include marks that suggest the three-dimensional object, like hatch marks around some of the edges to indicate a curve, to give a better idea of the proposed shape and how you want to develop it.

The problem with drawings is that they are two-dimensional. It can be difficult to project the idea beyond the pencil marks on the page and know how the sculpture will continue round the back. Do you even want to have a front and back to your sculpture, or would you prefer it to be a continuous piece that develops subtly all the way round? One way to resolve these problems is to make a maquette.

MAQUETTES

A maquette is a small sketch model, only about only 3-4 in (7.5-10 cm) high, created in three dimensions from any suitable material – clay, plasticine, wax or plaster – to record

your ideas and keep close by whilst you are carving.

It is worth jotting down your ideas in clay whenever your muse is around and adding them to your maquette collection until such time as you want to carve any of them. Keeping your maquettes visible is an incentive to begin a new carving, especially if you already have a block of stone in your store that has the necessary proportions

Whilst carving, your maquette will be your reference and constant guide. Comparing the planes of the maquette with those of the developing sculpture will help you see and understand the three-dimensional relationship between the two. This will enable you to clearly visualize what stone needs to be removed and how you need to carve the sculpture at a particular angle or in a particular shape to achieve your final design. It will also, crucially, indicate the balance of the proposed form and whether it can stand up safely.

Fig. 38 Maquette of Girl with Hands Behind her Head

MATERIALS FOR MAQUETTES

The material used to create a maquette is not critical. However, a flexible material such as clay, Plasticine or modelling wax makes it easier to modify ideas as they develop. With these materials it is simple to alter shapes and proportions by adding or removing bulk as required.

Wax is a particularly versatile material and can be purchased specifically for modelling purposes. It softens in the hands when worked or when warmed in hot water but hardens somewhat after use. It is also less liable to damage than clay if knocked over or dropped.

Dental plaster is a also a good material for maquette making. It is mixed with water to form a thick, creamy consistency; once it has firmed up to a workable texture it is built up on a board with a spatula.

Plaster will set hard within a few minutes so it is best to prepare small amounts, relative to the size of the maquette you are creating or to the speed of your working. It is a strong, long-lasting material, but some feel it lacks the spontaneity of more flexible products as the shape is constructed in layers. Once dry and hard, however, the shape or design can be refined or changed by trimming and adapting the maquette with a knife, plaster tools or rifflers. Plaster can be left textured, or sanded down to a smooth finish. It is commonly employed by sculptors who cast their work in bronze.

An alternative way to use plaster for maquettes is to carve directly into it. Pour prepared plaster into an appropriately sized box or mould and once the material is hard and dry, carve the design into the material with a knife or carving tools, if the block is large enough.

DEVELOPING THE MAQUETTE

Develop your maquette by changing and adapting it. If it is in clay or Plasticine, you can bend and alter the stance, bulk or height and potentially discover new and improved designs. The beauty of a maquette is that you can see and analyse the shape from every aspect – front, back and top – and alter and adjust it until you are satisfied with your creation.

When you are happy with the maquette, particularly if it is made in clay, it is prudent to mount it on a rectangle of thin wood or hardboard, leaving some additional space around the maquette for later marking out (see Fig. 42, page 72). Insert a nail or screw up through the base and into the clay, so that as it dries and hardens it remains stable. The base will distance and protect the maquette from damage from adjacent maquettes when you store it. A maquette may be top heavy; in these circumstances, pinning it to a thin base is the only means of setting it up in its carving position in order for you to use it as a reference whilst you work.

On the workbench and in constant use, a maquette can be vulnerable from flying stone and general movement of tools etc., so try to shield it from such danger. A clear plastic box over the maquette gives ideal protection and still enables you to see it from all angles.

When choosing an appropriate block for a sculpture, have the maquette in your hand so that you can try to discover a similarly proportioned stone. There will be far less roughing out for you to do and less wastage of material if the proportions of the block are similar to the maquette

The maquette will be used until the last stages of the carving when it is often best to discard it to give you the freedom to further enhance and develop your sculpture as a full-sized work of art, perhaps beyond your original concept.

Some sculptors find they can visualize a design in their head and work directly into the stone without any reference to a maquette. This is called direct carving. More experienced sculptors are able to work very successfully in this way and some would not consider any other method. However, you need to have confidence in your plan and be able to envisage every aspect of the proposed work. Often this is the result of excellent knowledge of the subject, as the sculptor intuitively knows the forms exactly.

If you decide to carve a subject you may know intimately, a cat or horse for example, it might be possible for a beginner to be able to imagine the structure of a sculpture adequately or perhaps refer to a photograph just to confirm points of detail rather than using a maquette, backed up by drawings on the stone. However, I would not normally recommend new carvers to use this method. It is easy to become very confused whilst tackling the complexities of a stone carving without a tangible, three-dimensional model for reference.

MAKING A COLLECTION

Building up a collection of sketch ideas is an important pastime for most sculptors. Henry Moore was a great maquette maker and collector of ideas. His maquette studio at the Henry Moore Foundation in Hertfordshire is open to the public. There you can really appreciate just how enthusiastic and prolific he was in gathering his ideas together, spending huge amounts of time portraying them in maquette form in plaster or a combination of bone or flint and plaster. They are a fascinating insight into how his mind worked and an inspiration to any sculptor.

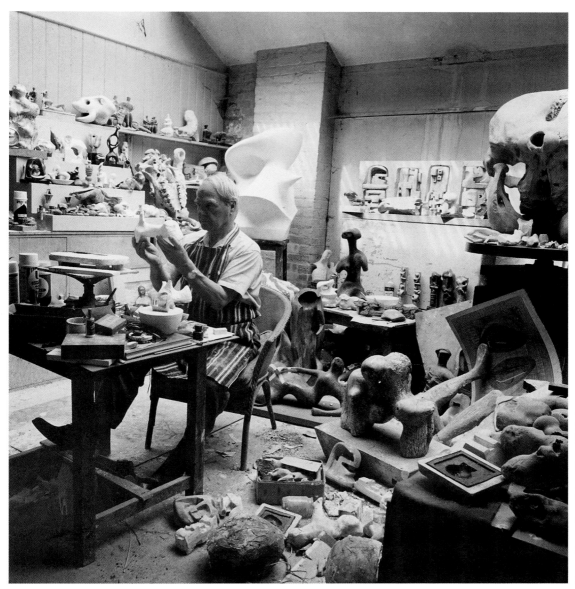

Henry Moore Foundation. Photo © Hedgecoe

Fig. 39 Henry Moore in his maquette studio at Perry Green

Traditionally, famous sculptors such as Rodin, Bourdelle, Brancusi and Henry Moore used maquettes to develop their ideas before taking one up and developing it into a larger, more detailed piece. It is becoming more common, when a major exhibition of a sculptor's works is collected together and displayed in a prestigious gallery, for there to be an area set aside for a display of various maquettes they have produced. These significant items are particularly revealing and exciting for those involved in making sculpture, who appreciate and will analyse closely the development of the sculptor's ideas. These maquettes also give the layperson an indication of what goes into the making of a sculpture and how the sculptor evolves ideas.

Your own personality will affect the type of ideas you develop and what appeals to you. In addition to your own thoughts and ideas you may find, like Henry Moore, that strange shaped stones on the beach with a hole at an odd angle, a bit of driftwood, a fragment of metal or a bone from your lunchtime chop provide inspiration. Make a blob of clay or plaster and set the found object on it so that it is the chosen way round and sufficiently aesthetically alluring to qualify as a potential carving. Use it as the basis of an idea, with additions and extensions in plaster, to develop something beyond the original shape. Once your sculptural thoughts are rolling you will become more observant and ideas will be triggered.

Accepting a commission can be daunting, but with the help of various maquettes to express your proposed designs, the prospect becomes a challenge. Perhaps having seen examples of your work a client might ask for ideas on a similar theme or style. In your own time you can develop the maquettes for presentation so that he or she has a good idea of how the commission will look when completed. At the same time you will have the satisfaction of knowing that all the aspects of your ideas are graphically set out and that you are already prepared to begin work.

2 Moving Forward from the Maquette

SELECTING A PROPORTIONAL-SIZED BLOCK

Once the maquette is complete you need to select a block of stone with similar proportions to the maquette but large enough to produce a decent sized sculpture. If you are purchasing the stone the supplier will either cut a piece to size or provide a block as close as possible to the required size.

Carving stone is both satisfying and physical and you need a large enough block to really feel the buzz of striking a carving tool with the mallet and seeing the stone fly. Do not think that selecting a small piece to start with is the best thing to do – you never experience the exhilaration of hewing away at stone and learning what stone carving is all about if the block is too small! So be brave and choose something bigger than you planned, maybe around 14 in high x 9 in wide x 9 in deep (36 x 23 x 23 cm) or even a little larger

for your first piece, so that you have some-
thing really fulfilling to show for your hard
work when the sculpture is finished.

More experienced carvers will probably
not be so concerned with the dimensions
of the stone so long as they can manoeuvre
it. New students need to consider weight
too, but dimensions such as I suggest will
reduce quite quickly as you carve and the
weight will reduce in proportion, making
the stone much more manoeuvrable. It is
difficult to generalize, of course, but it is
broadly accepted that about one-third of a
block will be carved away to produce a
sculpture.

There might be times when you choose
a stone from your collection that is not
conveniently cubic. The original block
chosen for demonstration purposes in this
book was, in fact, wedge-shaped, but with
sufficient width and depth to create a good sized sculpture.

Fig. 40 The chosen block of stone

Despite the stone being an odd shape, so long as you can find the necessary bulk within
it, it can still be a good choice. Cut away any major excess stone first, leaving the appro-
priate dimensions for the sculpture. You might find a tungsten saw useful for this.
Sometimes large enough pieces of unwanted stone can be cut from the block to be used
for another carving.

To judge approximately whether a block is of the right proportion for your maquette,
hold the maquette in one hand and a piece of wax crayon or pencil (which will show
clearly on the stone) in the other. Mark on the stone the approximate number of times the
height of the maquette will fit into the height of the stone. Then do the same for the
width. You need to have the same number (at least) as the height. Then do the same for the
side of the stone, measuring the side of the maquette against it. Confirm that this tallies with
the numbers you got from the height and width. There must be sufficient stone to allow
the same proportions all round the stone.

The maquette you prepared for your sculpture is the key to the carving and with its help
you will be able to reproduce the work to any size of your choosing. You will be taking
various measurements from it to establish the overall shape, proportion and detail of the
sculpture. Don't be daunted by this, it is quite simple once you start.

To begin the process of accurately assessing the size of stone required, you will need to
take measurements directly from the maquette, now pinned to the piece of hardboard or

Fig. 41 Removing stone with tungsten saw

Fig. 42 Taking and marking the widest measurements to assess stone size. (Note the widest front projection above is the jumper)

wood as previously recommended. Using a metal square placed perpendicularly against the maquette, mark all the extremities around the circumference of the maquette on the baseboard (here you can see the need of a good sized baseboard, mentioned earlier). Draw a square or rectangle around the maquette, incorporating all these extremity marks to establish the overall size of the stone you will need for the project.

Measure the height of the maquette and make a note of the reading. You can now multiply up the precise measurements of the rectangle to establish the exact size block required or to check the final proportions of a block you may already have. We will consider the making of a suitable scale rule a little later. It is always prudent to incorporate a little extra stone in your block to give you a bit of leeway when carving; the stone

might be slightly damaged on the surface or have a friable surface or irregular hollows in it. It is worth making a note of the dimensions of the maquette's base to help you later clarify the final shape and dimensions of the base of the sculpture.

ORIENTATING A BLOCK OF STONE

When you choose a piece of stone for your carving there are various considerations to be made. Obviously the stone must be large enough to fit your projected dimensions; the stone must have sufficient bulk in all directions to enable the maquette to multiply into it the appropriate number of times.

Examine the stone you have chosen to ensure you are happy with its orientation. Just because a flat base has already been cut does not mean it is the best way round for the shape of your proposed work, so make sure you don't prefer another orientation. If you are carving an uneven or boulder-shaped piece of stone, think about what orientation would use the stone most efficiently. Try reorientating it to see which way the maquette design fits most appropriately.

Avoid including any badly damaged areas of stone. If there are interesting markings, make sure they are situated in suitable areas and consider carefully the balance of colour on the block. For example, darker or more intensely coloured patches might look better at the top (or bottom) – by turning the stone you can make an exciting feature of them.

LEVELLING A BLOCK OF STONE

If you decide to reorientate the stone and not use its pre-existing base this could mean you will need to create a new flat base. This is not a problem. A stone block must be level before you can start work. A stone that tips to one side is no use and it is not possible to carve the sculpture first and level it at the end.

To level a block of stone you need a selection of random, flat pieces of wood, chipboard or hardboard, of various thicknesses. Tip the stone until it is standing perpendicularly – even if it is standing on a point – then prop it up with the battens until it can stand safely and independently without moving. If necessary get help to hold the stone safely whilst you deal with it. Try to keep the insertions beneath and within the extent of the stone, if you can.

Once the stone is in this position and propped firmly, find another flat piece of wood that just touches the highest part of the bottom gap and hold a piece of charcoal or soft pencil flat on the top of it. Starting from the top of the gap, slide the wood along the bench and around the stone, still level with the gap, marking a line at that level all the way round. The charcoal will leave a line parallel with the bench and this will become the new base line once the excess material is removed. All the stone below the line is excess. Remove the props and turn the stone on its side to cut or carve the waste from below the charcoal line right across the underside until the drawn line becomes the base level of the block.

Fig. 43 Marking the block to level the base

Check the newly cut block for flatness and stability and cut or rasp away any high spots. If there is an overall strip of stone several inches wide to be removed it may be possible to saw it away.

LEVELLING A WOBBLY BASE
It is possible to locate and remove any protrusions on the bottom of any slightly uneven stone sculpture base by scribbling charcoal densely onto a flat board, floor or other surface, lowering the stone base to be levelled onto the charcoal and twisting it around. The charcoal will mark the highpoints – the areas to be removed – by leaving a black patch on the stone and these areas should be rasped or carved away. This action can be repeated until the stone sits squarely on its base. Alternatively, you can sometimes sprinkle coarse sand on a flat surface and move the stone around on it until the sand itself abrades the uneven points away.

Marking Up and Carving Stone

1 Marking Up the Stone

Once you have chosen the stone and it is satisfactorily set up squarely on the bench you will be ready to mark the block with the detailed measurements and drawings enlarged from the maquette; these will make it apparent where the sculpture will be located on each face of the stone before any carving begins.

Never use felt tip markers on stone. Felt tip ink can penetrate the material quite deeply, especially on alabaster but also on absorbent limestones, and you may not be able to remove it all other than by cutting away stone, which can mean changing the contours of the work. Choose a coloured wax crayon or 9H pencil you can see clearly to indicate any strategic measurements you wish to show on the stone. Chalk and charcoal are not recommended for this purpose, as they are too soft and will rub off very quickly.

First carve away any particularly large sections of stone that you know are surplus to requirements. Should it be impractical to do this because of the large amount of stone involved, remove it with a tungsten saw. Relatively small areas can often be more quickly removed with carving tools.

Begin the marking up by measuring the total width of your chosen block and clearly marking the centre line down the front, across the top and down the other side, ensuring, with the use of a square on each aspect, that the line is perpendicular. It is also useful to make a similar line down the centre of the maquette, front and back, making sure that line is also perpendicular, to enable you to compare measurements easily from the centre line of each.

Fig. 44 Conventional callipers and proportional dividers

You will be using your established ratio to transfer all the measurements from the maquette to the stone. There are various ways to do this. Proportional dividers, which have an adjustable scale, are used by some sculptors; one end measures the maquette and the other, proportionately larger, indicates the size to be carved.

MARKING THE STONE TO SCALE

Start marking up the stone accurately by measuring the maximum height of the maquette with ruler or callipers and multiplying the measurement by the predetermined amount to establish the precise height of the finished sculpture. If you have already established that the maquette:stone ratio is, say, 4 (e.g. ¼ in (0.65 cm) on the maquette = 1 in (2.6 cm) on the stone), measure the maquette, multiply the height by four and mark this measurement on the stone on the centre line. Extend this marking across each face of the stone, so that the finished height of your proposed sculpture is exactly the same and clearly visible all around the block. If this measured height is very close to the top of the stone, say ½ in (1.25 cm) or less, it may not be worth removing; you could leave it to give you some optional additional height or carve it away later.

Mark the carving block 'F' (front) and 'B' (back) to ensure you always know which way round the sculpture is to be. This can be very useful during roughing out when specific shapes are still unclear and you can confuse the two!

Measure the very widest part of the maquette and scale it up, making a mark of this

Fig. 45 Marked-up stone. Note the position of the head and arms on the top surface

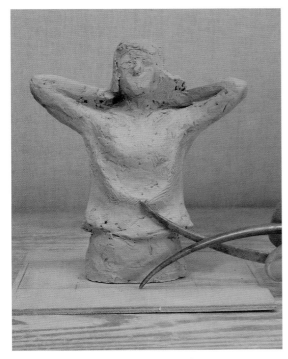

Fig. 46 Measurements being taken from maquette with callipers

Fig. 47 Establishing the scaled measurements for the stone with callipers

measurement on the stone equidistant from the centre line, both on the front and back face of the stone. Draw the marked lines down to the bottom of the stone and also up over the top and down the other side. This will establish and indicate clearly on the front, back and top of the stone the widest parameters of your carving.

Then measure the height of other features that will appear on the front, such as the top of an arm or shoulder, and mark that height on the stone, extending the markings around the sides and back of the stone.

Turn the maquette and stone sideways to measure and mark the overall depth of the sculpture. You will find that some of the markings that have been extended from the front will now marry up with the new measurements for the side of the stone. Continue until all the relevant measurements have been marked. It will soon become obvious from the drawing on each surface where the sculpture will be located within the stone and, at the same time, what will be waste stone.

A SCALE RULE AND HOW TO CONSTRUCT IT

If you are using a standard steel ruler to take measurements you can create your own scale rule that relates specifically to each carving and removes the need to calculate every measurement taken from the maquette (see Fig. 48).

Take, as an example, the demonstration sculpture being carved in this manual, the finished height of which is 40 cm and the height of the maquette is 15 cm.

With some care and using stiff paper, draw a horizontal line (see Fig. 48, line 1) 40 cm long (the height of the sculpture) and divide it accurately into 1 cm divisions. From point 0 draw line 2 at any acute angle, say 45°, 15 cm long (the height of the maquette). Join the ends of lines 1 and 2 with line 3.

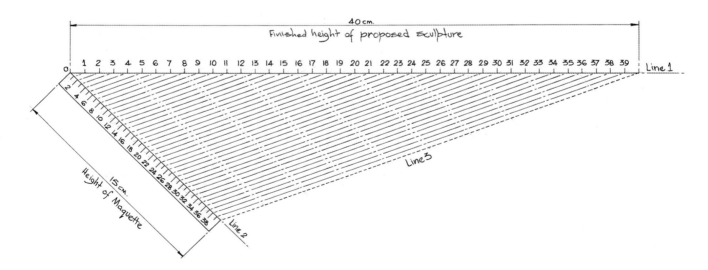

Fig. 48 Sketch of a scale rule and how to construct it

Then, with an adjustable set square or a set square and a straight edge to slide it on, carefully draw a series of lines parallel to line 3, connecting the 1 cm marks on the horizontal line 1 to the 15 cm line 2. Annotate line 2 as shown in the sketch (Fig. 48) and cut this out to attach it, in this case, to a 60 cm steel rule (see Fig. 47). This combined ruler can then be used for any required scaled measurements between the maquette and the stone. You will see, for example, that 16 on the maquette scale equals 16 cm on the full scale.

I use all of these methods at different times, but on smaller sculptures I often prefer to multiply up measurements taken directly from the maquette with callipers. A calculator can, of course, also be used to check all measurements.

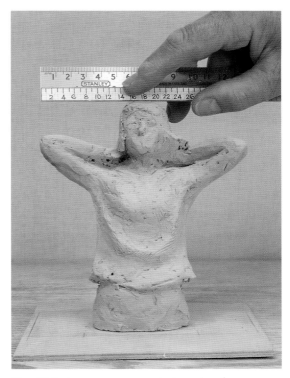

Fig. 49 Further measurements being taken from maquette with scale rule

TYPICAL MEASUREMENTS TO TAKE FROM THE MAQUETTE

On a proposed carving which is to be, say, a torso with head, identify the most important features and measure and draw them on the stone (see Fig. 50). In this particular example measurements would start with the height of the shoulders, extending the measurements on all sides of the block. Next, from the front, establish the position and overall width of the head (in relation to the centre line of the stone), taking into account any extra width required for hair or the tipping of the head to one side, and make marks of the measurement on the front face of the stone. Extend the line down to the shoulders and continue marking the width onto the top surface of the stone and down to the shoulders at the back. The head position, which will read as a rectangle, will be clearly visible now on the front, back and top of the stone, together with its position on the shoulders. The neck area can be drawn in but will only be used as a reference at this stage.

Next turn the stone and the maquette to the side and make all the relevant markings there, noting again the angle of the head from the side – if it is tipped forward or back. Similarly mark the position of the torso and its angle and stance. This method is used to identify as many strategic positions as possible on a sculpture. It can be useful to make paper sketches of your proposed sculpture, similar to that shown overleaf, and note down all the measurements you have taken from the maquette.

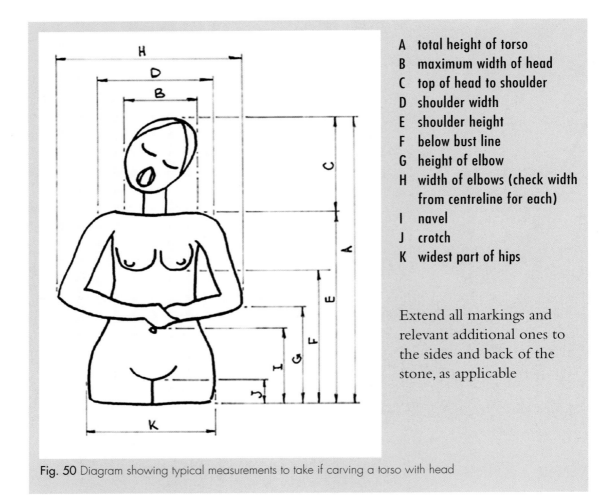

A total height of torso
B maximum width of head
C top of head to shoulder
D shoulder width
E shoulder height
F below bust line
G height of elbow
H width of elbows (check width
 from centreline for each)
I navel
J crotch
K widest part of hips

Extend all markings and relevant additional ones to the sides and back of the stone, as applicable

Fig. 50 Diagram showing typical measurements to take if carving a torso with head

Whatever the shape, complexity or size of your proposed sculpture and whether you are making a figurative or abstract carving, this is the basic system that enables carvers to scale up their work and display the proposed key areas on the stone. Keep checking relevant measurements as you proceed to be absolutely sure your markings are correct, even after carving has begun, and take as many as you find useful.

HATCHING AND DRAWING DETAIL ON THE STONE

Hatching is a method of marking stone to distinguish material that needs to be removed. The markings are made as criss-cross 'hatched' lines on those areas. It is a clear method of differentiating the unwanted stone from the illustrative drawings of the sculpture on the stone and acts as a type of framework around the sculpture. All excess stone can be hatched, ready for removal, and this will be the first area you carve away.

Fig. 51 Hatching. Note the width of the head markings and width of arm marking on right

Fig. 52 Rear markings on the stone

THE SIGNIFICANCE OF DRAWING ON STONE

Some students feel that if they have the maquette in front of them they will be able to imagine quite clearly where everything is positioned in the block and that only a few vague markings will suffice. In fact, once the flat, machine-cut surfaces have disappeared and the stone is lumpy and misshapen with no clearly recognizable forms, the sculpture within can be quite elusive. Marks on the stone are vital to keep track of where a particular part of the sculpture will be, so replace the marks as the stone is reduced. In the early stages of the carving you will be able to refer to markings on adjacent surfaces of the stone to confirm positioning. It can be extremely confusing to proceed without sufficient drawing on the stone to guide you. If you always keep the centre line in the same position, this will also guide you and enable you to check positions in relation to that line.

When starting the carving, everything is much too big and the overall proportions cannot be correct until the stone is sufficiently reduced. The emergence of shape will come gradually; what looks too fat and close together to begin with will be opened up and gradually move apart, making the sculpture look taller and progressively in proportion. It will also make space for detailed parts of the carving that were initially inaccessible. This is your aim: to gradually reduce, slim down and refine the design you have planned with the help of the maquette. With patience, and lots of drawing on the stone, this is what you will achieve. The strange thing about stone carving is that the more stone you carve away, the larger your sculpture appears to grow.

During my early carving days I produced a sculpture of a mother, father and baby penguin huddled together on the ice. I worked by eye, carving directly, and the general position of the figures seemed about right throughout the initial part of the carving. There were some quite simple bumps in the right places showing where the figures would be and early on the proportions looked good. But it is a common mistake to see everything in their current proportions.

As I reduced the stone and slimed down the baby to scale, he began to move further and further away, until he was completely isolated from his parents and gave no real indication that he belonged to them at all! Eventually drastic measures meant that I had to cut the baby right off the 'ice', prepare a space for him close to his mother and then fix him down where he belonged. It taught me how vital the drawing is!

2 General Carving Techniques

Carving is far more effective if you hold the tools correctly. Use a wrist and lower arm action with your mallet rather than a rigid and awkward shoulder and back thrust to give impetus and direction to the blow. It is best to hold the tool across the four fingers of your hand and then wrap your thumb behind it. This should protect your thumb from being struck by the mallet and give you a great deal of wrist flexibility and freedom to carve in a controlled way.

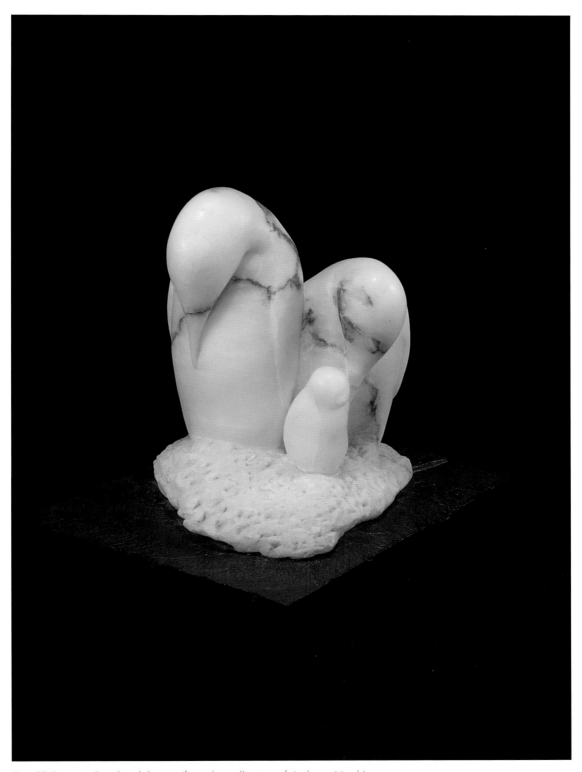

Fig. 53 Penguin Family, alabaster (from the collection of Anthony Hersh)

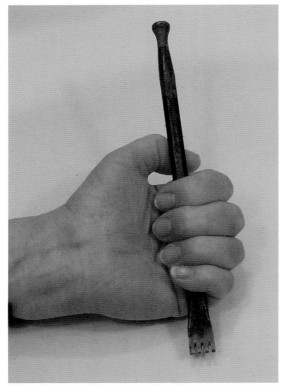

Fig. 54 Tools should be held across the fingers

Do not hold the carving tool with the fingertips, like a dart, as there is no strength of wrist action with this attitude which inhibits any real control of the tool's direction and reduces the cutting force considerably. Hold it lightly, just directing the mallet blows onto the block and towards the area of stone to be removed and using the flexible action of your arm and wrist to establish the direction of the cut. You need to stay in control of the strength of the blows, only cutting away the selected area of unwanted stone and always carving the stone away from you, not towards you. This will all gradually become second nature.

WHICH TOOL TO SELECT

Despite the excellent variety of stone carving tools to choose from there is no hard and fast rule about which you should use or in what order you should select one.

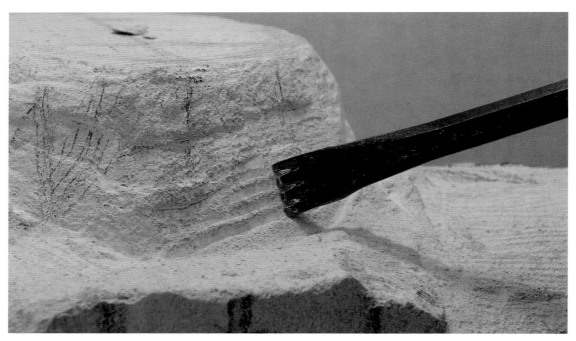

Fig. 55 Claw reducing Ancaster stone to shape

The basic idea when roughing out is to remove as much superfluous stone as quickly and efficiently as possible whilst staying in control of what is removed and from where. If you are carving a hard stone, start with a point or punch and move on to alternative tools once the majority of the unwanted stone has gone and a more precise cut becomes necessary. If you are carving a softer stone, depending upon the hardness and the amount of waste there is to remove, you can experiment with a claw, chisel or gouge.

A claw will cut effectively and reduce the stone in layers until the shapes are defined. There are occasions when the parallel lines that this tool makes can abrade the stone and create a friable surface, mostly on alabaster and other very soft stones. A flat chisel or gouge are therefore better choices for these stones and have the effect of smoothing and binding the surface together whilst still removing the excess.

A point is generally inadvisable for alabaster, because of its tendency to bruise, unless you are carving a very large piece. You should also avoid carving perpendicularly downwards, which will create white bruise impact marks in an otherwise translucent stone. You will not be aware of this damage until the stone is refined and polished at a later stage.

Sharp tools are essential on every stone to achieve a clean, effective cut. One must recognize the considerable difference between a sharp tool cutting the stone and a blunt one breaking it! Remember to feel your tools for a keen edge and to re-sharpen them from time to time.

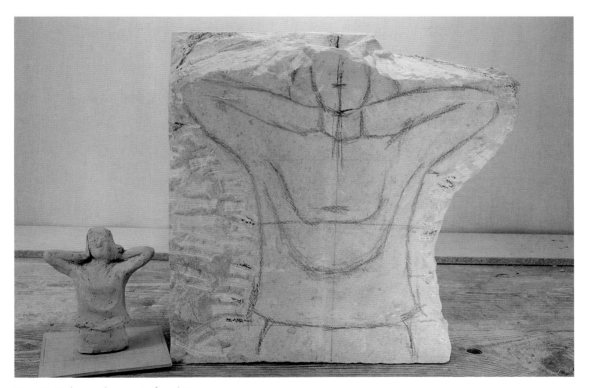

Fig. 56 Early roughing out of sculpture

ROUGHING OUT

This is the term used for the early stages of a carving when the superfluous stone outside the drawing is removed from the block and the process of shaping the sculpture is begun. This removal of stone relies heavily on the drawings you have made on the stone.

Carving the hatched areas of unwanted material gives an invaluable opportunity to assess the characteristics of the stone with your tools and gain an indication of how it responds to them. It will become obvious how heavy the blows need to be to control the cut. Using some force should remove impressive lumps during the roughing out period and this is what you want to achieve. The tool should not slide along the surface but bite into it, removing stone as it moves forward. If the tool tends to slip or carving only produces puffs of dust or removes small fragments, the angle is too shallow and should be raised. On the other hand, if the angle is too high the tool will bed into the stone and not move forward at all. So it is important to experiment and find the correct angle, perhaps adjusting the direction of the carving in order for your blow to be effective with that particular stone. You will automatically reduce the tool angle and fierceness of the blow later, when a delicate touch is required for the detailed final shaping.

To avoid any confusion converting the two-dimensional drawings you have on each plane into one, three-dimensional form, study the block carefully and frequently, particularly in the early stages. This will help you to understand the significance of the drawings and how they relate to each other and consequently where and what you need to remove to position the sculpture accurately within the block. Drawings on the top plane of the stone will significantly reinforce the information and confirm the sculpture's location.

As the roughing out progresses you should aim to dispose of unwanted flat surfaces and get the carving moving in all areas, systematically creating the first preliminary shapes and locating the areas that need to be cut deeper into the stone. It is very common to overwork one area, sometimes before the correct depth has been achieved, and then become intimidated by any surrounding uncut, flat areas, so that they become places you avoid. If you abrade all planes as early as possible you will find that the area appears more integrated and not so daunting.

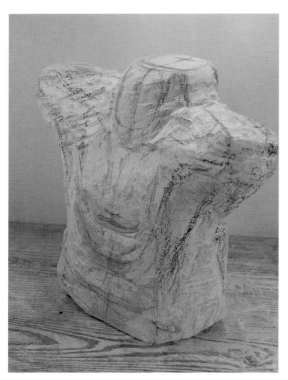

Fig. 57 Early roughed-out stone

Drawings on the stone must be replaced at their new depth and can be verified by the markings on adjacent surfaces. Always take advantage of these references – they are invaluable. In due course, two, or even three, adjacent surfaces, which were previously technically unconnected, will join together as the features from all surfaces merge, even though they are only roughed out and still oversize. The overall sketch sculpture will gradually emerge and you will see the shape of your carving although everything is too close together. As the shapes become more clearly defined, more stone will be revealed to make further shaping in the area possible.

Standing back from the stone is a great help when checking the relationships between certain parts of the sculpture with others, making their relative positions more apparent. Keep the maquette nearby to allow frequent visual reference, including viewing the carving and maquette from above. Be prepared to re-measure various details on the maquette to relate the drawings on the stone to the shape of the carving that is evolving. Orientate the carving and maquette in the same position in order to observe them both from the same viewpoint so that you do not find yourself cutting stone away from a slightly offset area. Then rotate both and compare again.

It is invaluable to routinely use your thumb or hand to mask areas of stone you are considering removing so that you can visualize the sculpture without them. This masking is effective for both large and small areas. Use this tactic wherever you are uncertain.

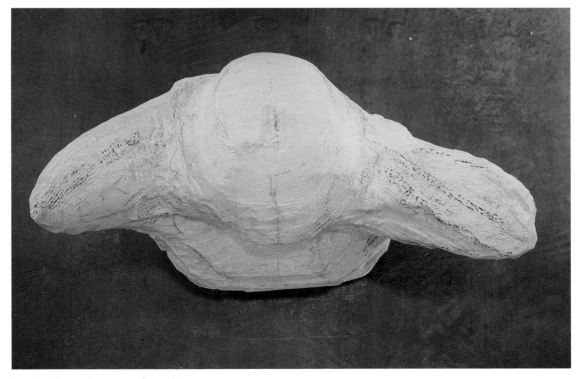

Fig. 58 The early carving from above

Fig. 59 Masking stone: area drawn in

Fig. 60 Masking stone: thumb in position to mask

Assessments become more and more critical as features, such as limbs, emerge and you need to verify correct angles, thicknesses and depths and the mass of stone required in which to place them. Careful carving at this stage will ensure that you can mark critical changes to oversized areas without removing too much stone. These adjustments can be made more and more precisely as the work proceeds until you are completely satisfied everything is where you want it to be.

ABSTRACTS WITH A HOLE

In the case of abstract work, following the maquette and the external contours is essential. Marking the stone 'F' and 'B' for the front and back is particularly helpful and central and vertical lines will help position many of the important features accurately.

Here, too, use hatched areas to indicate unwanted surfaces and rough out the sculpture all the way round before any detailed concave or convex shapes are cut in. This will ensure the internal contouring is correctly placed. Any holes to be incorporated within a carving should first be positioned, then marked in outline then gradually evolved as part of the overall carving progresses.

It is often possible to pierce the stone with carving tools. However, drilling through the stone too early can leave insufficient surrounding stone to develop the contours correctly. Trying to create a sculpture around a drilled hole rarely works. It is essential to develop an abstract 'in the round' so that the whole design evolves. Once the correct location for it has been established it becomes a comfortably placed focal point.

If creating a 'simple' spherical shape it is essential to produce an accurate hemisphere-shaped template in thick card to use around or within the curve in order to check and correct the contours. By holding and moving the template around the shape, high points can be spotted and marked with a wax crayon, charcoal or chalk, then carved or riffled away until the correct curve is achieved. A similar system can be used for any symmetrical abstract shape.

RASPING AND RIFFLING

There comes a time in the carving process when your sculpture is close to being finished. At this point it is beneficial to smooth an area of the stone to assess how close you are to the required dimensions. Where large planes are involved, steel or tungsten rasps can be used to do this; they reduce all surface irregularities, indentations and abrasions caused by heavy handedness with tools. This process in itself will reduce the level of the stone and help you analyse the overall appearance of your work. If you think that the stone is still somewhat oversized it is best to return to the carving tools and reduce it further, paying attention to the depth of tools markings.

Rifflers are used once the sculpture has more or less reached its final size but the most sensitive or detailed shaping is still to take place. A coarser riffler smoothes abraded surfaces relatively quickly but shapes the stone in ways that larger, flat tools cannot achieve. The

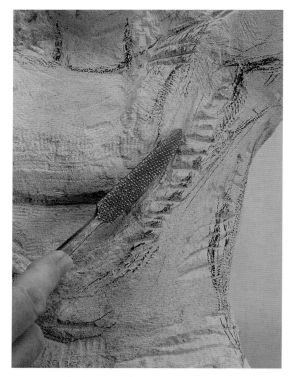

Fig. 61 Early shaping of breast area with riffler

variety and versatility of shapes available means that rifflers are very effective at completing the defining and contouring that may be required and removing all but the finest scratch marks. Rifflers are an essential aid to adjusting and finishing. They are a particular asset after the maquette has been abandoned and the particular nuances of your sculpture can still be developed. As the stone surface becomes finer, the identity of the stone is sometimes lost, as the material takes on the bland appearance of dusty white plaster. This can make the fine riffling appear to create more detail than you intended, perhaps in facial features. However, once the stone is washed and the colour becomes visible, you will find that the rubbing down with abrasives has enlivened the stone and that the details are not so obvious after all.

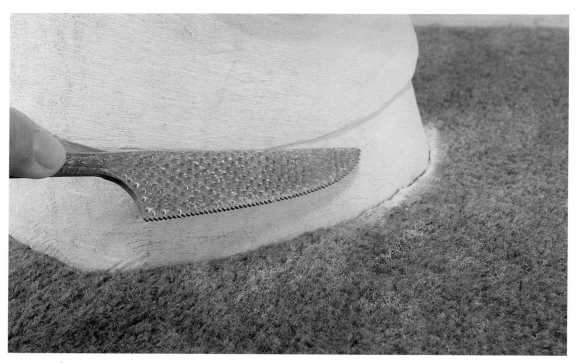

Fig. 62 Refining the bottom of carving

Fig. 63 Detailing drapery with the riffler

Fig. 64 Narrowing the edge of the base, avoiding damage (normally completed when the carving is more advanced)

SHAPING AND PROTECTING THE BOTTOM CONTOURS OF A CARVING

The shape of the underside of your evolving sculpture needs to be checked to ensure that the size and proportion are as they should be. It is quite common to find that the importance of the base size and lower part of the sculpture has been overlooked and the dimensions have not been cut back sufficiently. Correcting the dimensions of the lower part of your carving will ensure that all the proportions remain as originally intended.

If the sculpture is standing on the bench it is essential not to carve the outside excess stone downwards, towards the bench, as you cannot control the effect of this cut. The stone is liable to fracture and break back-wards, beyond the drawn line of the

Fig. 65 Result of carving the bottom edge of stone downwards onto bench

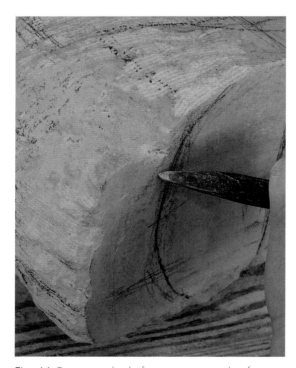

Fig. 66 Correct method of carving stone edge from the base of the stone

proposed sculpture, destroying some of the outer contour. Cutting down onto a hard surface creates vibrations that fracture stone and should always be avoided. In addition, it is inadvisable to carve at an angle that you cannot verify is correct.

If the weight of the stone allows it, reducing and re-shaping the bottom edge of the carving is best achieved by lying the sculpture down and cutting upwards from the base. This will enable you to remain in control of the stone being removed and avoid the risk of fractures.

Often the bases of really large sculptures need to be carved with the piece chocked up off the floor or workbench and carefully cut sideways, along the edge of the base, to prevent uncontrolled fracturing.

To avoid potential damage to your work as you move or lay it down to access various areas, especially towards the finishing stages of the sculpture, ensure there is a piece of clean carpet under the stone. Do not move the sculpture about on the hard surface of the bench and especially not amidst any stone rubble as, inevitably, this will damage the refined surface and erode the edges of the base.

Carving stone creates vibrations throughout the stone and quite routine carving can be responsible for the fracturing of stone lying on a hard surface. Sandbags are immensely useful, not only to chock up a work to a particular angle to make it more accessible, but critically to support any over-hang of stone.

A stone that has a sandbag under the top and bottom ends but with a 'bridge' of unsupported material is still vulnerable. Be aware of this potential danger and check

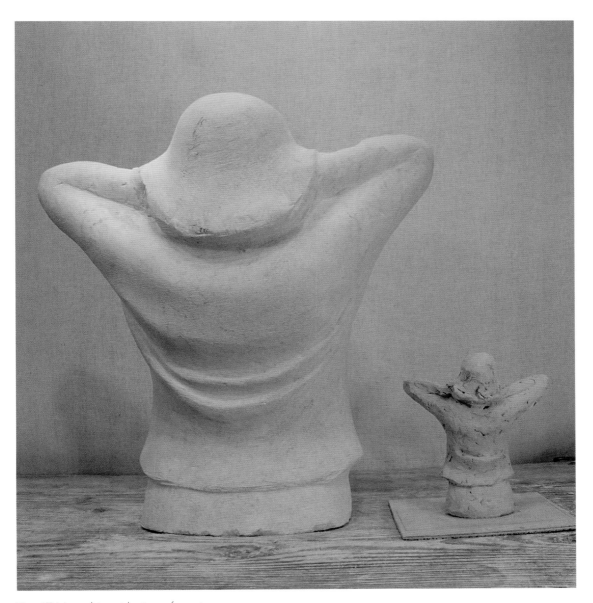

Fig. 67 Note chips at bottom of carving

that no stone is left unsupported, especially if it is long and thin. Bulky carvings are not as vulnerable, but any thin projections will be. A high-pitched ring emanating from the stone as you work it is an indication of a potentially dangerous situation. Ignore it at your peril!

Stone carving is a lengthy process, so where there is a large amount of material to remove or where the stone is hard and unyielding, it can take a considerable amount of time to see substantial results. You might occasionally feel you are making little progress and become frustrated as a result. Be patient and work logically and systematically. All the anxiety and hard work is worth it in the end.

ADDITIONAL TIPS AND REMINDERS

1. Have a 'eureka moment' every time you start a session! When you stop work, set up the carving and the maquette close together. Because your brain is in its most acutely perceptive mode when freshly encountering the work after a break, you will see at a glance which areas require the most adjustment. Working for too long can dull your perception; it is good to have regular breaks and to consider the work to be done before continuing.

Stand as far away as you can from your carving and check the overall stance of the stone from all sides to ensure the work is, for example, not too upright when, in fact, it should be diagonal or curved. Don't be daunted when you find when you felt certain you had created a really good form that the carving is still superficial and not as defined as you thought! Be objective, critically assess your work, then visualize how to proceed correctly. It is very common for new students to cut shapes into the stone, like a relief, and not to remove sufficient depth to establish the overall structural angles necessary to create the identifying profiles. Confidence to cut away more stone will come from the profile drawings on the block.

2. When releasing a feature and bringing it out of the stone, an arm or head for example, carve parallel and vertically close to the drawn line, removing the horizontal stone alongside it as you go. This will gradually give you the depth of stone necessary to release the feature and, in due course, to be able to carve its position within the stone accurately. Do not shape the feature too finely whilst the carving is oversized; leave a small excess of stone to give you some flexibility to adjust an angle or shape later. It is better to have a little too much stone than too little.

3. When cutting a curved surface (say an arm or an abstract curve) you will see there is a high point from which the plane appears to turn and descend in the opposite direction. Be aware of this change of direction and use it as an aid. Draw a line along the high point of the proposed feature and cut the stone around the curve using the high point as a guide from which to carve away.

Get into the habit of cutting the stone in the direction of the curves so that you are developing the shapes from the earliest stages of the work and every cut is a step forward. Reducing the surface of the stone in flat planes in an effort to delineate particular areas is not useful, as you will eventually have to shape the stone into curves, cutting away any corners you might have produced. Cutting curves from the beginning will save you additional work and from the chance of erroneously removing stone from the higher parts of a curved area.

4. When part of a carving needs to have an undercut area, carve the entire outer shape. Do not encroach underneath to begin with; initially emphasize the edge of the feature with a wax crayon. It is dangerous to undercut it until the sculpture is sufficiently refined

to be sure the feature is on the correct level in the stone. Undercutting locks the item in a specific position without giving you the option to move it up, down or deeper into the stone. If you make a strong undercut too early you will need to remove all evidence of the line before you can reposition the feature in the correct place and you could lose vital stone in the process.

5. It is worth noting that the back of the tool protects the drawn line area and keeps the stone behind it 'clean'; only the stone in front of the tool is cut away. This is very clearly illustrated in letter carving, where the letter is developed cleanly and the surrounding stone is chipped away. However, it is the case with all flat tools and gouges.

6. Where there are thin areas to cut in a sculpture, such as a freestanding neck with a head on top of it, remember that stone cannot support weights easily, so you must not expose any such vulnerable areas until the very end of the carving. Should you have revealed the entire neck too early it is quite probable that you could be happily cutting a completely different part of the sculpture and that the vibration of the carving activity will cause the head to fall off! Leave any such areas until cutting work with a mallet and chisel is completed everywhere else and only small tools are being used gently.

7. It is always important to sign and date your work as a record of what you have made. The best way to do this on stone is to place the work at a comfortable angle so that, with a pencil or scribe, you can write your name and the year. Then, with the corner of a small tungsten chisel or a fine and well-sharpened firesharp chisel, carefully incise along the lines you have written, scoring the stone slightly. Repeat this exercise, holding the tool slightly to the right (to widen the groove), and then again to the left, so that a fine, V-shaped line is produced in the method of letter carving. You can practise on the base of the sculpture at first. The finish should be modest but visible.

8. The use of a candle to illuminate your (probably) finished work is an amazingly effective way to see critically the shapes and surfaces of the completed sculpture. Candlelight will show up any badly shaped areas on the surface of stone and ripples you may not want to see. Try it! It also shows up the beautiful contours and nuances of the sculpture you have created and is a most uplifting and rewarding experience.

Finishing Stone

Finishing Techniques

THE USE OF ABRASIVES

Not all sculpture is envisaged with a smooth final surface; some works are enhanced by textured surfaces or a mixture of smooth and textured areas. Occasionally sculptors choose to leave weathered and uncut stone in its original rugged form on parts of the stone that do not need carving; this can add visual strength to the sculpture.

One of the most difficult things to do convincingly on a stone carving is to cut texture into the stone, as often the result looks too contrived or unacceptable. However, with the use of particular carving tools, very satisfactory texturing can be made on selected areas of a surface.

An even, abraded surface can be achieved by hammering the stone with a bouchard, producing an interesting effect that breaks up the light. A similar surface, though not with quite such an even abrasion, can be made with the point or a claw. By hammering perpendicularly onto the stone, twisting and turning the tools about at the same time, a good roughened texture develops. The parallel lines of the teeth of the claw can abrade or give linear or criss-cross marks to achieve another result. Like so many other things, it is all a matter of experimentation and personal preference.

There are some simple sculpture designs that may be enhanced by having various areas fine rubbed and others abraded to affect the light on those surfaces; for example, a student once produced a beautifully carved, but unexciting obelisk in Ancaster stone that sprang into life when panels on each facet were cut and then textured. Usually the area can be re-smoothed if you do not like the result.

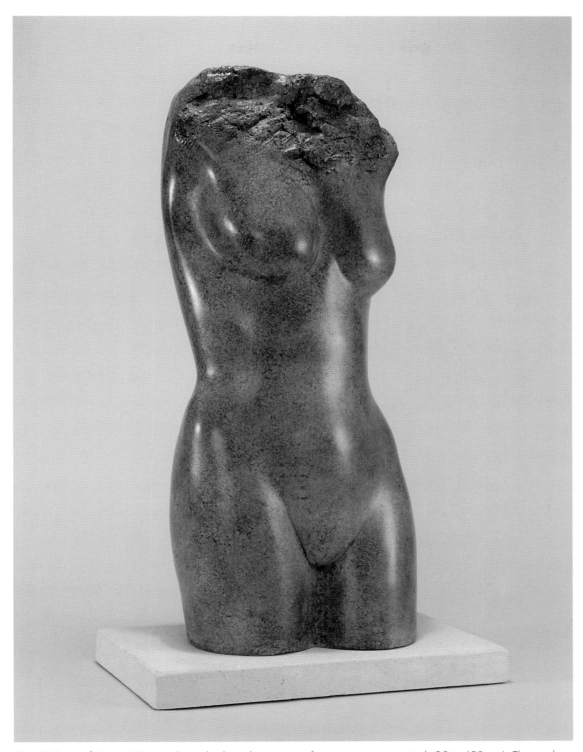

Fig. 68 Torso of Young Woman (limited edition bronze cast from soapstone original, 23 in/58 cm). The work features uncut stone at the neck

FINISHING AND POLISHING

Polishing stone is very satisfying and well worth the effort it entails. It is not until the stone is washed free of dust, and abrasive materials are used, that you get a real idea of the wonderful colours and markings to be found in the stone, unseen until this process begins. These colours become more brilliant as the rubbing down progresses. It is for this reason that your work needs to be a balanced combination of good sculpture design with the colour and character of the stone. The stone features should not dominate and overwhelm.

If the carving is small enough to fit into a large sink this will enable you to wash the sculpture under gently running water as you work. If you are polishing outdoors, a large butler sink, plastic or old zinc bath with a flexible hose nearby could be used for this purpose. To protect the stone from damage as you turn it around you should place the sculpture on a suitable pad, such as an old sheet, carpet square or similar, but ensure the pad does not leach colour that could stain the stone.

Polishing is done with diamond abrasive hand pads and wet and dry emery papers that finely smooth the uneven surface of the carving and gradually reveal the inherent beauty of the stone. Polishing with soft wax comes later when the overall surface of the stone has been reduced to a smooth and tactile finish.

Diamond pads have the advantage of being sharp and long lasting. They are available in several grits that are colour coded to indicate the fineness or coarseness of the abrasive. Those recommended for stone come in green, black, red and yellow – green being the

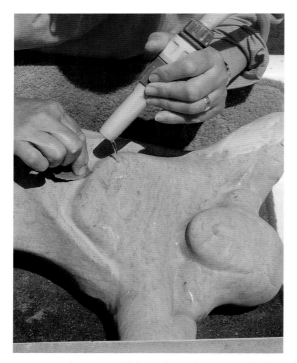
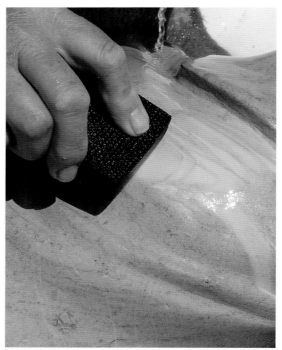

Fig. 69 and Fig. 70 Polishing the sculpture in a butler sink, outdoors

coarsest, yellow the finest — and they are usually offered in 4 x 2¼ in (or 10 x 5.7 cm) hard foam pads.

Wet and dry emery papers are less costly and are also available in a large number of grits, from very coarse 60 grit to very fine 1,200 grit and even finer. I recommend that a stock should be kept ranging from 60 to 1,200 moving up in approximately 200s, i.e. 60, 200, 400, 600, 800, etc. The exact grit is not critical so slightly different grades are acceptable. They are versatile to use but erode more quickly than diamond pads so that you need to change the small pieces you use fairly often. Wet and dry emery papers are always used wet for polishing stone and sandpapers are not suitable for this work.

The most efficient way to use wet and dry emery paper is to cut the sheet into approximately 2–3 in (5–7.5 cm) squares so they fit across your fingers and enable you to use the whole piece, turning it as required, until you can feel the abrasive qualities have gone. There is much wastage if you just fold the sheet in half, or even quarters. Large pieces are often too cumbersome to access the awkward areas that need abrading. Move the paper in a circular motion, preferably with the carving under gently running water to wash away the stone slurry, gradually working over the entire surface of the sculpture.

Half a sheet of wet and dry around a cork block will enable larger areas to be tackled more uniformly and effectively. Similarly, curved areas can be more successfully accessed by wrapping the paper around a cuticle stick, dowelling or, as Barbara Hepworth did, a rolling pin to rub down the internal surfaces of large stone carvings. Whatever helps you

Fig. 71 Wet and dry emery papers, diamond hand pads and stone resin

achieve the purpose of smoothing the surface is acceptable but do check that any angled metal used for this purpose does not rub through the wet and dry and damage the stone.

You will find a combination of both types of abrasive gives maximum flexibility. If there are wide sweeps of stone areas to be polished, diamond hand pads are recommended as they can refine large areas of stone effectively and also protect your hands. However, where there are raised and detailed features on the stone surface a hand pad might be too cumbersome to get around and inside the shapes, in which case wet and dry emery paper should be used.

However the same principle applies to both diamond pads and emery paper: you will need to start from a coarse grit to remove all unwanted irregularities from the stone and gradually move up the grit number to the finest ones (the higher the number, the finer the grit).

If the first coarse grit you choose actually makes scratches rather than reducing those that are already there, change straight away to the next finer grade until you feel the abrading action and can see a smoothing of the surface. If the paper hardly seems to make any change to the existing surface texture, then the paper you have chosen is too fine.

Work the carving until the whole surface has been polished with the first grit, the stone detail is showing through and the surface is beginning to feel smooth everywhere. The first grit you use will be the one that takes the longest as the stone needs to be reduced from the rough condition after carving and riffling to an even, overall texture. You will

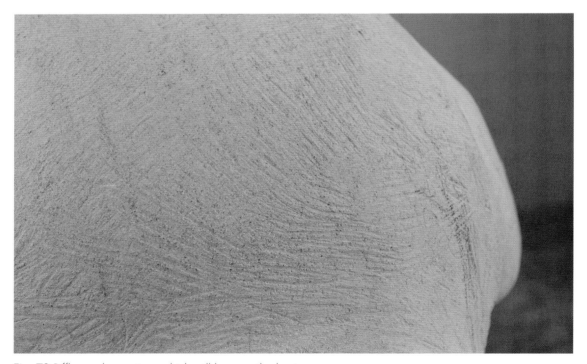

Fig. 72 Riffler marks on stone which will be smoothed out

then need to change to the next, higher number grit and repeat the process all over the stone again, although it won't take as long the second time around.

Repeat the process through all the grits, moving up in 200s, until the stone is vibrant with colour and has no visible scratches. Soapstone is probably the most revealing stone to work on as it shows up all the scratches clearly. As these are removed with the coarser grits others will appear when working with the next fine one, and so on until there are no scratches visible with the naked eye. How well finished a sculpture is to be depends on you alone. It is a case of how particular you are at removing all visible scratches. When the polishing is completed you can leave the sculpture to dry and contemplate the effect you have achieved.

Using abrasives on stone is a time for self assessment too, a time when various irregularities in your carving may well show up that are less than satisfactory. Only you can decide whether to ignore them or to go back to the riffler and abrasives and achieve a truly flawless result.

WAXING STONE

You will notice that the intensity of some stone colours will wane as the stone dries. The beautiful jewel-like colours of soapstone will become cloudy and alabaster will lose its translucency, becoming 'smoky white' on the surface. Some limestones will not change at all.

Waxing stone is a way to keep the sculpture protected from the ingress of dust and a fine layer that barely shows will prevent the stone from getting dirty. However, using a soft, white wax can also enhance the colour of the carving and give you complete control over how much, if any, shine you want. You can choose to build up layers of wax on the stone surface to bring out the colours and achieve the shine you like.

FINISHING TECHNIQUES FOR ALABASTER

Alabaster will immediately regain its translucency with a thin layer of wax and if you increase the number of layers this translucency will increase too, revealing not only the colour of the stone but also the cloud-like markings deep inside.

It can become compulsive to add more and more wax to this fascinating stone, but in due course you may hate the shine you have created. All is not lost. Just get out the wet and dry emery paper again, give the whole piece a rub down with a medium grit and repeat the previous processes, applying less wax this time!

I do not recommend the use of hard beeswax. It does not spread well on stone and tends to cling to the surface in bumpy blobs that give an immediate, very high shine as soon as they are rubbed. It is also difficult to remove. Soft wax is far more satisfactory to use and is instantly more controllable for shine.

Some people claim that alabaster can be enhanced by painting it with liquid paraffin to make the stone very translucent. I do not recommend this at all. Alabaster absorbs liquid

paraffin in large amounts and, although the stone becomes translucent, the overall result is to dull the stone and give it the effect of candle wax with a grey hue. The stone completely loses its vitality. Simple waxing as described above gives the best results, retaining the natural colour and clearly revealing all the translucent qualities of the stone.

FINISHING TECHNIQUES FOR SOAPSTONE

The treatment for polishing soapstone is different from other stones. It is the only stone that needs to be oiled with linseed oil before polishing, to restore the colours of the minerals within it that you see when the stone is wet. If you prefer the cloudier colours of dry soapstone you will need only to wax the stone; this will give it a lovely sheen and the colours will still be visible but more muted.

To reveal the very bright colours again, place the sculpture on newspaper and paint the entire exposed surface liberally with linseed oil (raw) with a reasonably sized – at least 1½ in (3.75 cm) – household paintbrush and leave the stone to absorb the oil for about twenty minutes.

Remove the oil thoroughly with kitchen paper, from all surfaces and every crevice, and leave the sculpture for two or three hours or overnight. Finally wax the surface in layers until you achieve the finish you like.

Do not leave wet linseed oil on the stone for longer than the recommended time and certainly not overnight. The oil dries and hardens to a heavy, sticky, glutinous film that is virtually impossible to remove, so only proceed with this process when you are free to see it through completely.

If you have areas on the soapstone which are textured I recommend that you include these in the oiling and waxing process so that the stone colour is the same overall and the texturing is incorporated into the sculpture and seen as part of the whole. The deeper areas in textured stone will need particularly close attention when removing any excess oil.

It is possible also to cut additional texture into soapstone sculptures after the oiling and waxing are completed if you like the idea of the lighter stone showing through. For example, some people choose to do this with hair that they want to pick out in a lighter colour with marks made with a claw.

REPAIRS

Once in a while you will inadvertently break a piece of stone and occasionally stone will crack and you will need to break it open carefully, remove any fine debris from inside and fix the stone back together again. It is always a shock when you have a breakage, but providing you are prepared for such an occurrence you just need to get on with the repair and continue with your work.

Stone resins made especially for such repairs are extremely strong and often you can barely see where the stone has been mended so that only you would know that it has! They are available in transparent and stone colours – beige, honey and straw – and need to be

mixed with a hardener before use. Generally speaking it is the straw colour that works for the widest range of stone, whether the stone is cream or quite a dark soapstone. The reason for this is that soapstone often has lines of light limestone occurring within it and it is somehow more acceptable to use a straw colour repair line, which is natural to the stone, than a transparent resin, even if this is mixed with dark stone dust. It just does not look natural since one never sees a dark-coloured line in soapstone. Once the resin and hardener are combined, the mixture is spread on the surface of both pieces of stone and they are pressed together as tightly as possible, pushing out surplus resin and then waiting until the resin sets firmly. It will continue hardening for some hours after it is safe to leave the sculpture and the repair will never come apart.

Stone resin is available in a paste form, which prevents the resin from running out when there is a vertical break, and in liquid form for horizontal breaks. Both of these are useful but I would generally say the liquid (horizontal) variety was more useful. There are small tubes of colouring available to adjust the colour of the resin. Stone resin is usually sold in large 2 lb (1 kg) tins, with monumental masons in mind; this quantity is too great for the average sculptor to store as it deteriorates and hardens in time. Small tins are difficult to find but are currently available from a small number of stockists, detailed in the directory at the end of the manual (see page 202).

Fig. 73 illustrates the presence of limestone on the left buttock and foot of the *Kneeling Girl* sculpture. Before carving, the limestone mark extended between the two buttocks and beyond. It is a frustrating mark, since it has all the appearances of a repair, but is not!

Fig. 73 Naturally occurring limestone in buttock and foot

Alabaster is very satisfactorily repaired with transparent stone resin or a simple epoxy resin, mixed with alabaster dust.

MOUNTING STONE

Many stone carvings do not need mounting, are well balanced and of sufficient strength of design to be left unmounted. Small sculptures often need to have thin felt or self-adhesive baize on the base to prevent damage to furniture. However, there are sculptures that can be enhanced with a base, sometimes because they are top-heavy or they have a projecting and vulnerable area needing the overall protection of a base and sometimes to add status to the sculpture.

The underside of the sculpture and the chosen base must be completely flat and level and any preparation required for the base should be completed in advance. Bases can be of wood, stone and sometimes acrylic, but if the sculpture is top-heavy for some reason the base must be sufficiently robust to support the weight without everything toppling over.

To attach the sculpture to the base it is necessary to drill up into the underside of the stone and, separately, through the supporting base. To do this you will need the help of an engineer's square or set square, an electric drill and usually two stainless steel threaded rods, cut to length, that will be resin-bonded into the sculpture and passed down through the base. You will also need some stone or car body resin.

It is necessary to decide where the fixings will be on the sculpture to ensure they are not too close to the outside edge (which could weaken the stone) but sufficiently wide apart to give stability. Lay the sculpture on its side and make marks on the stone where you plan to put the supporting rods.

Place the square adjacent to the marks and drill up through them into the stone, keeping the drill bit parallel with the square. When drilling the holes into the sculpture do not use the vibrating hammer action of the electric drill as this could fracture the stone. You may need help with this dual activity. Depending upon the size of the sculpture the rods will need to be deep enough within the stone to prevent leverage. On a carving, say, 2 ft 6 in (76 cm) high, a depth of 4 in (10 cm) drilled into the stone should be sufficient for the supporting rods (plus the depth of the base stone or wood) and the rods should be approximately ⅜ in (1 cm) in diameter.

With the sculpture on its side, slightly overlapping the edge of the bench, make a paper rubbing of the whole sculpture base including the drilled holes and mark the paper with a 'B' (on the side away from the sculpture) to indicate the surface that will be laid against the base. Cut out the stone shape from the paper rubbing and orientate this shape on the base in your preferred position. Be sure to place the face marked 'B' onto the surface of the base. Pierce through the centre point of the hole rubbing to accurately locate these positions. Drill the base and add a counter-bored hole underneath that will give a snug fit to the fixing bolts and allow for the fitting of a nut and washer and for a box spanner to tighten the nut.

If the sculpture is small enough to turn upside-down and you use liquid (horizontal) resin rather than the thicker variety (known as 'vertical' stone resin) you will be able to run the liquid into the holes before inserting the rods, then twist them into the resin, ensuring the threads are well covered. Make sure the rods are supported and vertical to the base until the resin hardens completely and the rods are rigid, then pass them through the base holes, fix with the nuts and washers underneath and tighten firmly.

Steady pins

Much smaller sculptures mounted on a base often only need a single threaded-rod and nut fixing. To prevent the sculpture from turning on the base and causing unsightly scratch marks a secondary short pin of smaller diameter, such as a small nail with the head removed – known as a steady pin – should be resin bonded into the sculpture and located in a 'blind' shallow hole in the base.

PHOTOGRAPHY

Digital photography has made it easy to record progress from block to sculpture. As you develop the carving these pictures are often valuable for clarifying areas where stone appears to need to be removed and observing changes that should be made, despite the fact that the pictures are only in two dimensions. Even if, after consideration, the changes do not need to be made, it is worth spending time contemplating the area before making your decisions. If possible the pictures should be printed up quickly so that they can be of practical use to you as well as an interesting journal of the evolution of the sculpture.

Taking photographs yourself is a real advantage when wishing to demonstrate your work to others or submitting them for consideration for a sculpture exhibition, since no one but you really knows how you wish each particular piece to be seen. You are bound to have favourite views of your carvings and aspects of them that might otherwise not be viewed in the way you wish to portray them. So taking a series of pictures of each piece, including particular details, will add to the interest shown in your work.

LIGHTING SCULPTURE

Every piece of sculpture is different and so is the room in which it is displayed. At night a halogen light set into the ceiling immediately above or slightly offset from the sculpture can produce an impressive result. At other times a soft side light is better. There can be no hard and fast rules, but experimentation is well worthwhile, as is moving the piece to different areas so that the carving can be seen in the round or from different aspects.

2 Photo Gallery One: Girl with her Hands Behind her Head

SUMMARY AND COMMENT ON THE CARVING

The methods discussed in this manual are those used in the development of the carving *Girl with her Hands Behind her Head*. This sculpture was made from Ancaster Weatherbed and measures 16 in (40 cm) x 15 in (38 cm). It is a small but fairly complex figurative sculpture devised to incorporate the various intricacies of a carving and to suggest the likely evolution.

With the hands linked beneath the hair at the back of the head, the arms form a diagonal from the elbows and downwards towards the nape of the neck, leaving the head prominent above the wrist area. The sculpture contrasts the strong angles of the arms with the delicacy and related angles of the drapery.

The crown of the head and back of the shoulders form the rearmost features on the stone (see Fig. 42) and the side view of the stone clearly illustrates the general diagonal stance of the carving and accentuates the slimness of the figure. The face is broadly abstract, with only the indication of a nose and slight indentations for the eyes, but the natural markings on the stone can suggest other features.

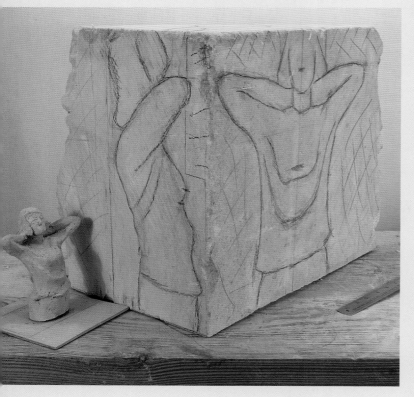

This block of Ancaster stone proved to be varied in quality, providing several hard, shelly areas in small patches: this was unusual in Ancaster, normally a very predictable, even stone.

Cutting the block with the striations set vertically has given an interesting suggestion of height to the piece. At the back of the head, the carving has responded in a similar way to wood grain, with the markings creating a circular feature of the crown of the head and the possibility to manipulate the striations to follow the curves of the hair.

The following photographs show the progression of the stone carving, and how it was approached. Comments below the photographs alert you to various features of the carving as they developed.

Fig. 74 Clear, measured drawings relating the front to side surface

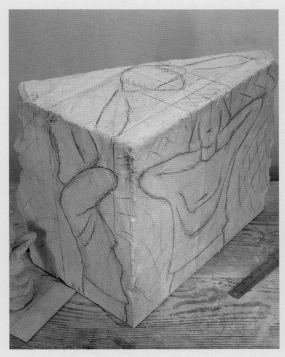

Fig. 75 Top drawings showing how the three adjacent surfaces relate

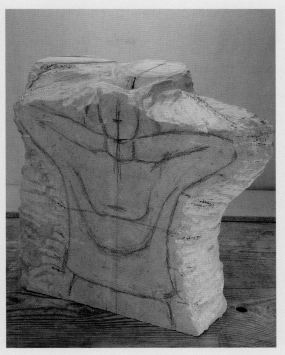

Fig. 76 Start of arm and head shaping with roughing out of sides begun

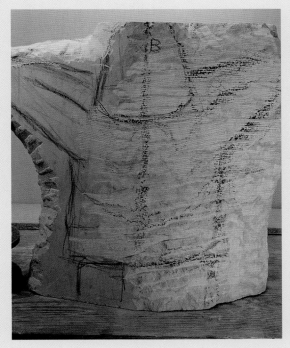

Fig. 77 Rear roughed out. Stone flattened from original triangular block

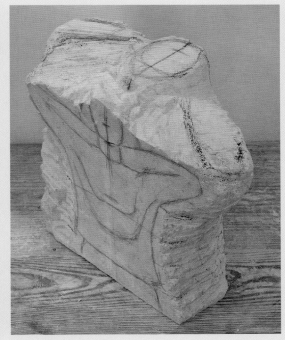

Fig. 78 Indication of stone to be removed from front. Note arm drawings

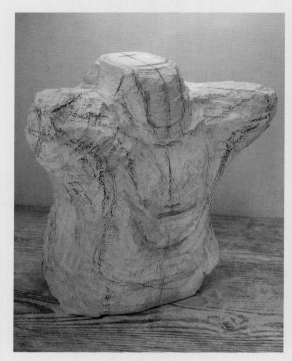

Fig. 79 Initial overall roughing out of stone well indicated

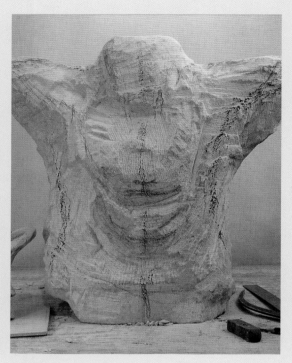

Fig. 80 Roughing out more advanced. Note use of centre line

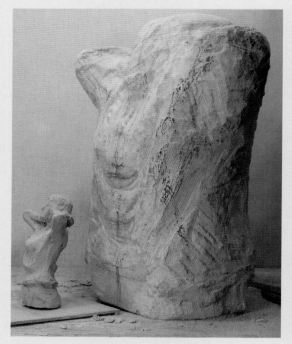

Fig.81 Central diagonals evolving. Stomach area still uncut

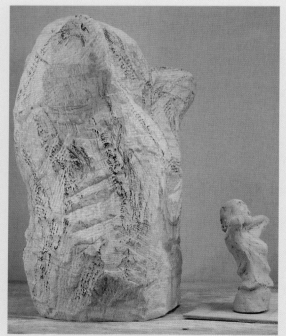

Fig. 82 Figure still very bulky. Drawings indicate cutting area

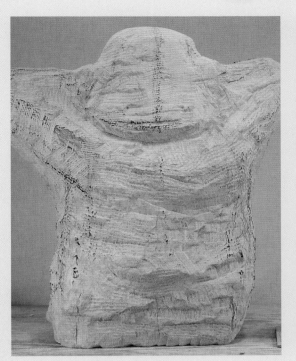

Fig.83 Back and head emerging. Width still too great

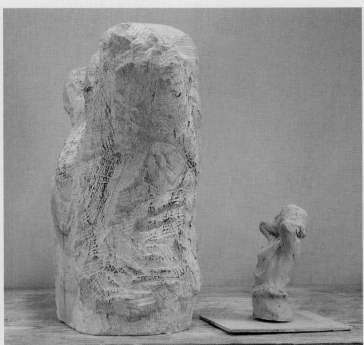

Fig. 84 Overall stance flat. Arms will be slimmed from the front

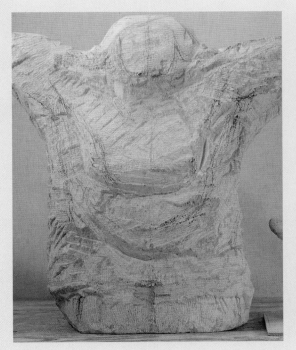

Fig. 85 Arms refining. Breast area and drapery delineated and commenced

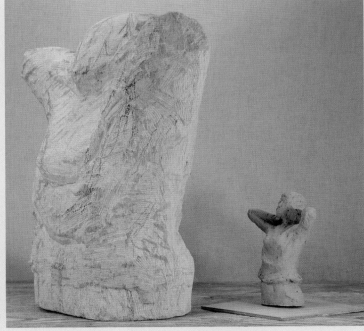

Fig. 86 Arms more set back. Angled overall stance emerging

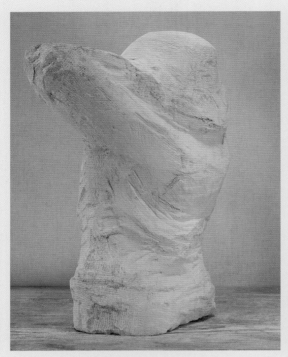

Fig. 87 First use of riffler to consolidate stone to assess progress. More contouring evident

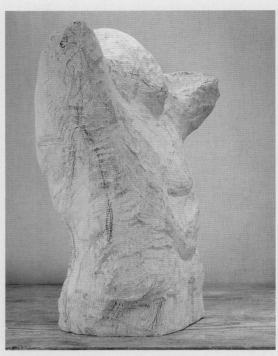

Fig. 88 Diagonal drawing indicating angle of central drapery

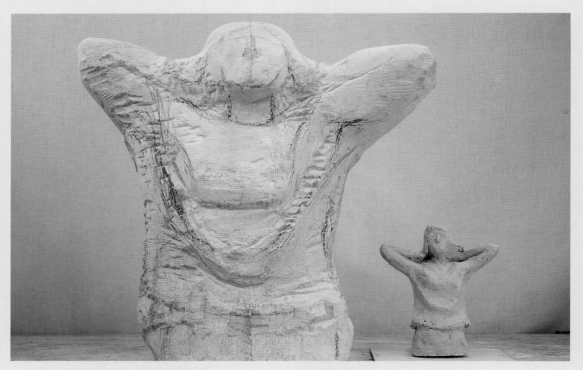

Fig. 89 Markings drawn for neck area. Body and drapery to be tackled

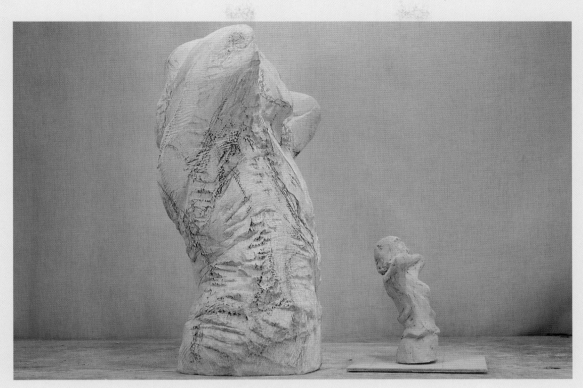

Fig. 90 Slimming and developing body angle simultaneously

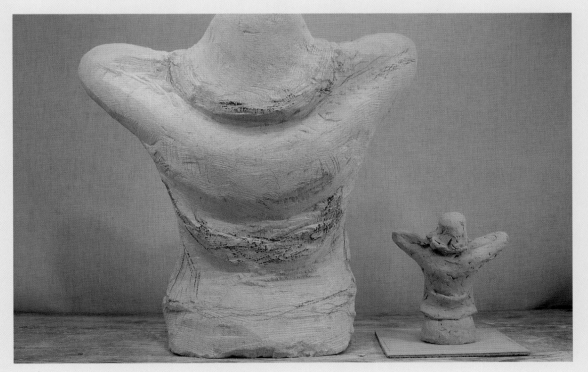

Fig. 91 Arms adjusted. Back drapery more defined

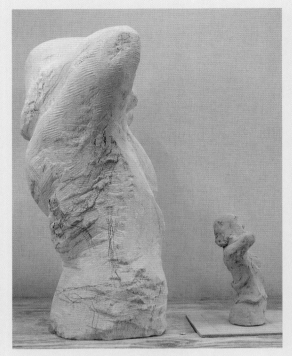

Fig. 92 Shape and stance more refined. Head and shoulders well related

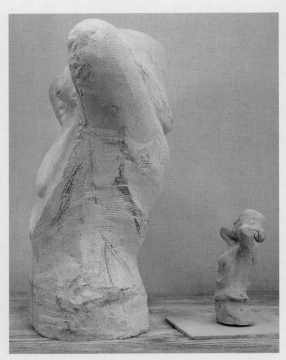

Fig. 93 Hip and waist shaping. Arms and related drapery still to be detailed.

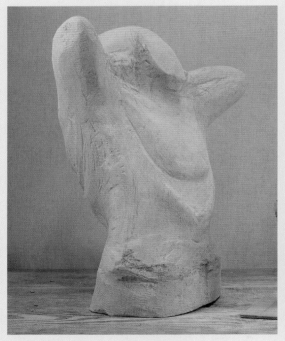

Fig. 94 Sweater hem emerging. Evolving relationship of front and back drapery

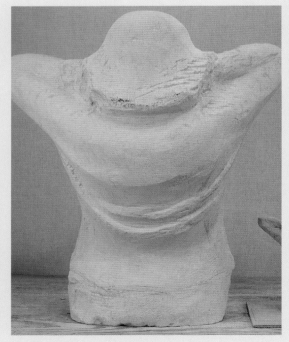

Fig. 95 Smoothing and riffler work evident.

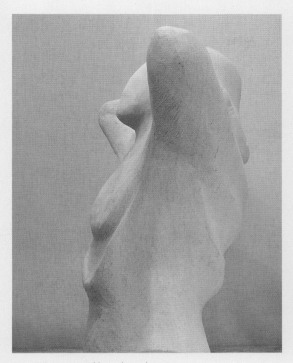

Fig. 96 Hair width reduced

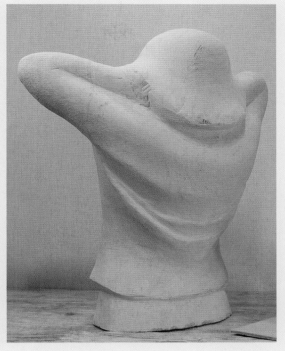

Fig. 97 As maquette, hair and shoulders are rearmost part of carving

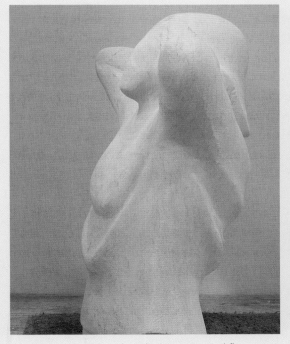

Fig. 98 Arms much reduced, slim waist and flowing folds

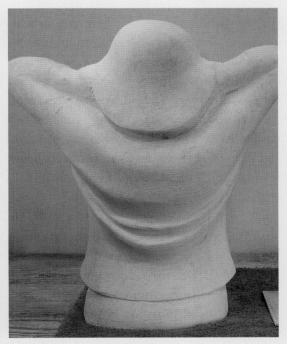

Fig. 99 All shaping and riffler refining completed. Ready for polishing

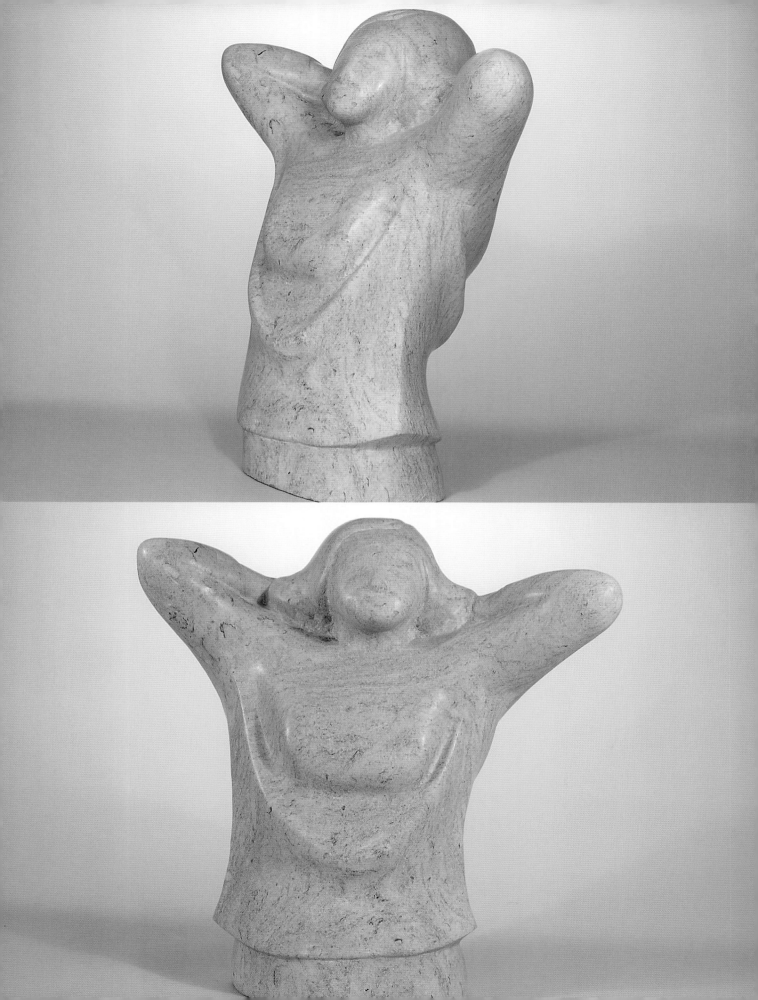

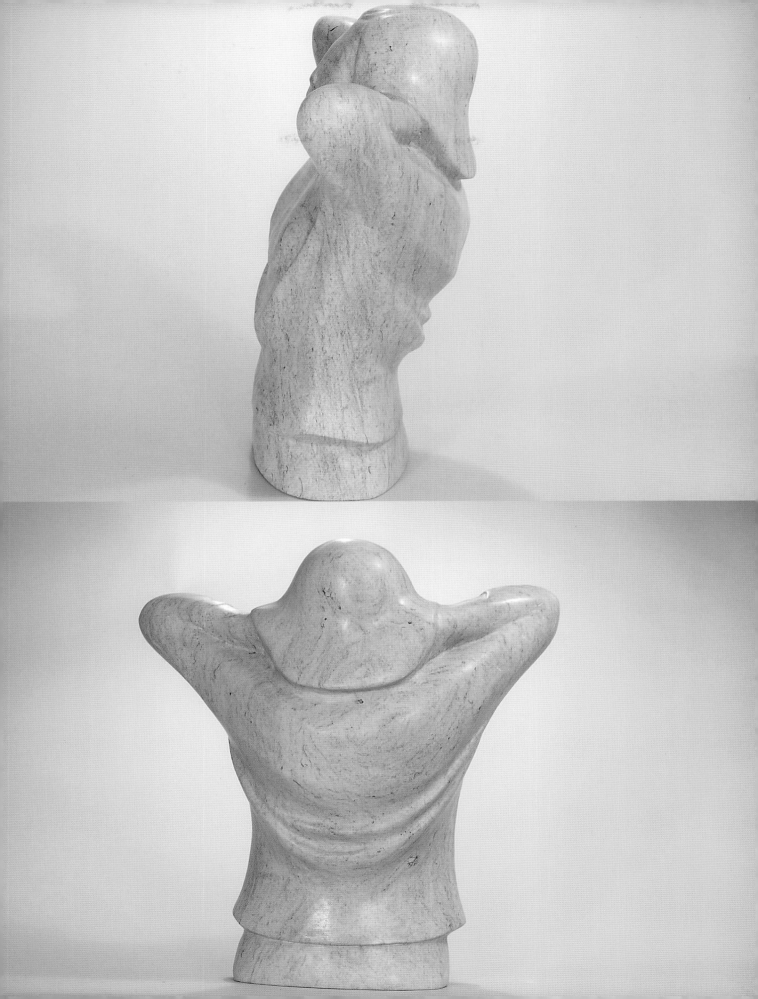

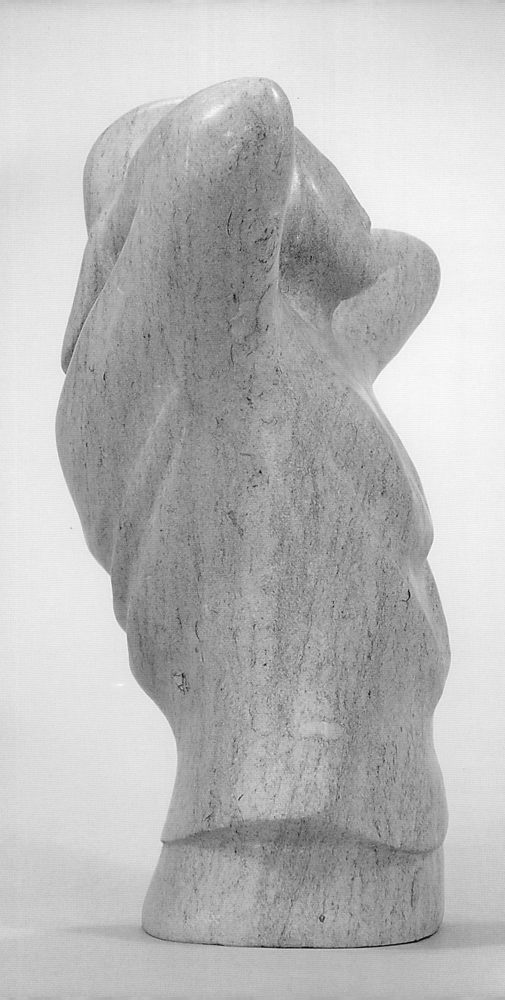

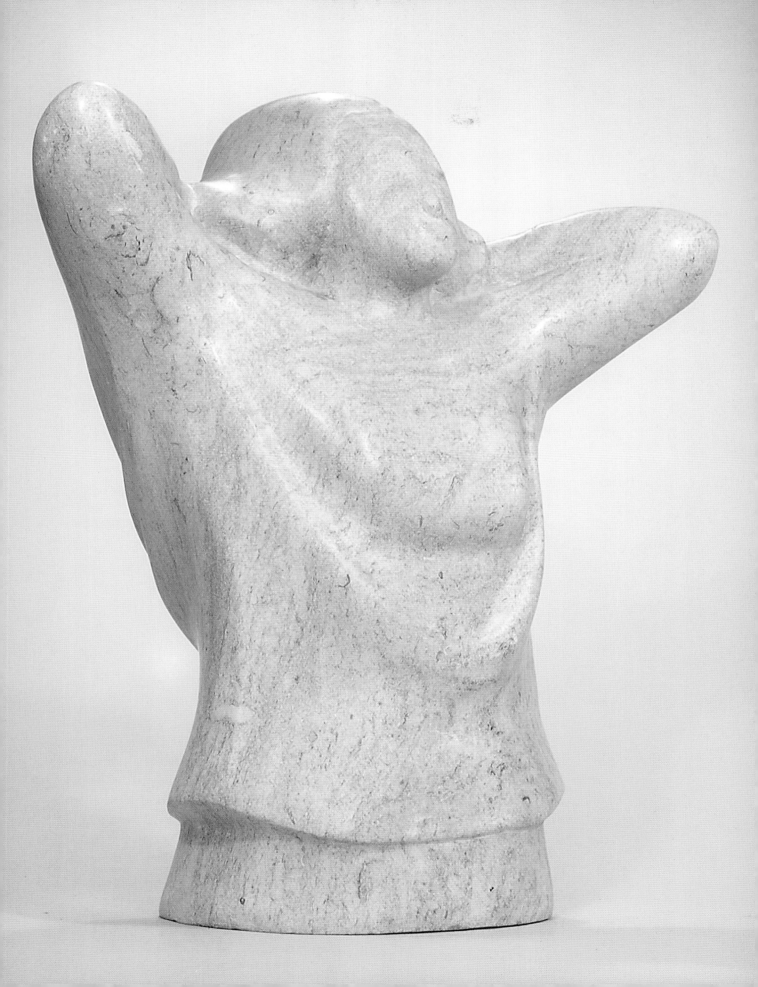

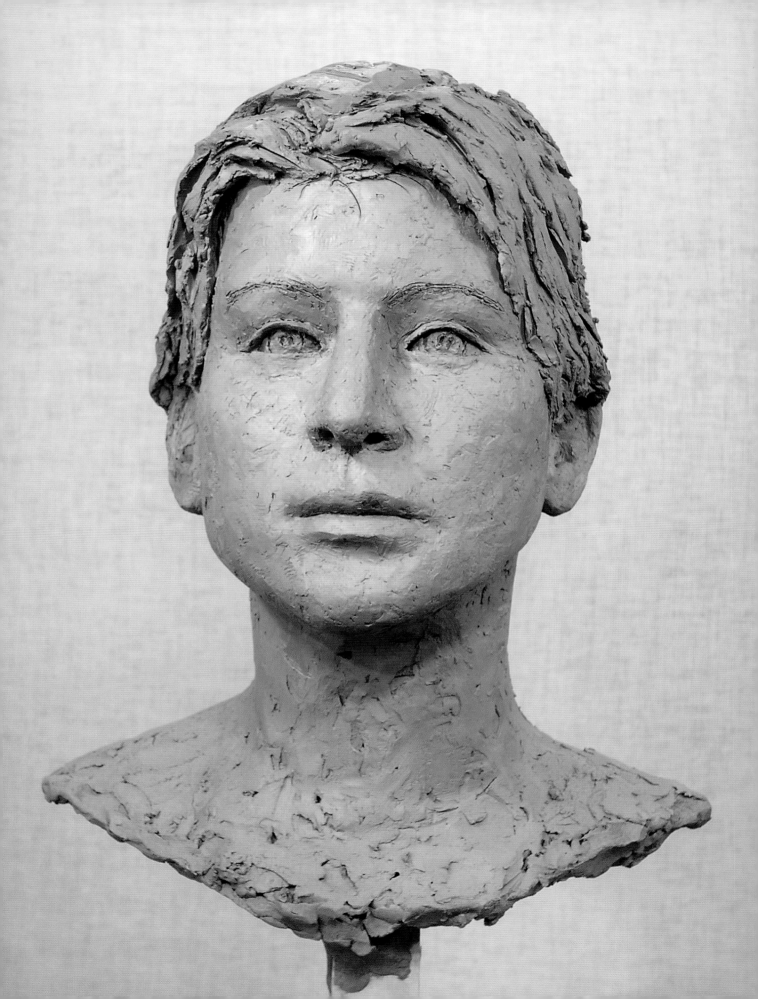

PART 2

MODELLING AND CASTING A PORTRAIT HEAD

Completed portrait in clay

Introduction to Modelling a Portrait Head

1 Introduction

Modelling a portrait head in clay is the joy of manipulating smooth, inert clay and transforming it into a vibrant, modelled study of a person. It is an exercise in observation and learning to 'see' and is one of the most challenging and satisfying three-dimensional art forms that exists and one that has been graphically illustrating mankind for centuries.

Portrait modelling can be approached by sculptors of all levels and abilities, even children. The techniques described in this manual, with adults in mind, are sufficiently straightforward to create highly successful results. Those who have made portrait heads before and are stimulated by the continuing challenge of new faces, will find that the unusual approaches described here will add to their perception and strengthen the impact of their work. Painting students who make a head in clay often say that they find the practical experience greatly enhances their understanding of shapes and shadows created by the bone structure of a head, and find their portrait-painting abilities improve markedly with this knowledge. It is my intention to pass on traditional ideas and some new ones that I have developed myself. These successfully generate a lively portrait and will enable you to achieve a good likeness.

Modelling will help you understand the nuances of the head and how the shapes of the skull influence the way we look. In the context of sculpture, and in my eyes, a portrait is a modelled likeness of a person that reflects his or her personality as well as their appearance. Watching that likeness evolve is exciting and rewarding, both for the model and the sculptor.

Constructing a clay portrait initially moves quickly and, with complete concentration is more an exercise in dexterity and observation than about previous knowledge of the head. It entails measuring the head and reproducing those measurements in the clay. Clay is built up on a simple head 'peg' (as opposed to cutting away material, as in a stone carving) and the model is present at all times to be used as a constant reference.

Every portrait evokes memories. Each one is unique and presents a learning curve with the character of the model playing a vital part. The model often influences the way in which we work and with most models you are completely relaxed whilst others may be awe-inspiring or intimidating – depending upon their personality and your interaction with them.

Confidence comes with practice and the time involved in making a portrait will vary so it is important not to confine yourself to a particular time scale. Bear in mind too that giving yourself *too much* time can mean that the modelling is overworked and you spoil your portrait. It is far more important to concentrate on the quality of the work produced and to know when to stop.

Every stage of portrait making is explained in detail in this book, from constructing your own 'head peg' to measuring and modelling the sitter until a successful head is produced. You will also learn the techniques for making a plaster waste mould of the head and casting it in *ciment fondu*, chipping out the mould to release the *ciment* head and finishing and setting it up on a stone or wooden base ready for display. All this is detailed here with photographs to illustrate each technique.

2 Workshop, Equipment and Materials

HEALTH AND SAFETY

As with all workshop situations, be aware of all health and safety risks. Masks should be worn where there are dusty operations and rubber gloves where allergic reactions to hands could occur, specifically whilst mixing plaster and *ciment fondu* or handling fibre-glass matting.

GENERAL NEEDS

Good light is essential within any workspace and daylight is always the best illumination. Supplementary lighting, in the form of small, hanging halogen spotlights, is a useful adjunct as these little lights are not too bright and can illuminate otherwise shadowy areas around your work or the model.

Spot and flood lighting on a suspended strip from the ceiling, similar to that described in the stone carving section of this manual (see page 22) add flexibility within a regular workshop to suit darker periods of the day. Fluorescent lighting should never be used as the only additional source of light. It gives no real shadows and is useless for portrait modelling.

To avoid visual confusion with any surrounding clutter, set up the modelling stand against a plain white wall or a hanging sheet against which both the model and the portrait can be seen clearly.

Modelling outdoors is not advisable as the clay will dry out and harden and you cannot be in total control of the light and environment.

The principal tools and equipment for making a portrait head are few and easily put together.

Requirements for modelling a portrait:

Clay ½ cwt (25 kg)
Beechwood or boxwood modelling tools, wire tools
Callipers
A rigid metal rule, 12–15 in (30 –38 cm) long
Free-standing metal modelling stand with turntable top (or bench turntable)
A head peg (for construction details, see page 123)
Notebook
Matchsticks (optional)
Plastic water spray bottle
Rolling pin
Plastic bin bag and string
Dais in chipboard (for construction details, see page 130)

METAL MODELLING STANDS

Modelling stands are produced commercially for the sole purpose of supporting portrait head pegs and modelling boards for small sculpture, etc. They are designed for the sculptor to use standing up and can be raised or lowered as necessary then locked into position.

The stands have a strong wooden or metal turntable at the top. Portrait head pegs are placed comfortably on this surface, enabling the portrait to be rotated frequently as the work proceeds. The small work surface enables the sculptor to move easily around the stand to gain subtle changes of view.

Fig. 100 Modelling stand

It is possible to sit down to model a portrait although this tends to inhibit the variety of views you would otherwise have. Should you choose to work in this way, it is advisable to purchase a square bench turntable and set it up at the correct height on a workbench. You can locate the head peg on this and model the head, turning the work easily and frequently.

HOW TO MAKE A HEAD PEG AND BUTTERFLY

A portrait head is modelled on a head peg, which consists of a plywood base and an upright wooden batten with an aluminium armature added at the top. This construction supports the clay that becomes the portrait head. The wooden batten elevates the head from the base and leaves space to build the neck and an indication of shoulders. Should you decide in advance that you want to incorporate a complete shoulder girdle as well as the neck, a wider baseboard would need to be used to accommodate the width of those shoulders (see Chapter 7.2. Armature for the incorporation of complete shoulders, p. 138).

Head pegs can be bought commercially or, alternatively, can be simply made in the workshop. They can be used over and over again.

List of components
A plywood baseboard 14 in square x ¾ in thick (35.5 x 1.9 cm) (larger width if shoulders are to be incorporated)
Two wooden battens 13 x 1½ x 1 in (33 x 3.8 x 2.5 cm)
One central batten (the peg) 10 x 1¼ x 1¼ in (25.4 x 3.2 x 3.2 cm).
Two triangular wooden stiffening plates 3½ x 3½ x ½ in x 45° (9 x 9 x 1.25 cm x 45°) or, alternatively, four 2 in (5 cm) metal angle brackets
Aluminium armature wire 4 ft 6 in long x ⅜ in square (137 x 1 cm).
Two small pieces of wood approximately 2½ in long x ½ in square (6.3 x 1.25 cm) for the 'butterfly' (see Chapter 7:2, page 136)
Screws and/or staples and a short length of wire to suspend the butterfly within the armature wire loops
(None of the dimensions for the above is critical.)

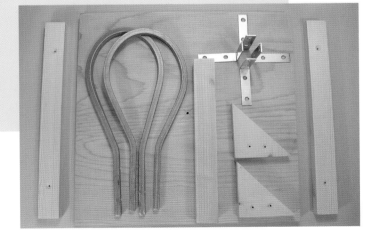

Fig. 101 Head peg components: baseboard, battens for underside, upright peg, wooden stiffening plates (and alternative metal brackets), armature wire cut and shaped

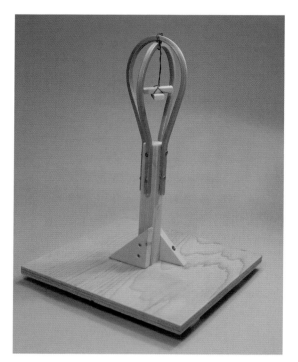

Fig. 102 Head peg with wooden stiffening plates

Fig. 103 Head peg upright using angle brackets

To assemble

Glue and screw the two 13 in (33 cm) battens to the underside of the board, insetting them sufficiently to allow finger grip space under the board (these battens are essential to enable the peg with a heavy modelled head on it, to be lifted from the modelling stand). Ensure the battens do not overhang the turntable of your modelling stand.

Drill a pilot hole through the centre of the board and similarly into the end of the 1¼ in (3.2 cm) square peg. Glue the central peg onto the board and screw through from the underside. To reinforce the rigidity of the peg, glue and screw the triangular wooden stiffening plates on either side of the peg and down into the board. Alternatively you can use four 2 in (5 cm) metal angle brackets.

Cut the armature wire into two equal lengths and form into two loops. Cross one over the other at the top and fix to both sides of the peg, with some of the armature wire flattened down the side of the peg for strength and support. Bend the loops formed to be slightly smaller than the size of the head you propose to model. Attach the armature to the peg with screws (you can use wire staples for this purpose but the screws give greater rigidity).

Troubleshooting armatures

Armature wire is supplied in lengths of square-shaped aluminium and is malleable, which makes it easy to bend into the required shape. When the wire proves to be a little too large

for the portrait, and emerges unwanted through the clay, tap the metal with a hammer to bend and bury it beneath the clay. You can then rebuild the clay over it.

CLAY FOR MODELLING

Pottery clay (grey or terracotta) is ideal for portrait modelling and general sculptural purposes. It is packed in ½ cwt (25 kg) heavy-duty plastic sacks where it should be left throughout the making of the portrait to keep the clay in good condition. This quantity of clay is required to make the average portrait head, including the neck and indication of shoulders.

Smooth clays are an ideal choice. Some others available contain grog (ground up ceramic) and are gritty. These clays are created for textured pottery to be fired in a kiln. It is unusual to choose this material for a portrait head, but it could be used to create a rough surface. Clay that is reinforced with nylon fibres and designed to dry and harden without firing or casting – often used by children – is not suitable for fine art portraits. The fibres distort the detail of delicate areas and give an unpleasant finish to a cast.

Clay is a very pleasant medium to use and should be firm but responsive to the touch. It should be easy to join pellets of clay to each other without them having to be pressed hard. The material should have a slightly greasy feel and be 'clean' to use. It is important to keep it in good condition.

Pull out a lump of clay from the bag, place it on the baseboard and work from that, rather than taking clay directly from the large open bag each time. This small amount of clay will require an occasional light spray of water to keep it in workable condition. If it dries out and begins to crack, discard it and use some fresh clay. It is always a good idea to keep the peg and baseboard sprayed with water to help keep the head clay damp.

Should the clay in the bag show signs of drying out, spray inside and close the bag again for the clay to absorb the water. Clay that adheres uncontrollably to your fingers is too wet to use; leaving the bag open for a while should quickly dry it out. You should not attempt to model with clay in this condition. If the whole bag of clay is too sticky to use it is probably worth 'wedging' it before you start work. Wedging is the process potters use to remove air bubbles or to reduce the water content in clay. It consists of slapping large lumps of the wet clay onto the surface of a bench over and over again, turning the clay as it is wedged. The bench surface, the hands and the ambient temperature all gradually absorb some of the water until the required flexibility is achieved. Once the clay is in good workable condition it should be restored to its bag.

MODELLING TOOLS

Modelling tools are handmade from hardwood, often beech or boxwood. They are tactile and quite sculptural in themselves. They vary in width and length to suit the work in hand and are usually shaped at both ends to give alternative profiles and, therefore, versatility to the tool. Lengths range from 5–10 in (12.5–25.5 cm) increasing in approximately 1 in

Fig. 104 A selection of large modelling tools 8–12 in (20–30.5 cm)

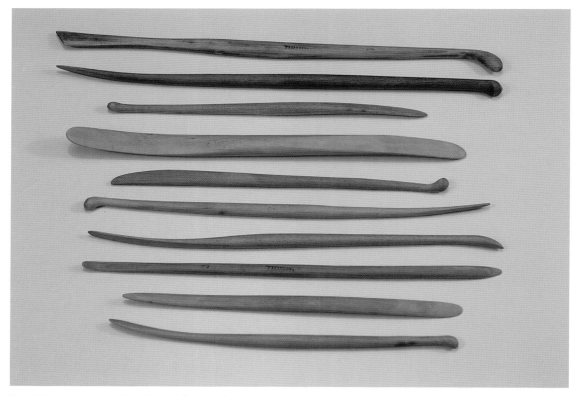

Fig. 105 A selection of small modelling tools 5–7 in (12.5–17.5 cm)

(2.5 cm) increments. Modelling tools curve upwards in opposite directions at either end, which, in use, elevates them from the clay and allows the sculptor to work slightly away from the surface of the work. Often one end is suitable for shaping or cutting away and the other is a round blob shape for smoothing down.

Thin tools offer better control when placing the clay or extending adjacent contours and should always to be chosen in preference to thick ones. The smallest beechwood tools with tiny curved ends are perfect for modelling details such as eyes, ears or nostrils. As with all tools, you can always benefit from as large a range of shapes and sizes as you can afford to buy. These should be professional tools for sculpture modelling.

In the early stages of making a portrait the best tools to use are your hands and fingers. If you would prefer to use wooden modelling tools, the larger ones are the most effective at dealing with bigger pieces of clay; change to smaller tools as the detail becomes finer and the surface of the modelling becomes tighter.

Any thick box or beechwood tools can be refined with sandpaper to your own taste. Never throw a broken boxwood tool away. If it breaks just reshape it with sandpaper and sooner or later you will find a use for it.

Like everything else that is handmade, good quality wooden modelling tools are becoming more difficult to find. Metal alternatives are often sold now but I would always recommend wooden tools as the first choice. Look out for collections of second-hand modelling tools in markets. Check them for variety and quality. You may be lucky and find a set of beautifully made old modelling tools, much thinner and more flexible than ones currently available.

Italy is renowned for sculpture and many sculpture tools, such as rifflers, are handmade there. They can often be found in tool and even hardware shops, so during a visit it is worth having a rummage to see if you can find some good examples at very reasonable prices.

MODELLING TOOLS TO AVOID

It is very easy to confuse pottery tools with sculpture tools as at first sight they look similar. However they are different and pottery tools are not appropriate for modelling use. Pottery tools are completely flat along their entire length and it is impossible to use them at the required angle for modelling. Their bulky and angular ends, designed for incising pottery, are the wrong shapes for the portrait sculptor and are therefore not recommended.

Do not use plastic tools for portrait modelling either. They are too thick, wide and flat and only suitable for use by children.

WIRE TOOLS

Wire tools are used to scoop or scrape away clay from overbuilt areas or for creating specific depressions in the clay. The tools consist of round or triangular shapes inserted into a wooden hand piece and usually have different designs at either end. They are produced in many sizes and qualities.

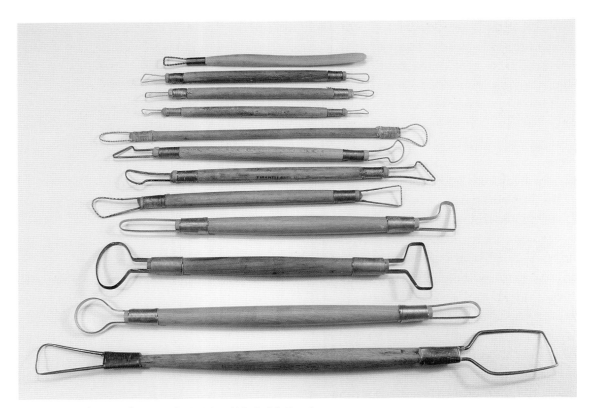

Fig. 106 A selection of wire tools 5–12 in (12.5–30.5 cm)

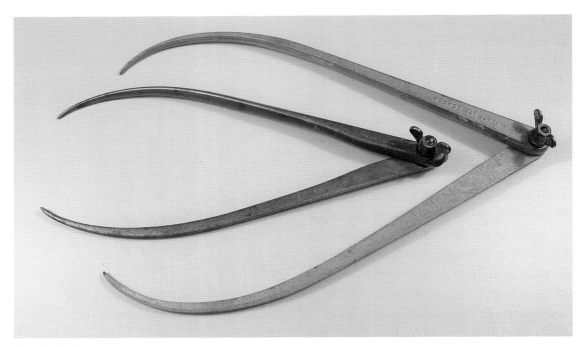

Fig. 107 Callipers

Often, when checking on the subtle contours of a portrait, you will see that the clay has been overbuilt, maybe in just a small area. In this case a wire tool is ideal for carefully paring the excess away, just removing a small amount of clay, but leaving the overall contour much the same as it was.

The most effective of the large wire tools are those that have serrated or angular edges (rather than round wire); these shave clay away cleanly and do not just slip over the surface. Very small silver-coloured wire tools with delicate ends are excellent for removing clay from tiny areas like the inside of an ear or nostril.

It is possible to make very satisfactory wire tools with broken, fine fretsaw blades set into a suitable handle. They produce a serrated surface that is good for both removing and producing a bonding surface to clay.

CALLIPERS

Callipers are an essential tool for taking the many measurements you need when making a portrait head and you will use them extensively, even if the head is not to be life-size but a proportion of life-size. The more experienced you are at making portrait heads the more accurate your visual measurements will become, but they will still need verifying from time to time.

Callipers are available in aluminium, plastic and sometimes in bronze. The aluminium ones are very reliable. It is important that the pointed ends of your callipers are sufficiently fine to register measurements accurately. I find that callipers that turn in too much at the pointed end make certain measurements difficult to take. When measuring some awkward areas, such as under the nose to the mouth or chin, the callipers should be crossed over so that the measuring tips can reach the undercut easily.

There is an unwritten law about using callipers and it is that you cushion the pointed ends with your fingertips so that the model is never touched or stabbed with the metal ends of the tool. The fingertip should be on a level with the tip so that the measurement is still accurate. I should point out that despite this recommendation many of the photographs here do not include my fingertips – this is purely for the benefit of clearer photographs.

Fig. 108 Fingertips cushioning the pointed calliper ends

CLAY CUTTERS, SPRAY BOTTLES AND ROLLING PINS

Clay cutter

A wire clay cutter, which is a short length of wire with a simple dowelling handle at both ends, cuts manageable blocks of clay from a larger one or, for example, removes a slice of projecting clay when the mould is being emptied ready for casting. It is a useful and cheap cutting tool to have in your toolbox.

Spray bottle

Have a water-filled plastic spray bottle nearby to dampen the clay whilst modelling when necessary. Never over-spray the portrait whilst you are working, so that water runs down the clay, as it will be impossible to blend new pellets into the existing work, as they will just slip about. Let the water absorb slightly before resuming work.

At the end of each session you should finely spray the modelling all over from a distance and then cover it with a large plastic bag, puffed open around the head and tied tightly with string around the peg below the neck area.

If the unused clay in its bag is in good condition just tie it up tightly, but if it is drying, spray it every now and then. It should not get too wet. Should you discover the clay has really dried out, or you have a new bag with clay in this condition, dig thumb holes deep into the top surface of the block, fill them with water and close the bag. The water will absorb into the clay and soften it.

Rolling pin

This is necessary to roll out the clay wall needed as part of the moulding process for the portrait. A kitchen or larger sculpture rolling pin can be used so long as it has no ridges or holes on its surface. Clay for the wall must be flat with no ridges or indentations.

A DAIS AND HOW TO CONSTRUCT ONE

The human brain has its limitations in retaining subtle detail viewed in one place and reproducing it in another. In the few seconds it takes to observe a very subtle contour on the model's face and turn back to the modelling to reproduce the shape in clay, much of the information has gone. A dais can help you overcome this problem. It is an optional extra but a most useful piece of simple equipment to have.

A low dais on which to place the seated model is ideal. They will need a comfortable office-style swivel chair to enable them to relax and turn easily. Note that a stool with no backrest is uncomfortable for a model who will be sitting for several hours. The dais is designed so that when the model is sitting on the chair, their head will be at eye level to yours. With the head peg set upon the modelling stand, also positioned at eye level between yourself and the model, every detail of the head shapes will be apparent just by moving your eyes (and not your head) between the model and the clay. You can virtually overlay the detail you see onto your modelling. If you remember to turn your

work to exactly the same position as the model and view all the profiles, you can use this overlay system throughout. This totally focuses your concentration and will make all the difference to the accuracy of the portrait.

A dais of suitable size and height can be made economically from a single sheet of chipboard 8 x 4 ft (2.4 x 1.2 m). The 4 ft (1.2 m) square platform created is large enough for a revolving, office-style chair and for your model to mount the dais safely.

Fig. 109 Dais, swivel chair and background cloth

Components required

One sheet 8 x 4 ft (2.4 x 1.2 m) chipboard
Four 38 x 1½ x ¾ in (96.5 x 3.8 x 1.9 cm) wooden battens
Screws and glue
Cutting:
The 8 x 4 ft (2.4 x 1.2 m) board should be cut into:
One piece 4 ft (1.2 m) square and four pieces 4 x 1 ft (1.2 x 0.3 m)
Each of the smaller 4 x 1 ft (1.2 x 0.3 m) boards should have an open slot ¹³⁄₁₆ in (2 cm) wide, cut 4 in (10 cm) in from each end to a length of 6⅛ in (15.3 cm)

Construction

The 4 ft (1.2 m) square board, which will form the top platform, should ideally be stiffened on the underside with four 38 in (96.5 cm) lengths of timber set 5 in (12.7 cm) in from each side and evenly spaced. These should be screwed and glued in place.

The use of 1½ x ¾ in (3.8 x 1.9 cm) sized battens is not critical, but this size not

Fig. 110 Baseboards slotting together

only gives adequate stiffening but also serves to locate the platform centrally over the box sides and prevents the top from sliding.

From the point of view of storage the platform top may be cut into two halves, but for stability the one-piece top is preferable. In either case assembly and disassembly is quick and simple and the platform can be stored completely flat.

Fig. 111 Stiffening battens under platform top

Modelling a Portrait Head

1 The Early Stages

THE FUNCTION OF THE MODEL

As the model for the sculpture featured in this book was a young woman (Diggy), I shall refer to the model as 'her' throughout.

The model will want to know your method of working and to understand her role in it, particularly as she may never have modelled before. It will inevitably take a little time for her to relax and become used to the routine. Unlike sitting for a painted portrait, it is not necessary for her to keep totally still, especially during the early stages when the overall structure is being built up. She will be free to talk to you, even if you cannot hold a particularly in-depth conversation, as your concentration may be elsewhere. Later, when you are working on the precise details of the facial features, such as her mouth, eyes or the contours of her cheeks, the model will need to be still as you examine and work on the complicated structure of these parts.

From the beginning, the model is responsible for rotating a quarter turn in the same direction every five minutes whilst you begin to rough out the shape of the whole head, initially working only by eye. Later, with the more intricate shaping of the structure, she will be required to move eighth or even shorter turns. These closely related views reveal the subtle changes of the head and facial features, how one contour leads to the next and where muscles begin and end.

Each time the model turns, your turntable needs to be rotated in the same direction, to exactly the same degree. This will ensure that the development of the head structure is

progressed at an even rate all the way around and that all clay additions are made in the correct place. The time restriction inhibits you from over-working one particular area. It is essential to stick to the regime so that every aspect of the head has equal scrutiny.

The model will appreciate occasional rest periods and some sort of refreshment from time to time. Sweets and chocolate always seem to go down well! Depending on the model's temperament, approximately two and a half hours sitting time seems to be comfortably acceptable. It is worth noting that when the model returns from a break she initially tends to sit up straight but later sags a little into a more relaxed position. If you detect this happening, delay starting your work slightly. Once they are familiar with your working methods and can see the quick development of the portrait, models often find the whole experience fascinating and start to completely forget about the sitting time.

Never work on your portrait without the model being present. If you refer to photographs you have taken during a sitting and spot what looks like an error of structure or detail in your work, make a mark on the clay or your notebook to remind you to look again when the model is present, and check when she returns. You will never get as accurate a view of the model from a two-dimensional photograph as you will from the three-dimensional model, so always check from the model herself: stand back, compare what you see and, if something looks wrong, take more measurements, then make the necessary adjustments.

PLACING YOUR MODELLING STAND

The structural shape of the head needs to be developed before any facial features are added; you need to stand back from the model to distance yourself from the details. Place the head peg and stand about 6 ft (1.8 m) from the model, ensuring that you have a clear view of her. The eyes of the model, head peg and your own eyes need to be at the same level, so that you have only to move your eyes from the model to the clay and back again. You should not need to turn your head. Most students find working in this fashion helps them focus wholly on the model and sculpture, so that they become completely lost in the shape of the head and reproducing the likeness.

Working whilst standing has the advantage that a slight sideways movement will reveal very subtle changes of view of the model. This is useful at many stages of working, so standing is to be preferred. If you do need to work sitting down, a bench turntable should be set up at the correct height so you can turn the work freely as the model repositions herself, and always be in a position to see the model and your work on the same level, as described above.

Later, when you think the structure is accurate, you will need to move much closer to the model to be able to see and study the features of the face, and how they will fit onto the foundation you have prepared. This is the time when the complexities of the human face really become apparent.

EXAMINING THE HEAD STRUCTURE

It is important to emphasize again that the structure of the head must be carefully built up before any facial features can be included. Unless the basic structure is correct mistakes will creep in and cause you to manipulate the features to fit inaccurate modelling. The most common consequence of this is to set the features too far back in the head, giving the face a squashed appearance.

Recording detailed measurements in a notebook means that you can refer to them at any time. However, there is nothing quite the same as re-measuring directly from the model – that is the whole point of having a model sitting for you. Don't be shy about re-measuring. You will need to check accuracy many times during the portrait process and it is more important to get measurements right than to be embarrassed about taking them.

EVOLVING A SURFACE FINISH

The clay needs to be applied in workable-sized pellets; place the material accurately to reflect the profile or contour you see on the model. As the portrait progresses, the pellets of clay you place need to become smaller and smaller and be placed more and more specifically – wooden modelling tools are able to place tiny clay pellets. These pellets form a 'jigsaw' of pieces that are built up until you are satisfied with the undulations and subtleties of the model's face/head, making sure nothing is overbuilt.

How you finish the surface of the clay is a matter of personal taste; you can smooth it very carefully with a tool into a lifelike surface or leave in place the defining pellets of clay you have carefully built up, still visible as your own 'handwriting' that is unique to you.

I personally prefer the latter because I find the textured surface adds liveliness to a modelled portrait, which is not a human head but a copy of one. The texture replaces the colour on a human head and gives it more vivacity and, as in a human head, it changes with the light in the situation in which it is placed. Textured surfaces must evolve on their own; they cannot be contrived at the end because they would enlarge the portrait unnaturally and are obviously not a natural development of the modelling.

2 The Initial Construction

PREPARING AND FILLING THE PEG

In the early stages of making a portrait, quite large pieces of clay can be used to fill the internal space and cover the outside of the armature.

Set up the head peg so that the centre of the front of the portrait head is in line with one of the flat sides of the baseboard (i.e. not across a corner). Spray the head peg and base to keep the clay moist. Starting from the top of the head peg, fill the armature with lumps of clay. Press them in place without compressing them tightly.

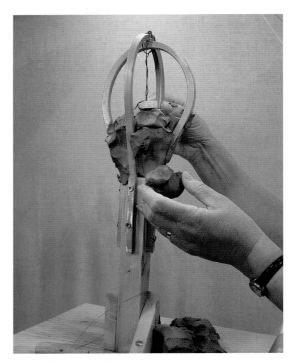

Fig. 112 Armature being filled and butterfly incorporated

PLACING THE BUTTERFLY

These two small pieces of wood, crossed at right angles and secured together with a length of flexible wire, are suspended from the top of the armature. Incorporate the butterfly into the clay as the armature is filled so that it is firmly and centrally embedded. Its purpose is to support the volume of clay inside the armature and ensure it stays in place.

Thinly cover the armature, developing the simple, oval head shape. The clay should be extended down onto the upright peg to start developing the neck area.

In the very early stages of making a portrait, taking measurements and transferring them onto the clay can be confusing. However, once you have covered the armature and there is some clay in place, a vertical line marked on the clay, indicating

Fig. 113 Armature covered

Fig. 114 Building up shape with loose pellets

the centre of the face, crown and back of the head will help you. Hold the callipers equidistant from the central line and build up width on either side of that line, with quite large pieces of clay, until the approximate width of head that you need is achieved.

The centre line will have to be over-drawn as the head shape develops, but it is a useful mark to have on the clay throughout the building-up process. As the model turns you will be able to take other preliminary measurements to enable you build up the whole structure. This forms the roughing out of the head. Be sure you know which is to be the front and which the back of your modelling.

ESTABLISHING THE NECK ANGLE AND ITS SIGNIFICANCE

At the same time as considering the initial facial structure you simultaneously need to reflect on the stance of the model's head and, in particular, the angle of her neck. It is easy to overlook this area of the model whilst you are thinking about the head shape, but the neck angle and thrust is of great importance.

Some people have a straight up-and-down neck shape with the chin protruding a relatively short distance from the neck. But there are others whose neck leans quite steeply forward from the clavicle area. This was the case with the model who sat for the portrait illustrated in this manual.

A portrait of a model with a straight neck shape is supported by the wooden peg passing straight up through the clay near the centre of the neck, behind the jaw line and with the armature wire

Fig. 115 Establish the overall shape of the model's head

Fig. 116 Note neck angle and consider the armature location

bearing the weight centrally within the skull area. However, when modelling a head with a forward neck thrust, the overall projection of the facial features beyond the throat/neck area must be given consideration early on. The throat needs to be located at the front of the head peg and the neck angled forward from that point. Should you overlook the need to reproduce this angle at an early stage, you are likely to find, later on, that the head peg will obstruct the throat area of the neck and the facial features are not sufficiently forward. For this reason, sufficient allowance should be made for the throat area of the head peg to be adequately covered with clay and for the diagonal of the neck to be built beyond it.

ARMATURE FOR THE INCORPORATION OF COMPLETE SHOULDERS

Portrait heads can be finished at the bottom of the neck, or with an indication of shoulders or with the complete shoulder girdle incorporated. Some portraits are enhanced by the addition of shoulders, especially on young people, but others are not.

If you decide to include shoulders, a larger baseboard will be necessary to accommodate the extra width and for the overlaying of plaster and *ciment fondu* during the casting process.

To support the additional clay required for the shoulders, a wooden batten measuring 2 in high x 1 in deep (5 x 2.5 cm) should be fixed securely with two screws, horizontally to the upright peg shaft. It should be as wide as the shoulders less 1 in (2.5 cm) on either side, to allow for the build up of clay. The distance from the jaw angle down to the shoulder should be measured to assess the correct position of a shoulder batten that leaves adequate depth for the modelling.

ADJUSTING THE ANGLE OF THE HEAD ARMATURE

If you find that the model has a characteristic tendency to tip her head to one side, it is possible that the whole armature can be pushed slightly to one side to replicate that bias. Do not move the armature too much and accentuate something that should be subtle. This alteration is often better done later on in the modelling process, when the head is more advanced, although some restoration to the pushed area may be necessary.

3 Measuring the Head Structure

There must be an infinite number of places on the head from and to which measurements can be taken to establish size and distance. The measurements you need will become apparent as you work; although there are many that are essential to everyone you will find others that are particularly important to you. The following are the most basic requirements:

Essential basic measurements

Ear to ear

Ear to centre of top of forehead at hairline

Neck thrust angle

Height of forehead, from bridge of nose to hairline. Mark a line

Bridge of nose to tight under nose. Mark a line

Under nose to lowest part of chin

Length of upper lip, from the touch-lip line to tight under the nose. Mark a line

Width of forehead before eyebrow turn

Height of forehead at turn of eyebrow to hairline

Height of face, from hairline to base of chin. Mark a hairline

Ear to chin. Assess the angle of the jaw and ensure it is the same as the model's

Length of jaw, from marked ear points

Chin to crown of head. Add essential clay to take account of this distance

Width of back of the head. Use the drawn centre line to ensure equilibrium

Width of cheekbones

Length and width of neck (side to side and back to front)

Additional width and depth measurements if incorporating shoulders

WIDTH AT EAR LEVEL

With the basic structure in place, the first specific measurement to take with the callipers and note down is the distance between the ears, just at the inner edge of the small cartilage flap, the tragus. Once you have located each earhole in the clay and checked their relative levels, small ear holes can be marked clearly on either side of the head. These ear markings form the axis of many of the other measurements you will take, so are crucial. Ensure they are not too high or low, forward or back on the clay.

Looking down from above, establish that the ears are located correctly, then mark the holes with matches. The exposed tip of the matches should be the actual measurement of the width between the ears.

Fig. 117 Measuring ear to ear

EAR TO CENTRE OF FOREHEAD AND WIDTH AND DEPTH OF FOREHEAD

The distance from the ear hole to the top of the centre of the forehead – measured to the vertical centre line drawn on the clay – establishes the next useful measurement and should be marked with a modelling tool. The protrusion of the forehead from the ear (seen in profile) and the width and depth of the forehead from the hairline to the brow can then be accurately established and marked too. Have a look at the forehead where it turns diagonally over the eyebrow and make sure you model it clearly. Perhaps draw a small vertical line in the clay marking where the turn begins.

Fig. 118 Building up forehead

OTHER CRITICAL FACE MEASUREMENTS

Once the extent of the forehead is established there are three critical measurements to take and mark on the clay with a modelling tool: from the top of the forehead to the bridge of the nose, from the bridge of the nose to tight under the nose and from under the nose to the chin. Then check the total length of the face.

Fig. 119 From the top of the forehead to the bridge of the nose

Fig. 120 From the bridge of the nose to tight under the nose

Fig. 121 From under the nose to the chin

Fig. 122 The total length of the face

With these measurements clearly noted as lines on the clay you will become aware of the structure of the facial features and where they will be placed in due course.

Fig. 123 Clay detail marking mouth, nose, eyes and forehead measurements

Fig. 124 Measuring the chin length

Fig. 125 The clay jaw area from behind

Next consider the measurements from the ear hole to the jaw and the corner of the jaw to the chin. Make sure allowance has been made for any neck thrust; this is the time when the neck angle will become very apparent.

Measure the distance from the jaw angle to the centre of the model's chin. Make sure the callipers are held at the same angle when adding pellets of clay to the modelling to establish the full protrusion of the chin. Double-check the length of the chin by measuring from the ear hole too. Do the same on the other side and, looking at the model from the front, begin to develop the whole of the jaw area. Building up the jaw will move the portrait forward from the neck peg. Keep the modelling within the actual measurements to allow more detailed shaping to take place later.

Fig. 126 Diagonal length of head

Fig. 127 Length of neck

Carefully measure the length of the head from the crown to the chin and the width of the crown. It is easy to overlook these measurements and forget that the shape so far has only been roughed out.

Confirm the length of the neck, measured from the ear hole to the shoulder, and other neck measurements including the width and depth. Enliven the neck area with any visible musculature, first marking it on the clay and then building up the height as it appears.

INCORPORATING SHOULDERS

If you are incorporating shoulders to your modelling they can, at this point, be modelled as a natural extension of the neck and down onto the baseboard.

Study the profile of the model, including the curve of her back and how the shoulders relate in prominence to the features of the rear and front of her head, and, from the front of the portrait, note the slope of her shoulders.

VIEWING THE CLAY AND THE MODEL FROM ABOVE

It is revealing to view your model from above to see the projections of the cheeks, nose and chin and how far they extend beyond the model's forehead as well as to note the shape of the top of the head. Ask the model to sit on the edge of the dais and stand behind her and view from overhead. Place the head peg on the floor or dais beside the model to make comparisons.

CHECKING YOUR PROGRESS

Frequently check your progress by looking at the model and your clay from exactly the

Fig. 128 Width of neck

Fig. 129 Looking down on the head to establish forward structure

same angle. Stand right back – more than 6 ft (1.8 m) if possible – and compare the similarities and differences between your work and your model.

Look at the clay in all profiles and study the shape of the head, its length and width across the crown and down from the crown to the neck. Do not neglect the shape of the top of the head or, in due course, the additional modelled height of the hair.

Compare the slope and length of the forehead and check that the cheek line is correctly related below it. Check in profile the alignment of the forehead and cheeks and how far forward the chin is in relation to the cheeks (see page 145).

Check whether the chin is adequately forward or back, the jaw is still at the correct angle and all other features are lining up precisely. Make any corrections.

OVERBUILDING

Overbuilding the clay, sometimes in an effort to correct faults, will mean that the head will become too large and adjustments will have to be made when you finally discover the mistake. This can happen if you apply pellets of clay that are too large or not enough thought is given to where you place them. Use small pellets of clay and only add them to the contour you can see, not beyond.

If something is wrong you will have to decide where corrections should be made, whether you should remove some clay to reduce an area or whether you should add clay somewhere else. Always check and re-measure, otherwise your mistakes will compound and your portrait will not resemble the model. By standing back you see the work more objectively and can spot mistakes that need action. This system of working around the structure thoroughly prepares the early modelling to receive the nose, eyes and other features which you can now construct.

4 Accidents

Accidents do happen and mistakes are made. Fortunately, clay is a forgiving material and can easily be rebuilt or restored.

On one of my early portraits I discovered that although the features looked great there was something seriously wrong. I eventually realized that the whole of the front of the face was set too far forward and this was particularly apparent in profile. Reluctant to lose all the modelling that I was pleased with, I took a large knife and cut the whole of the front of the face away, from the forehead downwards, supporting the removed material in my left hand, and cut another half inch depth away behind it. As I moved to replace the face after the surgery, it slipped from my hand and fell onto the floor. The colonel who I was modelling didn't bat an eyelid as I bent down, picked up his face and put it back on the head as best I could. Surprisingly, it was not irrevocably damaged and I repaired the squashed parts. The likeness returned and all was well. His photograph is in Photo Gallery 4 (see page 198).

During one teaching session, a student inadvertently raised her modelling stand too high, and a whole room of students watched horrified as the head peg with the nearly completed head, in slow motion, fell to the floor with a splat. The head was compressed to half its previous height but still had some well-observed likenesses intact – the armature had successfully held the head in its original position. With her recently acquired knowledge of the model's features, it was imperative for the dismayed student to restore the image immediately, without much time for anguishing. Remarkably, the head was re-modelled into a fine piece and everyone benefited from the confidence inspired by the student coping so well with such a heart-stopping event.

5 Detailed Modelling of the Facial Features

Having modelled the whole structure of the head, and taken this as far as possible, the precise work on the features can begin. At this point, move your stand close to the model.

NOSE

The nose dimensions you have previously measured and drawn on the clay, delineating the length and width of the nose and their relationship to the mouth, are critical.

Taking the forehead, specifically the eyebrow, as the starting point, examine how the nose emerges; whether the nose begins at the top, at eyebrow level, or, more usually, just below it, leaving a hollow into which your finger can comfortably fit.

Fig. 130 Showing critical positional drawings on the clay

Fig. 131 Profile of portrait showing 'skeleton' nose

Fig. 132 Profile of portrait showing nose with thin filling

Prepare a flexible sausage of clay approximately ¼ in (6.5 mm) in diameter and about 4 in (10 cm) long. Leaving the 'finger' space on the clay clear, hold the sausage vertically and press one end onto the point from which the nose emerges. Drop the other end down and attach it precisely on the line indicating the bottom of the nose (so that the thickness of the clay stops at the line), at the same time shaping it to a sketch profile of a nose. Shorten the sausage if necessary. or make another one if the first proves too short, long or bulky. The nose does not need to be an accurate shape at this point.

Take another small piece of flexible clay and form this into a thin, flat, roughly triangular shape and pop it into the triangular space created by the sausage. With a small modelling tool, join the two together, creating a thin triangle of clay.

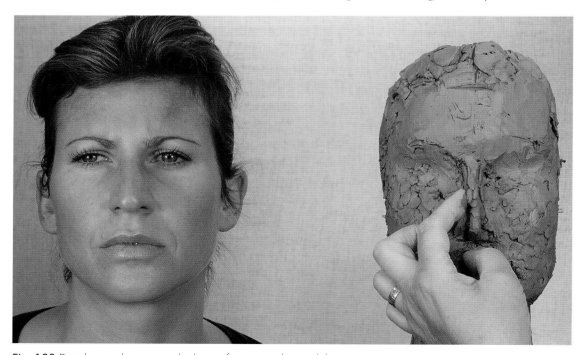

Fig. 133 Developing the nose with close reference to the model

Fig. 134 Profile of nose being built up with small sausages

This thin, skeleton nose forms the delicate structure onto which you will fashion and aesthetically define the nose, building it up with tiny sausages of clay rather than cutting back a bulky, rough lump of clay.

These small sausages of clay placed vertically down the nose, on either side, should be added until an appropriate width is delicately constructed.

Re-measure the width of the model's nose at the bridge and keep the clay within that width. Also check the contours further down the nose until they begin to take shape accurately. Check the length of the nose again. When the shape is correct from the front, concentrate on the nose profile, delicately adding any small bumps or hollows.

Nostrils

Measure the total width of the nose at the nostrils and check the markings on the clay.

With flexible clay, make a tiny, thin cap, similar in size to the model's nostril over the tip of your finger. Supporting it with your fingers, place the hollow edge against the clay nose with the concave side outwards, so that it is no wider than the width-defining lines. This will become the first nostril.

Fig. 135 Exact width of the nostrils indicated

Fig. 136 Nostril cap

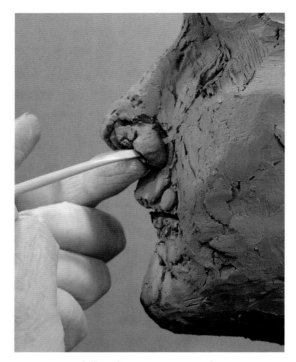

Fig. 137 Modelling the nose cap into place

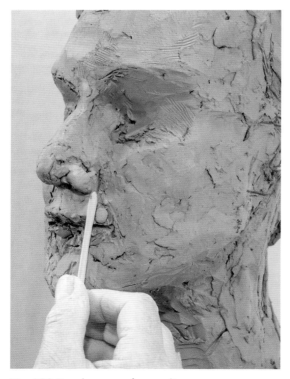

Fig. 138 Development of upper lip

Model it into place with a small tool. If it proves to be too bulky, re-make it. Fashion it to the shape of the model's nostril, leaving the inside hollow and trimming the bottom edge for correct length. The nostril profile and height should be the same shape as the model's. Do the same on the other side.

Having placed both hollow nostrils and formed the open edge to the 'bean shape' you see in profile, make sure the nose modelling is as fine as the model's. Check the central fraenum between the nostrils, noting how thick and visible it is. Add any small lumps of cartilage you see inside the nose, ensuring they resemble those of the model. All this will add character to the portrait and create similar shadows to the model's.

Once the nose and nostrils are complete you can adjust the cheek area to relate correctly to the nose. This 'filling in' can also be done after you have built up the mouth and chin areas.

UPPER LIP, LIPS AND MOUTH

With the nose in place you will naturally move on to construct the upper lip, which is closely allied to it. Upper lips can tilt forward from the underside of the nose, drop straight down or even lean backwards. Study the profile of the model carefully. Observe the angle you have to produce and model the shape in profile, noting also from which part of the fraenum the lip emerges. It can be located at the very back of the nose or emerge from the centre of the fraenum. Build the lip downwards with tiny clay sausages and pellets, adjusting the angle and adjacent fullness as you proceed. Make sure the lip is balanced on both sides.

One of the most common mistakes when modelling this area is to make what you know best – your own upper lip and mouth – and not 'see' the subtleties of the model's mouth. Check carefully!

The fleshiness of the upper lip area will create the actual lips. However, the line formed by the lips touching should still be drawn on the clay. Check the width of the mouth and the distance from tight under the nose to this horizontal line and ensure its accuracy, as any small discrepancy in the height of the upper lip will immediately take away the likeness to the model.

Looking at the profile, build the clay forward for the lower lip to meet the upper lip appropriately, checking the angle of the lower lip and its fleshiness. With a small modelling tool, carefully curve the top surface of the lower lip downwards, creating the shape you can see. Similarly, compare the shape of the underside of the upper lip and reproduce the contours sensitively.

From the front, fashion the centre of the lip area, adding fullness with tiny pellets of clay. Observe the projection of the chin in relation to the nose. Reproduce all contours both in profile and from the front.

The corners of the mouth can be tricky to reproduce. Spend time examining them thoroughly, then use curved-ended modelling tools to replicate them.

Once the mouth area is complete, consolidate the jaw, chin and under the chin and note how that area extends to the neck.

EYES AND EYELIDS

Lively eyes bring animation and expression to a portrait. They are best modelled by creating separate eye sockets and eyeballs then building eyelids over them. This creates a good profile, showing the natural curve around the eyeball, and establishes the various dark shadows that bring a portrait to life.

Measure the distance from the eyebrows to the cheekbone to ensure you have left sufficient space for the eye socket. Using a fairly large, round-shaped wire tool, gouge out each socket from just below the eyebrow to just above the cheekbone, deep enough to receive a spherical eyeball.

Make two similar spheres of clay approximately 1 in (2.5 cm) or slightly less in diameter. Place them lightly and centrally

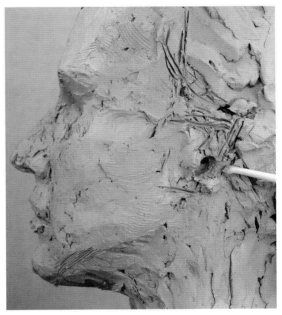

Fig. 139 Profile. Note start of nose beneath the eyebrow, protrusion of nose, shape of upper lip, development of lower lip, chin and jaw line (with ear hole clearly marked)

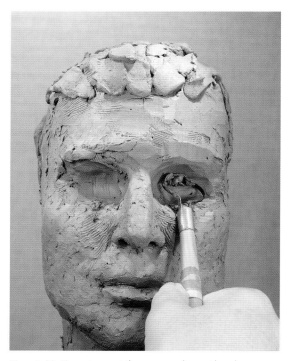

Fig. 140 Gouging out the eye socket with a large, round wire tool

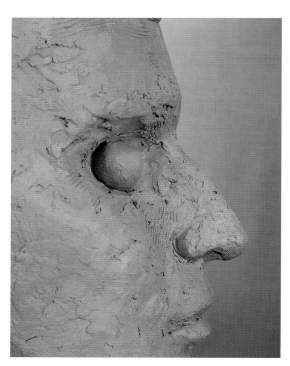

Fig. 141 Profile, with eyeballs being checked for correct depth

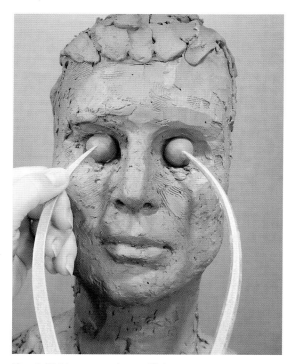

Fig. 142 Measuring the width between irises

into the sockets and view the work from both profiles to see whether they sit inside deep enough, i.e. below the top profile of the nose – ensure the model is sitting in profile for this. If the spheres are too prominent, remove the eyes and deepen the socket or cut away a facet from the back of the eyeball and try again. Make careful comparisons with the model. Is the curve of the eyeball, as located, correctly set against the protrusion of the nose at this point? When you are totally satisfied that the profile views of the eye are correct, give each eyeball a little twist to secure them.

Measure with callipers the distance between the model's irises, i.e. the distance between the centre of the eyeballs. Compare this distance with the clay eyeballs you have placed. You may need to roll them to the left

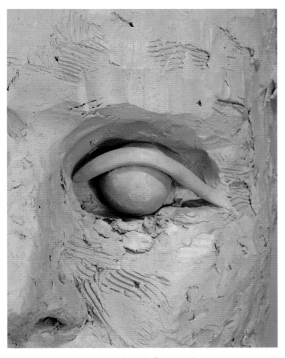

Fig. 143 Making eyelid with flattened clay

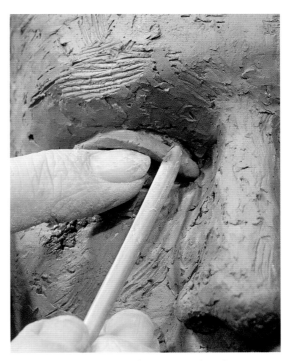

Fig. 144 Supporting the clay as it is placed

or right to locate them accurately. Be sure they are level and equidistant from the nose. Remove any 'iris' marks you may have made on the clay eyeball with the callipers as these give the impression of staring. Measure the inner corner of the eye on either side of the nose and mark this distance on the clay. Do the same with the widest part of the eye and mark this extremity also

Using flexible clay which does not crack as you bend it, make a ⅛ in–¼ in (3.2 mm–6.5 mm) thick sausage for the upper lid, flatten it slightly and lay it across the eyeball from marked corner to corner, touching the clay gently onto the eyeball. With the help of a small wooden modelling tool, shape it to the same curve as the model's eyelid. Smooth a section of the back of the eyelid to the eyeball to secure it in place.

The upper eyelid area needs to be filled in and built up with tiny horizontal sausages of clay. A young person will have firm, rounded and more fleshy shaping here than an older person. The final shape of the eyelid can be adjusted with very small modelling tools as you build in the eye detail.

Make the lower lid in a similar way, noting how this is set slightly inside the upper one, and develop the flat facet dropping below the eye and onto the cheek. To indicate 'bags' under an older person's eye, fairly wet clay can be 'dragged' appropriately below the eyes. Compare with the model at all times.

You will now be able to construct the remaining detail of the area below the eye, which follows the curve over the lower part of the eyeball. Blend the area into the cheeks and

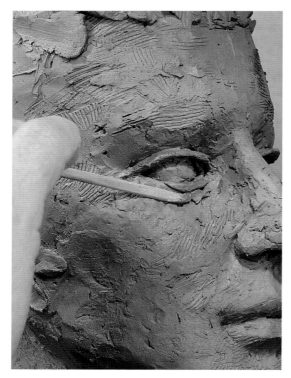

Fig. 145 Profile of clay showing lower eyelid construction and its relationship with the cheek

Fig. 146 The ear hole and drawing showing proposed ear placement

generally refine and fill the contours of the nearby nose and cheeks.

To create the impression of eyelashes and give added shadow to the eye, add another thin and flattened sausage onto the front of the original eyelid, extending it forward. As you add this clay, support it with your finger and model it into a thin blade, blending it into the existing eyelid.

The corners of the eyes will have deep holes that drop down beside the eyeballs. Fill these to remove the very deepest depression but leave enough depth to create a shadow in the eye. This will be very life-like when cast.

To add character, once the head is more or less completed, small 'crease' lines can be drawn onto the clay with a very fine tool or knife, if they exist on the model. These might be at the corner of the eye or elsewhere on the face, but smooth them over if they look wrong.

EARS AND TROUBLESHOOTING EARS

As with the other facial features, the ear should be fashioned to look exactly like the model's. The ear hole you have been using as a measuring point needs to be developed to be similar in size and shape to the model's ear hole, dropping diagonally into the head for about 1 in (2.5 cm). At this point you can form the little tragus, the cartilaginous protrusion above the earlobe in front of the hole.

Note the angle of the model's ear against the head and draw a similarly angled line on the clay. Measure the length of the ear and mark this also. Check the relationship between the top of the ear and the eyebrow and how it relates to the nose to ensure the ear is placed correctly.

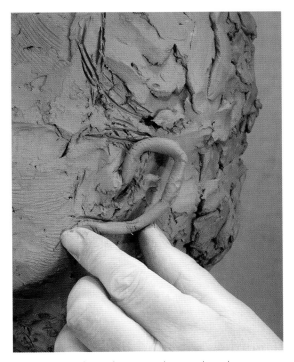

Fig. 147 Ear-shaped sausage being placed

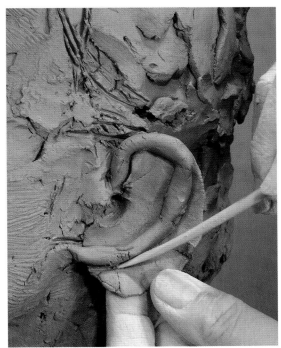

Fig. 148 The sausage and oval will 'weld' together

To form the ear shape, roll a sausage of flexible clay about 4 in long x ¼ in diameter (10 x 0.65 cm) and attach one end of it inside the ear hole. Extend the sausage round to the top mark on the clay and down to the bottom mark, pressing the sausage onto the clay to temporarily secure it. You should see an ear-shaped sausage at the correct angle and of the right overall size.

Press out a small lump of clay in your fingers until it is thin, flexible and oval-shaped. It should be slightly larger than the ear you have delineated. Leaving the sausage secured at the top and bottom of the embryo ear, release the curved area and support it in the fingers of your left hand. Slip the flexible oval of clay behind the sausage and touch the sausage onto it. Still supporting the ear with your fingers, use the blade of a small modelling tool to cut away the excess of the thin oval along the ear-shaped sausage. The sausage and oval will weld together and the ear will stay in place. This operation is quite simple, although a little complicated to describe in words!

To develop the back area of the ear, make a small rectangular block of clay about 2 in long x ½ in wide x ⅜ in thick (5 x 1.25 x 1 cm), bend it into a curve and slip it behind the ear, modelling it firmly, with a tool, to the head on one side and to the ear on the other. Ensure it resembles the shape of the back of the model's ear and is not too thick. Cut away any excess clay. This additional bulk will enable you to reproduce the inside contours of the ear with modelling or small wire tools, referring constantly to the model. You will find the clay ear structure to be remarkably strong.

Fig. 149 Ear wedge inserted

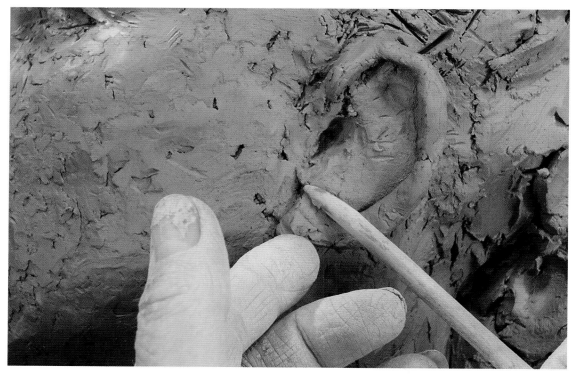

Fig. 150 Beginning the shape of internal parts
of the ear

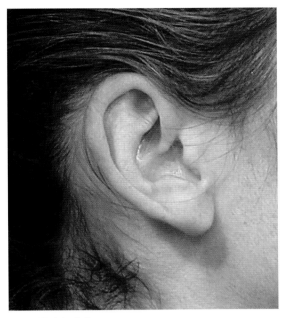

Fig. 151 Model's ear

Fig. 152 Detail of modelled ear

Take advantage of the flexibility of the ears and adjust their angle away from the head so that they project similarly to the model's. They feel remarkably like real ears in the way they move!

Make absolutely sure that the ears are at the same height and position on the head – Look again from above. If you complete the second ear having forgotten to check the height and position of the first and discover one is out of line with the other, you can move the whole ear virtually unscathed. Take a sharp knife and cut down behind the ear, close to the head. Hold it carefully in your hand and, having flattened the area to receive it, carefully place it in the correct position, joining it to the head with a modelling tool and making any necessary repairs or adjustments to the hole and the ear itself.

If the ear is too tall or wide, slice away the rim until it is correct, make another small sausage, a similar width to the adjacent one, and place in the correct position.

Once the ears are completed, many of facial details in the jaw and neck areas can be adjusted and improved where necessary

NECK

The neck develops gradually throughout the modelling of the head, but once the ears are in place the structure of the neck can be completed. Develop the muscles you can see on the model, extending them to the collarbone area, and decide exactly how you wish to finish the head – either at the bottom of the neck or in an extended shoulder area. Complete the bottom of the neck area tidily so that the portrait has a definite 'finishing line'.

HAIR

The hair shape will have been roughed out and developed with the overall head structure but needs to be finished in its own right once the rest of the portrait is complete. In order to enable the sculptor to see the detail of the head and face, the female model will often tie her hair back. Once the portrait is completed the model can free her hair so that it can be modelled in its usual style.

Confirm the height from chin to crown, chin to forehead hairline and from the hairline to the topmost point of the model's hairstyle in the front. Build the hair up above the forehead if necessary and develop any additional shapes or heights visible, taking into account the contours of the skull. If the hair drapes over the ears it is better to sweep the clay across a modelled ear (where you know the quality of the modelling is excellent) than overlay a large amount of clay with no structure beneath.

Some people cannot decide how to tackle the finish of hair in clay. Do not use a comb to scrape the clay into shape! It does not work having masses of parallel lines, which have obviously been made mechanically, compared to the rest of the portrait, which has the marks of your modelling techniques imprinted upon it. Slipping soft clay along with your thumb in the direction in which the hair flows will give a natural sweep, and building up height with the use of additional clay in the same way will all look right. The occasional lift under the clay with a tool will add shadows to the hair. Some experimentation is necessary to find a technique that works for you. I always feel that a little artist's licence is acceptable when modelling the hair, especially as the hairstyles of those with longer hair often change slightly from day-to-day.

FINISHING

Create a neat edge to the bottom of the portrait, whether you have just modelled the neck or a collar and shoulders. It does not have to be straight.

Stand back and check the whole structure of the portrait again for accuracy. Re-take measurements if something looks wrong and sort out any discrepancies. Move close in and compare your model with the detail you have been reproducing. Always use the model whilst doing this, as otherwise mistakes will be made.

COMMENTS ON MODELLING SPECTACLES

Although modelling and casting spectacles can be achieved successfully in bronze it is not possible to add these to a clay portrait that is to be cast in plaster and *ciment fondu*, except by inference. You can overlay small sections of the shape, for example the bottom of the frame against the cheek or eyebrow, to give an indication that the model normally wears glasses, but that is all. On a bronze portrait an actual pair of glasses is often cast separately and then added to the portrait at the end. Even this can look unnatural, as, again, it is a commercially made object placed on a hand-modelled portrait.

7 Photo Gallery Two: Diggy in clay

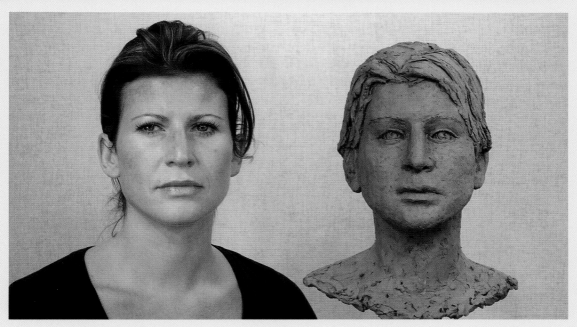

Front view of model and clay

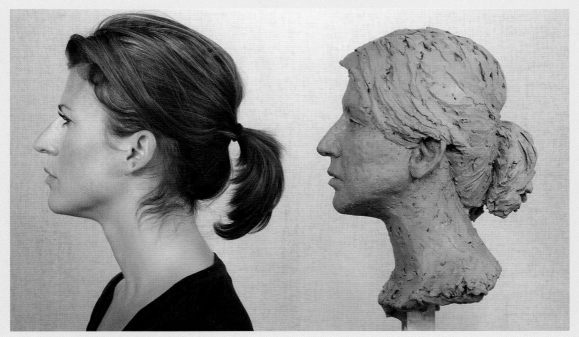

Profile of model and clay

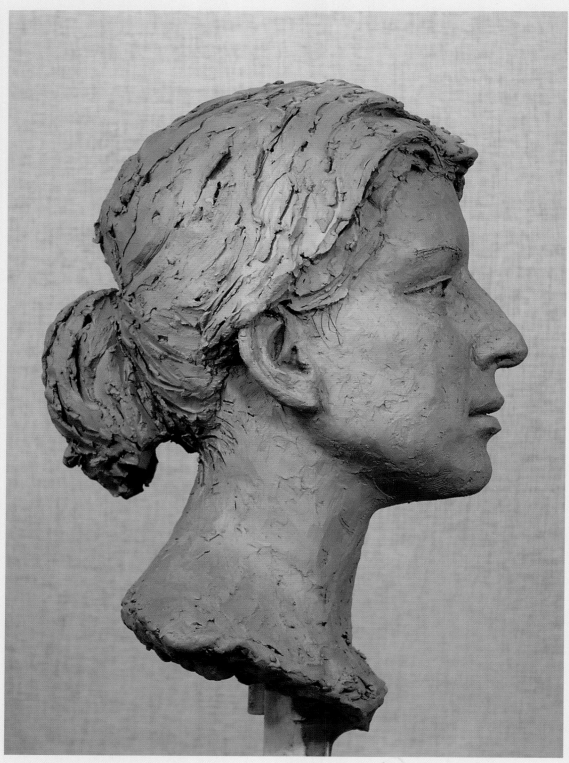

Right profile

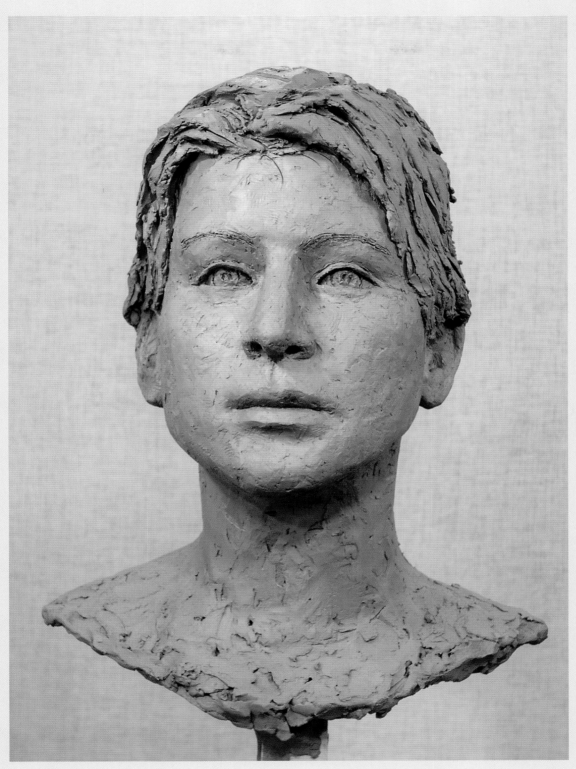

Front view

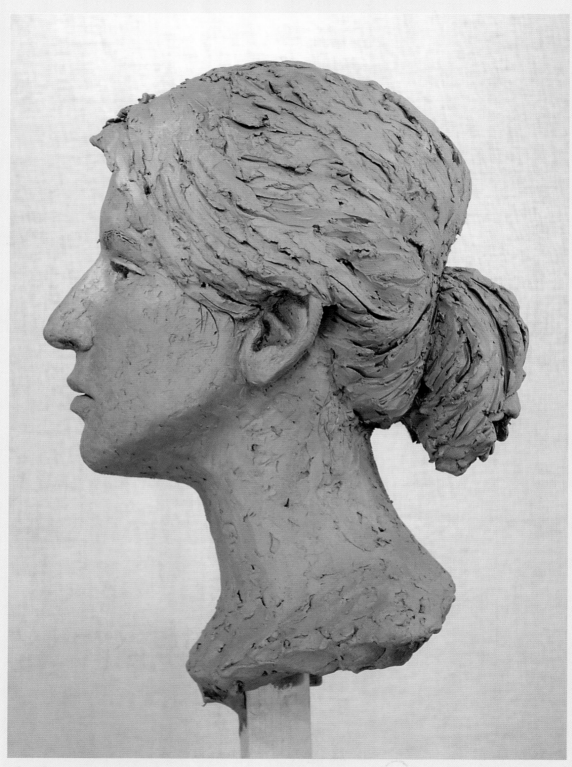

Left profile

Making a Two-piece Plaster Waste Mould

1 Introduction

This chapter gives you a step-by-step explanation of how to make a mould of a portrait head and this introduction outlines the processes before the more detailed instructions that follow.

The mould is known as a 'waste mould' as it is used just once and then chipped away to reveal the cast material below. A portrait head is normally moulded in two halves: front and back. The clay modelling is divided vertically with a narrow band of clay placed all round the head, from the bottom left-hand side of the sculpture, up and over the hair and down the other side. This clay 'wall' is made from rolled-out firm clay strips pressed into place. Its location is critical as it allows the front of the mould to be removed without hindrance when it is opened as it contains no deep undercuts, whereas the mould of the back of the head contains all the large undercuts and 'locking' features (such as the ears and hair etc.) that would prevent the mould from being opened smoothly.

The front half of the portrait is moulded first. Dental plaster is prepared and applied to the face and the front of the clay wall. The plaster is applied in two layers, the first of which is coloured. The colour indicates the area close to the surface of the portrait that, during the chipping away of the waste mould, needs to be removed with care to prevent the tools from damaging the head. The second, usually thicker, top layer is white and is built up to give the mould sufficient strength and thickness to support the casting material used later.

To prepare for the second half of the mould, the portrait is turned so the back of the head faces the front to expose the clay. Before the plaster is prepared, the clay wall is removed so that the plaster for the back mould will be applied directly onto the head and

onto the newly visible seam surface of the front mould. After the clay wall is removed and the front plaster seam is revealed a clay wash is applied to the plaster surface, which will act as an excellent separator of the two parts of the mould. Then the back of the head is cast using the two-layer plaster process described above.

Great emphasis will be given throughout the explanation to the cleaning and exposure of the seam line dividing the front and back sections of the mould. This is because even the tiniest amount of plaster bridging this line will prevent the mould from opening when it is completed.

Materials required for making a two-piece portrait mould
55 lb (25 kg) sack of fresh dental plaster
Blue poster colour or small tube of blue watercolour paint
Plastic washing up bowl with flat bottom
Newspaper
Rolling pin without blemishes or surface faults
A flat-bladed old dinner knife or similar, without serrations
Water spray bottle
½ in (1.25 cm) blunt wood chisel and wooden or nylon mallet
Steel straight edge 18 in (46 cm) or so
Dental and small modelling tools and scribe to remove clay
Pottery clay cutter to remove clay (optional)
Strong string
1 in (2.5 cm) household paintbrush
Plastic sheeting for bench/floor protection
Large sink or old zinc bath
Dustpan and brush and bin
Brass shim (if using, measure length around head)

2 Preparing a Plaster Mould

BRASS SHIM WALL

Thin brass strips, known as brass shims, have traditionally been used as a way to divide up clay models for casting. Although this system can be employed for a portrait head it is usually chosen for more complex sculptures that need several 'caps' or part-moulds to cover larger areas.

Brass shim, available in a variety of widths, can be cut into triangular-shaped pieces and inserted into a clay head in a similar location to the clay wall; plaster is cast around it, then

the shim is removed with pliers. However, I find that shim leaves an uneven and rather thick, protruding 'flashing' on the finished cast, which often creates a lot of remedial work and can leave a 'scar' on the portrait. I shall therefore describe in detail my preferred method of using a clay wall.

CLAY WALL

The clay wall forms the barrier between the front and back of the modelled head and enables the moulding to be done in two sections: the front and the back.

Protruding ears, with their undercuts and internal shaping, and some parts of the hair create 'keys' that hold the clay tight inside the mould so that, in due course, the mould cannot be removed. It is essential, therefore, that one mould section is produced in such a way as to be completely unrestricted from being lifted from the clay when the two halves are separated. If the clay wall is placed correctly, the front section can be removed first without constraints.

The back mould will be left with the undercuts and the head peg still in position. In due course, the clay here will be cut away manually to prevent the undercut features from being damaged. These undercuts are, therefore, always located behind the wall.

To prepare the clay wall, roll out a slab of clay to about 16 in (41 cm) square and ½ in (1.25 cm) thick. Using the straight metal edge, cut the slab into 1½ in (4 cm) width strips. These are easily handled when placing them around the head and can be cut to specific lengths and joined together as required.

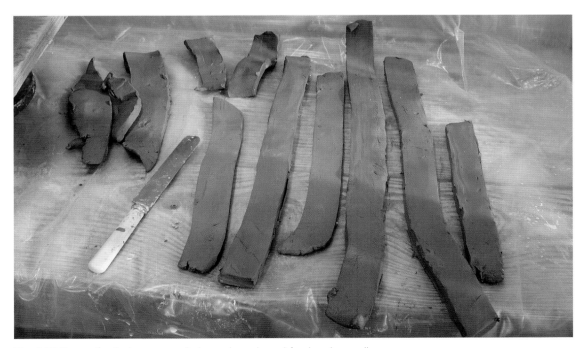

Fig. 153 Strips of rolled, untrimmed clay to be selected for the clay wall

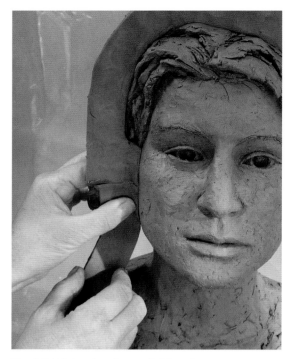

Fig. 154 Fixing the clay wall. Note finger pressure marks that need to be removed before moulding

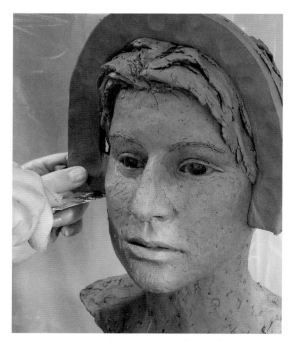

Fig. 155 Note gap below clay wall on left, close to the eye, to be pressed down

Starting at the top of the head, near the front of the portrait, hold a strip with both hands close to the modelling and gently press it down onto the clay head until it stays in place. The dampness of the clay wall and the head will be sufficient to hold the two parts together. Do not add water to bond them.

If the curve of the top of the head is such that the clay wall looks as though it will split apart as it is being applied, it is best to cut the clay wall with a knife to three-quarters of the way down the strip to allow this to happen cleanly and leave an open 'V'. Continue placing the strip and then fill the open triangle with a triangle of similar size and thickness and carefully smooth the join so that the wall front is completely unblemished.

Continue in this way, placing the band over the hair, down the face in front of the ears and around the back of the cheeks, pressing the wall as close as possible to the clay modelling so no gaps or light can be seen.

Once the clay wall reaches the jaw, allowance has to be made for the inset of the neck. Cut a strip of clay that will reach from under the jaw to the base of the neck and widen it by adding another strip along-side. It needs to be 'tailored' close onto the neck and the total width of the band should end up matching that of the outside edge of wall, down to, and including, the shoulder line. Join the clay wall and the widening strip cleanly. The front surface of the whole clay wall needs to be smoothed to remove any finger marks, indentations or burrs anywhere on the clay.

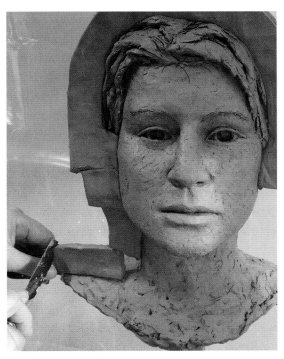

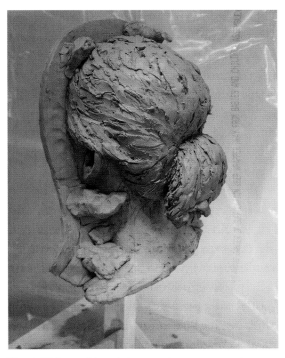

Fig. 156 Clay wall being inset and tailored to neck area. Note gap under clay wall, close to the eye, that still needs closing

Fig. 157 Rear of head showing buttressing and cut curve of clay wall

BUTTRESSING

To ensure the clay wall cannot collapse or be inadvertently knocked down whilst the plaster is being applied during casting, clay-wedge buttresses must be put in place.

Using scrap pieces of clay, make triangular wedges and push them carefully onto the head, behind the clay wall and attached to it. The wedge should be about ¼ in (6.5 mm) below the wall height so as not to interfere with keeping the cleanliness of the seam line later. They can be placed in vulnerable areas at about 8 in (20 cm) intervals around the back of the clay wall. Because of its shape, this buttressing will stay in place and does not need 'fixing' down hard. Larger buttressing triangles of clay will be needed in the neck area where there are taller sections of clay wall.

CUTTING 'KEYS'

At the top of the centre and at either side of the clay wall, cut a 'key' with a wire tool as a means of ensuring the two halves of the mould will later fit together accurately; just scoop out some clay, leaving an oval indentation of about ¼ in (6.5 mm).

Before proceeding with the plaster casting check again that you have removed any clay burrs, small holes or blemishes that you can see anywhere on the face side of the clay wall and around the 'keys'.

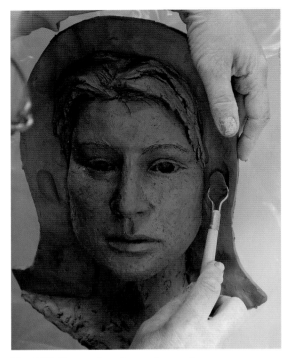

Fig. 158 Cutting 'keys' into clay wall

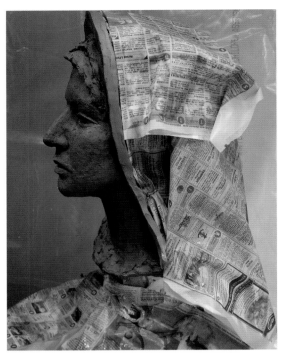

Fig. 159 Rear of clay and head peg board covered with newspaper

With the clay wall complete, cover the back of the head with newspaper sprayed lightly with water to encourage it to sag and 'hug' the clay closely. Tuck the paper as close to the wall as possible, covering the ears, hair, neck and head peg, where exposed, to protect it from plaster splashes and a lot of cleaning off later.

3 Introduction to Using Plaster

Only use fresh dental plaster for making a mould for a portrait. Builders' plaster is unsuitable because it is coarse grained, too soft and will not show the fine detail required.

Once mixed with water, plaster begins to harden quickly. It changes texture from runny to 'single cream', to 'double cream', to 'marshmallow' and then to a crumbly texture before finally hardening; all this can happen within 2 or 3 minutes! At the crumbly stage the plaster should be discarded and another lot mixed. This means you need to work at a fairly fast speed.

Once the plaster layer is completed, clean the bowl thoroughly and remove any remaining crumbs of plaster with a knife before washing both thoroughly. Dry plaster left on the bowl can make lumps in freshly mixed plaster that needs to be smooth and creamy. A smooth, flexible plastic bowl will enable you to bend the sides sufficiently to loosen set

plaster and remove it as you prepare for the next stage. Ridged bottomed bowls make removing hard plaster difficult and time consuming.

Do not put any plaster down the drain; it will set and cause a blockage.

4 Moulding a Plaster Head

MIXING PLASTER, THE FRONT MOULD

When mixing plaster, always add plaster to cold water; warm water will accelerate the hardening of the plaster.

For the front half of the portrait, fill approximately a quarter of a bowl with cold water. The amount will vary according to the size of the head and you will need to assess the quantity of water you need as you work. Be aware that plaster will bulk up the water by at least half as much again as you add it. Colour the water by adding a teaspoonful of blue poster powder or watercolour from a tube and mix thoroughly to create bright blue water with no lumps from the colorant. Make sure the bowl is well supported on the bench or a lower table as you prepare the plaster mix.

With totally dry hands, open the plaster sack and fluff up the material to some depth to thoroughly loosen it. 'Sieve' the powder through your fingers into the bowl so that it falls evenly over the water across the whole bowl, keeping your hand dry at all times. Continue adding plaster in this way, without stirring, until the plaster appears evenly distributed across the bowl and you can see it lying just below the top of the water. Close the sack of plaster, remembering that the introduction of any dampness to the sack will ruin the contents.

Place the bowl on the bench, close to the modelled head, and mix carefully with your hand. Do this below the water surface to prevent the introduction of bubbles. Gently incorporate the plaster so there are no lumps and until the plaster is of single cream consistency. It will look thin and creamy on the hand. If it looks transparent on the hand it is too thin and you need to wait a short time for it to thicken slightly before use. If you think the plaster you have mixed is too thin, do not add new plaster at this stage; it will harden at a different rate to the first plaster and create lumps that will be difficult to remove before the plaster sets.

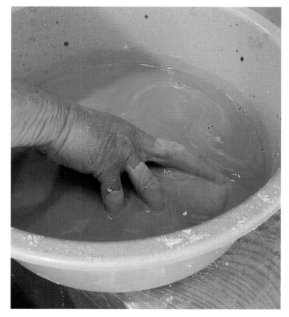

Fig. 160 Mixing first coat of blue plaster

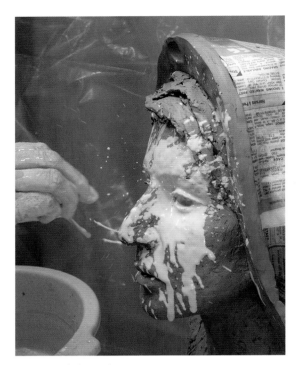

Fig. 161 Flicking plaster

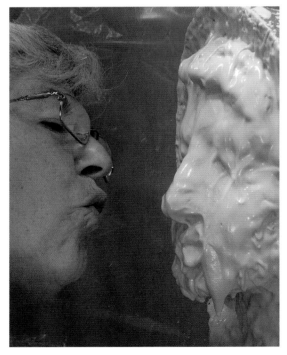

Fig. 162 Blowing plaster into undercuts and deep areas

APPLYING THE BLUE PLASTER COAT

The blue layer of plaster is the most important as it records all the fine modelling detail you have worked on over the entire surface of the portrait. The plaster will record everything, so you should apply this material as accurately and attentively as possible.

Holding the bowl close to you, flick the plaster onto the clay so that it adheres and travels. If it runs thinly down, like milk, wait a few moments, without mixing, for the plaster to thicken slightly. The material should adhere to the clay and be mobile but definitely look like single cream. Try not to touch the clay itself at this point, as you will leave marks that will show on the mould.

Flick the plaster all over the clay and ensure it reaches into every nook and cranny; blow it up into the nostrils, under any hair overhangs and especially deep into the eyes and under the chin. The flicking action ensures that the plaster impacts on the clay, forcing much of it into the lines and modelling marks. Include the whole of the clay wall in the flicking. The area under the chin is complicated as the weight of the plaster makes it want to sag; you must make sure that large air spaces beneath the chin do not develop. Allow the initial thin plaster to bond onto the clay, then add more layers.

As the plaster thickens and once the whole surface has been covered with the creamy plaster, slow down slightly and thicken everywhere you have covered, not forgetting to include the whole of the clay wall, to the top edge. If the plaster is still mobile you can continue to blow needy areas.

The 'marshmallow' texture of plaster is the most useful as it can be trailed and

dribbled strategically to reinforce the first layer in the most vulnerable places. You will be in complete control of where you put the plaster and how thick it is at this stage. The top surface of the blue layer of plaster does not need to be smoothed down; in fact, a rough surface is useful to key in the second layer.

As soon as the blue layer is completed, clean the top edge of the clay wall seam before the plaster gets very hard. Use the blade of a kitchen knife, holding it with two hands horizontally over the top of the clay wall. Start at the top of the head and use a dragging, not a cutting, action to drag off all the spattered, excess plaster from the top of the wall all the way along to the very bottom until it is clean clay again and the top surface is still horizontal. Start again at the top of the head and do exactly the same down the other side. Clearly

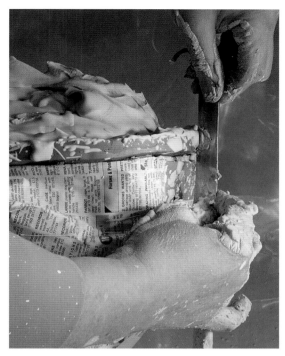

Fig. 163 Cleaning the seam. In this illustration the seam line is in front of the clay wall, but very thin

expose the seam line right around the head. It will show as a positive thin brown line on the face side of the head just behind the blue plaster. There must be no plaster anywhere across the seam.

APPLYING THE WHITE PLASTER COAT

The second coat of plaster is left white. It is mixed more thickly than the blue first coat as all the fine detail has been filled and this layer is just to reinforce and thicken the mould.

Fill the bowl a with a little more cold water than before and, with dry hands, sift the plaster through your fingers until it appears evenly across the bowl just on or very slightly above the surface of the water. This plaster should have the consistency of double cream when mixed.

As all the facial detail is now covered with blue plaster, you can flick the thicker plaster directly onto the roughly finished blue layer, efficiently filling up hollows and creating the overall thickness required, including the clay wall, so that it is strong.

Once the plaster is the consistency of marshmallow you will be able to trickle it again, so that it runs slowly and then stays in place. Ensure that the build up is even and thick, especially over the nose area and under the chin. As discussed earlier, the area under the chin is tricky and the plaster needs to be built up in layers as it changes consistency. It may want to drop away in places, leaving big air holes.

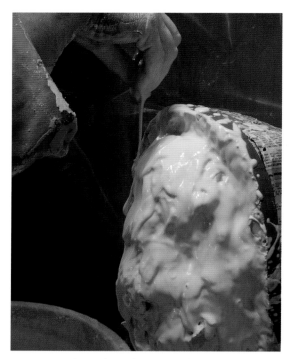

Fig. 164 Trailing white plaster over the blue layer to the top of the clay wall

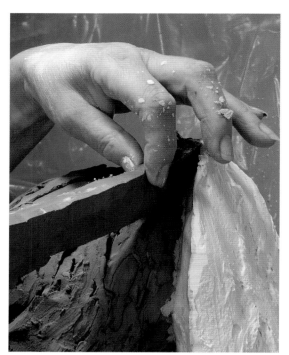

Fig. 165 Removing the clay wall

At the seam line, the plaster should be built up to the same height as the clay wall and extend forwards, to finish well in front of the nose area; it is better for the mould to be too thick than too thin. Finish the mould with a smooth surface all over.

After this application, clean the seam again so that the brown clay wall is clearly visible all the way around the portrait.

REMOVING THE CLAY WALL

Turn the back of the head towards you. Carefully remove all the protective newspaper from the clay and any rogue specks of plaster that may have spattered onto it from the front.

Starting from the outside edge of the mould at the top of the head, carefully peel away the clay wall from the plaster all the way around the mould and, using an upward motion to prevent any damage to the portrait, lift it off.

With a small wooden modelling tool, gently remove any plaster that may have run onto the back half of the portrait. Then concentrate on the surface of the newly exposed plaster wall and remove any roughness or projections; ensure it is completely smooth all over, right to the very edge of the seam. You can use a modelling tool or your thumbnail to do this. Do not rush this operation, as it will ensure an easy opening of the mould later.

Fig. 166 Removing any plaster runs

Fig. 167 Preparing the wash in a clay 'bowl'

THE CLAY WASH

The clay wash acts as an effective separator between the two halves of the mould and should be applied carefully to the plaster wall after the clay wall has been removed. Make a small clay bowl in your hand and pour in a small quantity of water. With a 1 in (2.5 cm) paintbrush, make a creamy slurry and paint this along the entire face of the plaster wall, right to the portrait edge. It does not need to be very thick, but it must be obvious everywhere. The back of the portrait can now be moulded.

THE REAR MOULD, BLUE COAT

The rear of the head is more complicated to mould as it contains all the major undercuts. It is therefore essential to be aware of each area that needs special attention before the application of the blue plaster layer starts.

Fig. 168 Painting wash onto the seam

Assess the position and complexity of the ears, the ear hole and the area behind the ear and just how close each of these places is to the front mould. The plaster must fill all these hollows, holes and fissures, without air bubbles, so plaster will need to be flicked and blown into all these parts to ensure they are thoroughly filled and covered. The surface can then be backed up with further plaster to reinforce the layer, as before.

Check other areas that will need particular attention. In the case of my model, the over-hang and undercut of the pony tail needed plaster to be flicked and blown upwards to ensure that adequate plaster covered the fall of hair, without air pockets. This type of area needs to be covered well as it would be a pity to lose any shaping so carefully worked in clay. It is worth spending time blowing plaster to fill gaps to ensure the detail remains. Plaster blown under and along modelled hairlines will guarantee that the detail of your work will stay clearly visible on the plaster mould.

The application of the blue layer of plaster is the same as for the front half of the mould but more water and plaster will be needed to allow for the larger mould. Use about half as much again of water this time, colour it and add the plaster to just under the surface; mix to a single cream consistency. Deal first with the ear areas and any other awkward places that need special attention, then continue with the rest of the back of the head, blowing along hairlines etc. Flick the blue layer onto the (now plaster) clay wall, right up to the top, so that the whole seam is covered.

Fig. 169 The ear and under the hair filled first with the blue coat

When all the blue plaster has been used, clean the seam all round the mould immediately, exposing the thin brown line that clearly indicates the clay wash between the two halves of the mould. You should see this extending end to end around the entire head. Do not overlook the very end of the seam line, at the shoulder area.

THE REAR MOULD, WHITE COAT

Make up the white plaster with half as much powder again as the previous blue plaster coat, add plaster powder to just above the surface of the water and mix to the thicker, double cream consistency.

Start in and around the ear areas again and deal with any other awkward areas whilst the plaster is still loosely mobile.

Thicken the back of the head with plaster and, as the plaster assumes the marsh-mallow texture, slowly build up the entire

back area, coming forward from the (now plaster) seam line horizontally. Make sure the whole back area is well covered and leave the final surface smooth and rounded. If there is any spare plaster (before it goes hard), you can reinforce any parts of the front half of the mould that you might consider a little thin.

Clean off the entire seam again before the plaster goes hard. A clear brown line from the clay wash must be visible all around the seam line. If it is not, you must use the knife in the way previously described (see page 169) to expose it, even if you have to dig down to find it.

The plaster can now be left to dry and, as it does so, it will begin to heat up. Cover the whole mould with a damp cloth and leave it until it is completely cold – about 30 minutes to 1 hour.

Fig. 170 The brown seam line should be obvious all round the plaster

OPENING THE MOULD

Once the plaster is completely cold it will be hard and the mould will be ready to open and the internal clay removed. This is one of the most exciting stages of making the portrait.

Remove the newspaper from around the base of the head peg, exposing the wood. Take the plaster, with the head peg, to the sink and lower it carefully into it, so that the plaster seam line is in line with the tap. Run water slowly onto and along the seam line; use your hands to push the water along the length of the seam. As the water flows it will gradually swell the seam line clay wash and push the two halves apart.

Encourage the water to seep into the gap; this will help the front mould section to slide downwards and away from the clay

Fig. 171 Water running on closed seam line

Fig. 172 Mould just beginning to open (1)

Fig. 173 Progress of opening mould (2)

Fig. 174 Mould opening (3)

Fig. 175 Mould open (4)

inside until, with a little guidance from your hands, it finally comes completely apart from the back section, leaving the clay within almost intact.

Remove the plaster from the water and pull away the wet clay from the inside of the front mould. Wrap the mould in a wet cloth; it must stay damp at all times.

EMPTYING THE MOULDS OF CLAY

The modelled clay inside the rear mould is now revealed and needs to be removed. As the back of the portrait contains all the undercuts, you will need to remove the clay with various wire and beechwood tools. You will also need to remove the armature. All the plaster projections you see on the inside surface of the plaster mould are the deeper details you have carefully modelled onto the clay, so you need to protect them. It is essential that, as the clay is removed, you do not damage these points. Place the mould on a wet cloth as you work to keep it moist.

The cheese wire with handles on both ends will quickly slice away the face of the portrait. Thereafter, remove all the clay inside the armature, down to the top of the upright wood support, with wire or modelling tools. You can also cut away any clay on the outside of the armature that you can reach without damaging the mould.

With small up and down movements from the neck end of the head peg, loosen it, then slowly ease the metal away and pull the whole armature from the clay. Avoid twisting the

Fig. 176 Front of clay face being removed with the cheese wire

Fig. 177 Wire tool excising clay to expose the armature

Fig. 178 Removing the armature from the mould

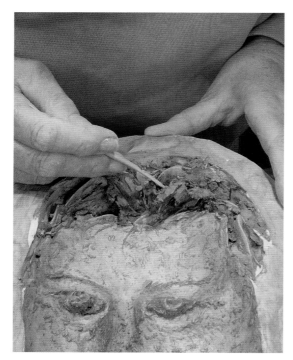

Fig. 179 Clay being picked from the mould with a small wooden tool

armature in such a way that the metal wire damages the inside of the mould. If the armature is reluctant to come away you may need to remove more clay from the sides of the mould.

Once the armature has gone, all the rest of the clay can be removed carefully. Sit down, since every particle must be picked out of the mould. Dental and small modelling tools are excellent at this.

Clay sticks to itself, so any small bits that remain in the mould, especially along hairlines and round corners that are more or less inaccessible, should be dabbed with pellets of clay shaped to fit into those places. The seam lines should be included in the cleaning so that no clay wash remains.

Delicate areas, such as inside the eyes and eyelids, nostrils and ears must be cleared very carefully so that the plaster projections and undercuts (which could be the eyelids) are not broken by clumsiness. Beware of washing out the mould. Surprisingly, much damage can be done to the fragile modelling by doing this, and the clay smeared in the process is more difficult to remove.

The idea is to leave the mould absolutely pristine. Any clay that is left inside the mould will prevent that area from being cast fully in *ciment fondu* and an undetailed section will show in the portrait.

If the mould is to be unattended for any length of time it should be wrapped in wet cloths.

OILING THE MOULD

Once the mould is damp, clean and ready for casting a separator needs to be added to prevent the *ciment fondu* from adhering to the plaster and to allow a clean chipping out

of the head. Soft soap is often used for this purpose and is quite effective. I prefer the use of linseed oil (boiled or raw), as this is lasting and very stable.

Pour some oil into a small bowl. Using a clean 1 in (2.5 cm) household paintbrush and a very small amount of oil, paint the surface and all the undercuts of the plaster so that there is just a bloom of oil upon it. Do not leave any puddles as these will spoil the final surface of the cast and such a volume of oil is unnecessary. Include the seam line in the oiling, which will help with the final chipping out of the waste mould.

Once the two halves of the mould are oiled they should be fitted and tied together while still damp to prevent the plaster from warping. The locating keys that were cut into the seam area will come into operation here and the two surfaces will lock accurately together as a result.

TYING THE MOULD TOGETHER

Cut two lengths of strong string that will easily go all around the plaster and wet them under the tap so they will shrink. With the mould lying safely supported on the bench, wrap the string around the centre of the two halves. With a sharp knife, cut a notch into the plaster directly beneath the string on the highest and thickest areas, e.g. the seam lines, centre back or centre front of the plaster, and tie and knot the string tightly so that it drops into the notches. This will prevent it from slipping off the curved mould. Repeat this process further down the mould. The tied mould should be covered with wet cloths to stop it warping until the casting takes place.

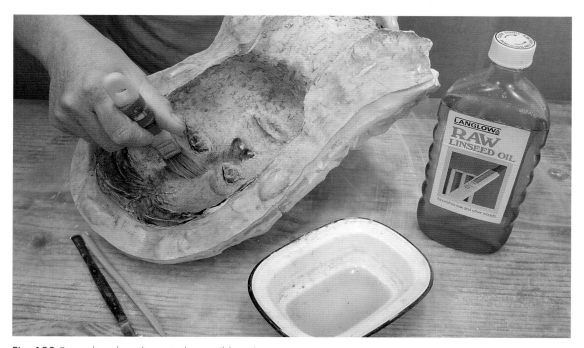

Fig. 180 Spreading the oil sparingly to a 'bloom'

Casting a Portrait Head in *Ciment Fondu*

1 Introduction

Casting in *ciment fondu* is a popular procedure that gives excellent results. It reproduces the finest details of modelling and is a particularly robust medium, even when thin. *Ciment fondu* is a very fine charcoal-grey alumina cement (see alternative colours, page 190). For a portrait head it is mixed with water and laid down in two layers: the so-called 'goo' coat and the aggregate coat. The goo coat is used when runny to give the fine, detailed surface to the sculpture. The second, thicker coat, which is placed behind the goo coat, contains an aggregate that adds greater strength to the cast. The total thickness of both coats required for a portrait head need be no more than ½ in (1.25 cm). Each half of the portrait mould is cast separately and, when completed, the two halves are wired together; the seam line between them is also cast separately. Once the cast head is complete it is left to cure for about 30 hours after which the waste mould (the two-piece plaster 2-part mould) is chipped away, leaving the *ciment fondu* ready for final finishing.

Materials required for casting
The two-piece plaster mould of a head
1 bag very fresh *ciment fondu* (5½ lb/2.5 kg)
Aggregate – silver sand, washed sand or coarse grog (approximately 3 lb/1.5 kg)
Water and plastic water spray bottle
Plastic washing up bowl without ridges

Fibreglass matting (chopped strand mat)
1 in (2.5 cm) household painting brush
Sponge
Old sheet
Plastic protection for floor and workbench
Small wooden modelling tools for occasional use
Old kitchen knife
Strong galvanized wire 12 gauge (2.5 mm) (approximately 7 ft/2.1 m)
Pliers
Small old torch
3 pt/1.7 l plastic jug
½ in (1.25 cm) blunt wood chisel
Small metal file
Tape measure
Wood glue (e.g. Unibond etc.)
Hessian or gauze bandage

2 Order of Work

PREPARING AND LAYING THE GOO COAT

Ciment fondu must be kept totally dry in its closed bag away from water, wet mugs or damp hands. This material is hygroscopic, which means that it will quickly acquire soft lumps that indicate dampness within the material that might render it unusable. Any suspect *ciment fondu* should be tested to ensure it solidifies to a stone-like hardness before casting. Hard lumps in a bag of *ciment fondu* indicate that the material is totally unusable.

To prepare *ciment fondu*, cold water is added to the dry powder and mixed to a single-cream like consistency. (This is the reverse of plaster, which is mixed by adding plaster to water.)

The plaster moulds should be thoroughly damp (but not wet with puddles) before beginning any casting. Dry plaster moulds will immediately suck water from the wet *ciment fondu*, depositing it as dry powder on the surface. It is best to make sure that the two halves of the mould have been wrapped in wet cloths or thoroughly sprayed all over a few hours before casting begins.

Start with the face section of the portrait and prepare to mix the *ciment fondu* in a dry plastic bowl. Have a jug of cold water nearby. Use a dry cup or mug as a measure and place three measures of *ciment fondu* into the bowl. Add water a little at a time and mix immediately and well, incorporating all the powder and water as quickly as possible and

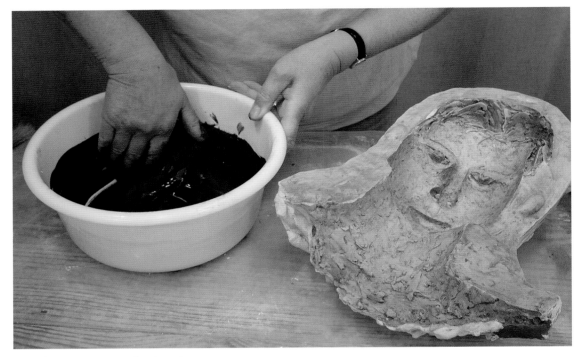

Fig. 181 Mixing *ciment fondu* with water

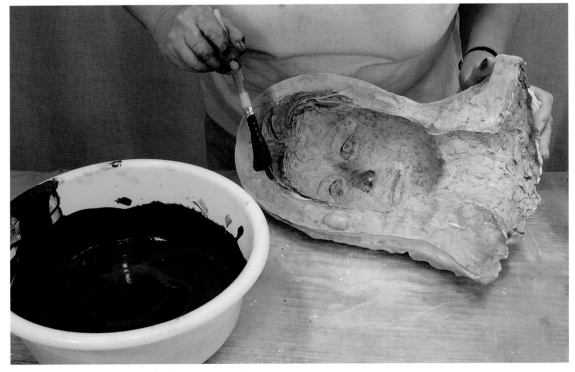

Fig. 182 Stippling in *ciment fondu* to run smoothly

smoothing out any soft lumps created as you go. Keep adding small dribbles of water until a single cream-like consistency is achieved. Very fresh *ciment fondu* thickens quickly after mixing but it will not spoil if water is added in small quantities or water spray is used to control the texture and maintain the creamy consistency.

It is possible to hold the plaster mould on your lap as you add the *ciment* if you prefer not to stand at the bench. Holding the mould comfortably will give you the flexibility to roll and turn it about as you introduce the goo coat and will encourage the runny material to flow into all the recesses. Right-handed people should work from the right to the left of the mould to be able to see and control the flow of the *ciment* and left-handed people should work the other way round. This is a very calm activity and should not be rushed.

Taking the dry household paintbrush, half load it with the goo coat and, working from side to side, from the outer edge at the top of the head, carefully stipple and vibrate the brush on one spot, encouraging the *ciment* to roll off the brush and flow along the indentations and into the modelling. Tip the mould to encourage this flow but allow a good covering to remain. If the *ciment fondu* does not run it means it has thickened and you need to add water and mix it again with the brush.

Do not use the dark *ciment fondu* like paint on the plaster surface just to colour it; let it flow and stop naturally, then recharge the brush and carry on, gradually stippling the material over the entire mould, building up a small depth of about ¼ in (6.5 mm) as you go. Painting the goo coat makes it difficult to see how thick the *ciment* is on the plaster and gives no strength to the cast; if you watch it running along the surfaces you are far more in control of the thickness you want to build up.

Incorporate all the dry material from the sides of the bowl as you add water. Scrape off any build up of *ciment* on the brush so that it does not become too fat and clumsy in use. Very fresh *ciment fondu* starts to harden, sometimes in minutes; don't worry about this, just spray on a little water and re-mix it to prevent it from getting out of hand. You will quickly achieve a mix that is of a suitable consistency to use again.

Work in a systematic way, carefully filling all the recesses and undercuts as you go and making sure areas such as the reverse of the eyes are well covered, for added strength. It is not necessary to fill the nose but do

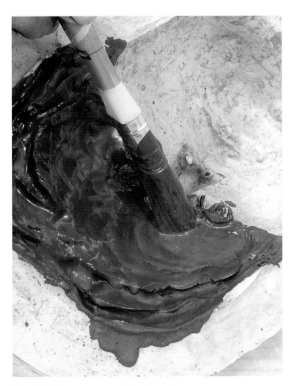

Fig. 183 *Start at top of the head*

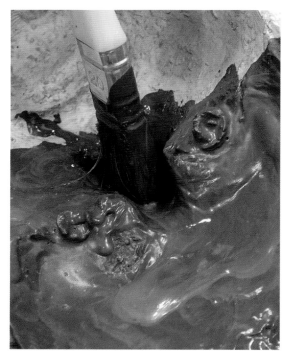

Fig. 184 Stippling *ciment fondu* into the nose

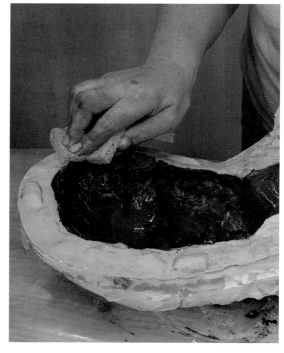

Fig. 185 Cleaning the seam, leaving a pristine surface

ensure the entire surface has a good layer of goo coat. Continue working right down to the neck edge. The bottom of the neck should be finished with a tidy edge, as it will be visible when mounted on a block later. For extra strength, remember to build up the 'high spots' of plaster that show in the negative; the back of the eyes, the mouth, eyebrows and undercuts that have been sliced into the clay. This method of working, with a controlled runny goo coat, will ensure that every detail of the modelling is reproduced well.

Once the initial goo coat covers everything and you have allowed the *ciment fondu* to thicken to a double cream consistency, start again at the top of the head and reinforce the first layer where it looks 'hungry'.

Ciment fondu sets as a very hard material and, once solidified, cannot be removed. It is therefore extremely important that as soon as the goo coat is completed you clean the seams so that they are clear of all traces. With a clean, damp sponge, remove the smallest crumb or smear of *ciment* from the wide seam area around the head; even tiny gritty bits, that may lurk in odd crevices on the seam surface, could later prevent the two halves fitting tightly together.

Occasionally, the height of the *ciment* close to the seam edge is such that when the two halves are placed together they are prevented from closing. To completely avoid this possibility, remove a small amount of *ciment* from the seam area with the sponge or a knife, trimming it towards the centre of the mould, and so reducing any high build up of *ciment* you may have placed there. The effect of this will be to expose and widen the area of the seam line. However, the

ciment you remove will be reinstated, as the seam is cast separately later.

TROUBLESHOOTING

Should the mix be too wet for either the goo coat or, later, the aggregate coat, vibrate the bowl on the bench and excess water will rise to the surface of the *ciment*. Lay some kitchen paper gently on top of the mixture and tap it with the back of your hand to absorb some of the moisture. Lift the wet paper off carefully and discard it. Re-mix the *fondu*, incorporating the contents of the bowl and restoring the single cream (or drier, aggregate coat) consistency. Repeat if and when necessary.

Should you find you have not prepared enough goo coat to cover the mould, make up some more in a dry bowl. This added material will not diminish the quality of the cast.

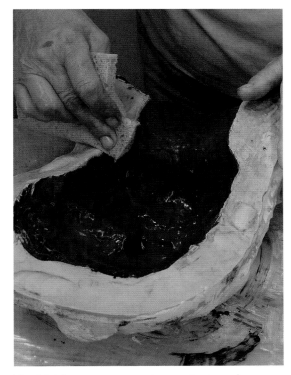

Fig. 186 Removing *ciment* diagonally down from seam edge of mould

FIBREGLASS

Fibreglass or strand-glass will give extra strength to the cast. It is particularly useful for binding the seam when the two mould halves are joined later. The *ciment fondu* used to cast a portrait head is actually strong enough not to need this material heavily strewn on its interior surface, but just a few fibres, sparsely criss-crossed and lightly touched onto the surface of the goo coat, could give you peace of mind if you can't believe a thickness of half an inch will be strong enough! It is vital to keep the fibres from overhanging the seam. They would prevent the two halves of the mould from closing tightly together.

PREPARING AND CASTING THE AGGREGATE LAYER

The second, aggregate layer of *ciment fondu* contains a reinforcing heavier-duty medium and provides added strength to the cast. Various materials can be used as aggregate, for example, coarse grog (which is ground-up fired clay), various sands or ground stone. Grog (obtained from clay suppliers), silver sand or washed sand are the most commonly used and easily acquired aggregates for casting *ciment fondu* and all are ideal for a portrait head.

In a clean and completely dry plastic bowl, mix together *ciment fondu* and your chosen aggregate, approximately 1:3 cup measures of *ciment fondu*:aggregate for the front mould. Mix them together dry so they are completely amalgamated before adding water.

Fig. 187 The aggregate layer, mixing with the fingers. Note texture

Fig. 188 Placing the aggregate layer away from the mould edge

Small amounts of water should be added to the *ciment fondu* and aggregate, which should be thoroughly and quickly mixed by hand. The consistency of this layer is completely different from the goo coat. It is sometimes likened to horse dung. It should be firm and moist and able to hold together as a slightly floppy piece in the fingers that can be handled without breaking.

Form a piece about the size of a large postage stamp and about ¼ in (6.5 mm) thick, into a roughly square shape. Starting at the top of the mould, about 1 in (2.5 cm) in from the edge, place it gently on top of the goo coat. Do not push the aggregate coat through the goo coat but leave it on top. On the front of the chipped-out portrait head, the goo coat will appear as a refined, dark surface. The aggregate layer will be lighter and coarser on the inside of the head. By just touching the aggregate layer gently onto the goo coat, the coarser coat will not penetrate the goo or be seen.

Build up lines of aggregate across the whole mould, even in thickness, butting each piece up lightly to the next and touching them together. The pieces should form a joined patchwork of aggregate layer. Odd spaces between the pieces should be filled with other small wads of *ciment* to maintain the thickness of the aggregate and all high points of the underlying plaster should be covered too, ensuring there is a sufficient height of *ciment* to back up the eye and mouth areas, or any other area that you think might need a little reinforcement. Give the neck edge careful attention again, making it smooth and using the fingers to create a tidy ½ in (1.25 cm) thick finished edge to the cast.

When the aggregate layer is complete, clean the flat plaster seam all round as before. Check that the aggregate layer of the mould is not high near the seam edge and, again, cut away with a knife any material that could prevent the moulds from closing.

When the front half of the mould is complete, carefully wrap it up in a very damp clean cloth and leave it aside with the *ciment* facing upwards. The cloth will prevent the plaster from drying out and will also keep the *ciment* damp. The *ciment fondu* will begin to harden and cure fairly rapidly – which is what is required.

CASTING EARS AND AWKWARD AREAS

The second mould (of the back of the head) should be treated in the same order as the first, but with double the amount of materials. Work in the same way as for the

Fig. 189 Small gaps being filled with aggregate

first half of the mould, starting from the top of the head with goo coat and paying attention to vibrating the goo deep inside any undercuts or unusual shapes by turning and rolling the mould.

As the ears stand proud of the portrait, they are comparatively thin and vulnerable, so it is wise to give the outer rim extra strength by placing one or two long fronds of fibre-glass inside the rim of the ear after first running in some goo coat. Touch the fibreglass in place, just inside the *ciment* surface, with a wooden modelling tool. The ears will need to be backed up with the aggregate layer, although most of the delicate shaping will be filled with the goo layer.

For a ponytail, it is necessary to place quite runny goo coat inside inaccessible areas and swill the material all around, using your fingers to ensure everywhere is covered. Don't be tempted to fill a ponytail with *ciment fondu*.

Inaccessible clay that has inadvertently been left hidden inside the mould will cast in the shape of the clay you have left there, which means you will lose the finer contours of your original modelling. This would be a shame but not be a total disaster as *ciment fondu* can be 'invisibly' repaired later – a very useful advantage of this material

As soon as the aggregate layer has been laid on the second half of the mould and the seams cleaned well, it can be wrapped in a wet cloth, *ciment* surface uppermost, and left to cure for a couple of hours until it is hard to the touch.

Fig. 190 Tightening the wires around the mould

Fig. 191 The neck end of the seam line, awaiting the goo coat

CLOSING THE MOULD

When the second half of the mould feels firm, carefully place the front mould on top of the back one and fit them snugly together with the locating plaster keys on the moulds locked in place.

With a tape measure, determine the total circumference of the widest point of the (double) mould, and add 6 in (15 cm). Cut the galvanized wire to that length. Slip the wire underneath the mould, pushing it into the slots previously cut for the string, and pull the ends up with the pliers. With the ends overlapped, pull and twist the wire so that the two halves of the moulds are tightly secured together. Repeat this exercise in the notched area lower down the mould to bind the moulds really firmly. Under no circumstances should you thump the mould because the *ciment fondu* could become dislodged at this point.

CASTING THE SEAM LINE

Once the mould has been wired together, the white seam line and the gap between the two halves will become obvious; you will be able to see and feel the seam area that needs to be filled. Casting this area is dealt with in exactly the same way as the rest of the mould, starting with the goo coat and following up with the aggregate coat, although this time the goo should be mixed in the jug, making sure you prepare plenty to cover the seam line all round. A second pair of hands can be useful for this – one person to pour and the other to coat the seam.

Keep the lighted torch handy to watch your progress. Hold the mould almost horizontally so that you can control the flow of

goo from the neck end. Pour the *ciment* from the very outside edge of one side of the mould, covering the full width of the white shallow area. Rock the mould slightly from side to side to cover the seam indentation. Watch the goo roll down the seam line, ensuring every part is covered, right to the bottom of the mould. Then turn the mould to enable you to see the opposite, uncast areas, using the torch to help. Run more goo slowly from the opposite side of the head and down to the bottom of the mould, tipping the mould as it flows. A reinforcing layer can be run in as the goo coat hardens slightly. Allow the goo to emerge right to the neck edges. Place fibreglass fronds horizontally across the seam line on top of the goo coat in several places to ensure the two halves are bridged. This is best achieved with the fingers, although a long artist's brush can help.

Fig. 192 Pouring goo coat along the seam line

Prepare the aggregate coat in the bowl: 1 part *ciment fondu* to 3 parts aggregate. Start at one end of the seam and place the aggregate layer in appropriate pieces over the goo coat and fibreglass and across the seam, level with the adjacent sides of the cast moulds, which by now will have hardened somewhat. You will have to complete this operation by touch, as it will not be possible to see down inside the head; however, you will find that the soft goo coat is easy to locate. Follow the goo coat line, placing the aggregate along the seam and checking on the outside of the mould to ensure you are following the line accurately. Continue until you emerge at the opposite neck edge. Neatly finish the neckline to blend in with the adjacent work.

The casting is now complete. Leave the head securely propped with the open neck uppermost and the whole cast covered with wet cloths for 3–4 hours in order for the seam to harden all round.

Ciment fondu is designed to cure under water, as this ensures that the heat generated by the curing *ciment* does not dry out the portrait too quickly. So, once hard, stand the mould in a bucket or large plastic, galvanized or ceramic bath with the neck edge uppermost. Gently fill the hollow interior and the bath with cold water and cover the upright cast opening with a cloth that hangs in the water. It is not essential for the whole head to be completely submerged so long as a wet cloth is in place to keep the *ciment* and plaster wet. Leave for approximately 30 hours to cure. The head can be chipped out any time after this period.

CHIPPING OUT

Once the *ciment fondu* has cured, the waste mould can be chipped away from the cast to release the portrait.

Remove the cast from the bath, empty it of water and towel dry the plaster. Remove the wire ties. Place the cast on the work-bench with clean and dry protective cloths beneath it.

Chipping out is most effectively achieved with a ½ in (1.25 cm) blunt wood chisel cutting vertically down into the plaster. Working vertically down into the surface quickly exposes the blue plaster and then the *ciment fondu* layer. The vibrating action of the tool and the flick of your wrist help to separate the oiled plaster from the *ciment fondu*.

Support the head to prevent it from rolling about as you chip the plaster away and have a dustpan and brush and a bin

Fig. 193 Chipping away plaster from the portrait. Note vertical chisel

nearby to clear the debris as it builds up. With the mallet and chisel, begin at the top of the mould, just in front of the seam line, and cut gently vertically into the surface, opening up a small width of plaster. Cut through the white and then the blue layers of plaster until a very small area of dark *ciment fondu* is revealed. It is at this stage that you quickly realize how thickly, or thinly, you applied the plaster!

Do not cut a deep slot blindly into the plaster, as you can easily damage the *ciment fondu* below. It is preferable to make two parallel cuts, then remove the plaster between the two holes so they expose a wider area of *ciment*, as this is far more controlled. Move the chisel along in about 1 in (2.5 cm) increments and tap the mallet gently.

As the plaster breaks away and the head is released it is easier to anticipate the area below the surface of the plaster and to know your position on the portrait. Make use of any photos you have taken of the model so that you work more carefully, especially in the front near the nose, eyes and mouth.

Do not allow plaster rubble to accumulate under the portrait as you work since it can cause damage to vulnerable areas, such as eyelids and nostrils, as you work around the mould.

Leave 'muffs' of plaster over the ears to protect them and return to these once the rest of the portrait has been exposed. The ears are quite delicate and you will need to exercise caution as you chip the plaster away. Remove plaster around and behind the ears, leaving

any small pieces that remain inside to be eased away with dental or scribe tools later. The same caution should also be exercised around the eye area so that no damage is done to eyelids or other delicate parts. Once all the main areas of plaster have been removed, time can be set aside to sit quietly with the dental tools etc. and pick out all the remaining small pieces of plaster lodged in the undercuts until the surface of the portrait is clean and no telltale white fragments remain.

CLEANING THE PORTRAIT HEAD

Once cleaned of plaster, the portrait head should be scrubbed hard under running water to remove any small, loose flecks of plaster as well as the bloom that appears on the surface of the *ciment fondu*. Place the portrait on a soft sheet whilst you scrub it in

Fig. 194 Removal of plaster from undercuts

the sink. Surprisingly, as the *ciment* is so hard, a scrubbing brush does not damage it, but be sensible about scrubbing around the eyes and ears and perhaps use an old toothbrush for these parts. You will be left with a most attractive, clean, charcoal-coloured surface that will dry to a lighter colour.

3 Finishing Techniques

REPAIRS TO CIMENT FONDU

There are always some repairs and remedial work to be done to any *ciment fondu* cast, but the good news is that *ciment fondu* is very easily repaired and damage is often just on the surface. You may find small areas you have inadvertently chipped with the chisel, especially in the early stages of chipping out. Occasionally you find *ciment* bubble marks that need filling.

Any seam line flashing needs to be removed first. With a cast that has had a clay wall this will be minimal. Use a small metal file to take away any flashing, tight to the surface, and, where possible, marry any markings that link both sides of the seam. Try to erase the seam effect in this way.

All surface hole repairs need to be made when the portrait is thoroughly wet, so, if it has dried out, the head should be left under water overnight or for at least a couple of hours.

This will prevent the head from absorbing the water from the *ciment fondu* as the repair is laid down.

Should you discover a hole that goes right through the cast and it is too big to cover, coat a piece of wet bandage, hessian or fibreglass matting in *ciment* goo, and lay it across the back of the hole. When this has dried, the area can be built up with more goo, as required, and covered on the inside of the cast to back up the front. Leave this to dry before turning the head about.

As the *ciment* hardens you can restore any damaged surface markings using a modelling tool, blending the surface with the adjacent one so that you cannot see a repair has been made. For small repairs, make up half an eggcup of goo on a saucer or plastic lid. It should be the consistency of thick cream. Mix six or seven drops of liquid wood glue into the *ciment* to ensure good bonding to the repair area and spray the goo with water when necessary to keep the *ciment* soft. The material will thicken quickly and this firmer *ciment fondu* will enable you to carry out repairs using modelling tools, reproducing any shaping required. The goo coat can be 'trailed' in a particular direction as it hardens to create a bulk of material where some has been broken away. This is useful, for example, for damaged eyelids or hair areas.

Whilst attending to repairs on the *ciment* head it can be useful to create a small, level *ciment fondu* pad, about 1 in (2.5 cm) wide, on the front edge of the neck of the portrait. This could be incorporated with the existing *ciment* to provide a place on which the head can rest on a stone or wood mounting block to ensure its stability.

FINISHES

If the portrait has no repairs, it can be mounted leaving the bloom on the surface. The bloom gives a mottled finish, similar to pewter, and can be very attractive.

If there are repairs to be done, the goo filling that has not been in contact with plaster will be darker than the rest of the cast and will show up. In these circumstances, or if you prefer the look of wet, scrubbed *ciment fondu*, you can paint the entire surface of the head with matt black paint (commonly known as 'blackboard' paint), and when the paint is completely dry, polish the finished surface lightly with soft wax. This produces a very appealing, professional finish, not unlike the appearance of some bronzes.

ALTERNATIVE COLOURS

Besides the usual charcoal-coloured *ciment fondu*, the material is also available as a white casting material. This is not a good colour for a portrait head, as the detailed work cannot be seen clearly. However, if you add red oxide to the dry *ciment fondu*, a terracotta-type colour can be achieved. Experimentation is always recommended to achieve the required density of colour before use. This *ciment fondu* is used in exactly the same way as that described above.

MOUNTING ON A BLOCK

A portrait head is traditionally mounted onto some kind of block, to raise and support it in the correct stance. The material chosen for this is very much a matter of taste, but wood or stone are the most common choices. Either way, the method of fixing is similar.

Materials required for mounting a portrait head

Wood or stone block, cut to required size and finely finished

A steel measure

Threaded stainless-steel rod and appropriate nut, plain washer and spring washer

Piece of white chalk or water-soluble white pencil

Drill and bit to make hole in block

Small tin of car body filler (with hardener)

Small tin of resin (with hardener)

Fibreglass matting

8 in (20 cm) length of narrow dowelling (or a round pencil)

Old knife with a flat blade

Felt or baize for base of block

Cellulose thinners to clean resin from tools (optional)

To mount the portrait head illustrated in this manual I chose to use a marble block 10 in wide x 7 ½ in deep x 4 in high (25 x 19 x 10 cm). The fixing is with a ⅜ in diameter x 8 in long (10 mm x 20 cm) stainless-steel threaded rod, bonded with fibreglass onto the inner front neck area of the *ciment fondu* and backed up with car body filler paste.

To establish the length of the rod required, measure the total height of the chosen block, then determine the additional amount of rod required to fix inside the neck area. Cut the steel rod to this total length. When fitted into place the rod needs to be about ¼ in (6.5 mm) short of the bottom of the block, to prevent it from scratching table surfaces etc.

Hold the head on the block to establish how far forward it should be placed. The

Fig. 195 Supporting rod set in place inside the front of the neck.

front of the neck is normally mounted fairly near the front of the block. Manoeuvre the head around the block into a stance that is satisfactory from all points of view, and determine the lowest point of the neck that will make contact with the block. If you added a small pad of *ciment fondu* (see page 190) to this point it will help form a stable mounting area. Mark this point on the outside of the neck and on the block with a discreet vertical chalk line. This is where the supporting rod will be aligned in the block. At the same time, with the chalk and the aid of a small set square or engineering square, mark a vertical line on the outside of the side of the neck to indicate the vertical position at which the rod should be fixed within the neck. This is a critical mark, as it will graphically indicate the fixing angle of the rod inside the head. Once the rod is set in place with resin you will not be able to change the angle of the head on the block.

Prepare an amount of filler paste and hardener, about the size of a large egg, and mix according to the manufacturer's instructions. In line with the front chalk mark, build up a thick layer of the material on the inside of the neck, between the bottom edge of the neck and 3–4 in (7.5–10 cm) up, making sure it is well bonded to the *ciment fondu*. If the neck has a forward thrust you will almost certainly need to add extra paste at the top of the inside neck area so that the rod can be aligned appropriately there.

When a sufficient amount of paste has been built up, use a suitable piece of wooden dowelling to make a groove in the paste to receive the steel rod; keep checking both front and side views to ensure that the groove is accurately aligned according to the chalk markings. Allow some twenty to thirty minutes for the paste to harden.

Apply a generous coat of resin (prepared as indicated on the tin) to the area in and around the groove where the rod is to be fixed. Position the rod in place, ensuring that the correct length is left protruding from the bottom of the portrait, and overlay an appropriate-sized piece of fibreglass matting. Use a throw-away brush to stipple plenty of resin into the matting, removing any air bubbles and making sure that the matting is closely bedded to the rod and surrounding *ciment fondu* – ensure that the rod stays accurately in place. The resin will set solidly in a few minutes and you will then be ready to back up the fibreglass with a good layer of car body filler paste. You will need to work quickly through this part of the process. The curing time can be adjusted by the amount of hardener used, but too little hardener will require you to hold the steel rod in place for a longer period of time.

With this demanding part of the operation completed, the head is ready to mount. To prepare the block, determine the location of the rod within the neck of the portrait by measuring the distance from the discreet vertical chalk line you made at the front of the neck to the rod. Measure this distance back from the mark you made on the top of the block; this will be the point at which to drill a vertical hole ⅜ in (10 mm) diameter right through the mounting block. Counter-bore the hole from the bottom of the block with a ¾ in (1.9 cm) diameter drill to a depth of about 1 in (2.5 cm).

Fig. 196 Base of marble block, counter-bored to receive tightening nut, seen from underneath the block

Drop the rod with portrait into the hole and apply locking liquid (Loctite, or similar) onto the nut area of the rod to encourage the nut to stay firmly in place. From under the mount, add a plain washer, a spring washer and the nut and, with a box spanner, tighten the nut until the head feels firm and stable. Be careful not to over-tighten the nut; the force generated is quite considerable and could cause damage to your portrait. (Note: in some materials a ⅜ in (10 mm) steel rod would not fit into a ⅜ in (10 mm) hole, but a ⅜ in (10 mm) masonry drill through stone will give a nice snug fit for the rod.)

To protect furniture and as a final professional finish, cut to size some felt or Fablon style felt and fit it to the underside of the base, covering the counter-bored hole.

Stand back and admire!

4 Photo Gallery Three: Diggy in ciment fondu

The finished portrait of Diggy in *ciment fondu* mounted on marble base

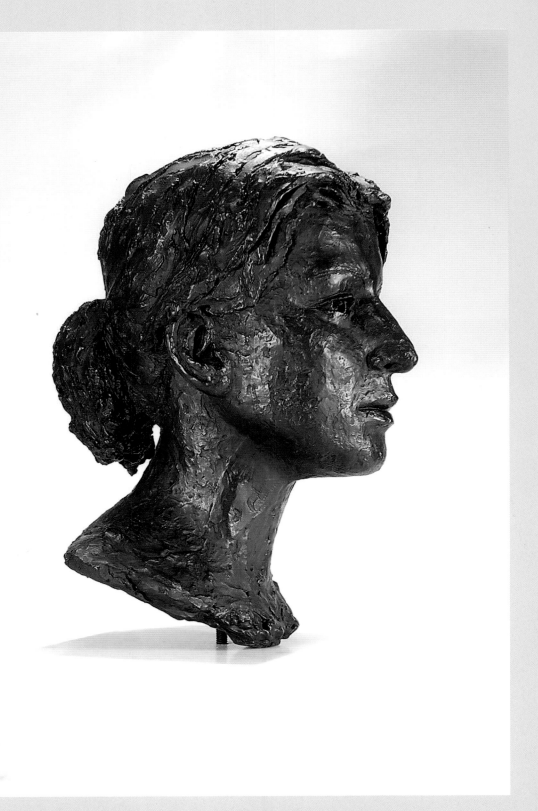

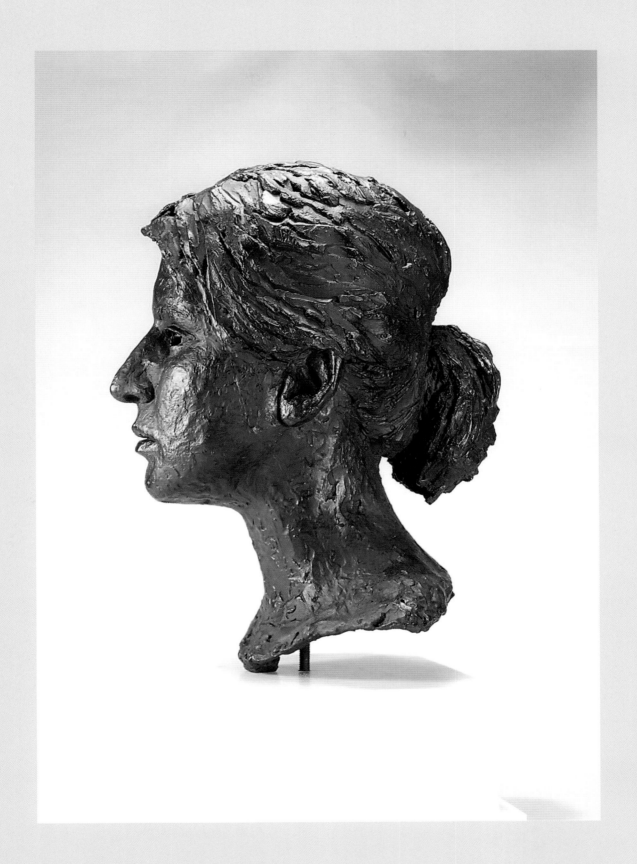

5 Photo Gallery Four A Portrait Collection.

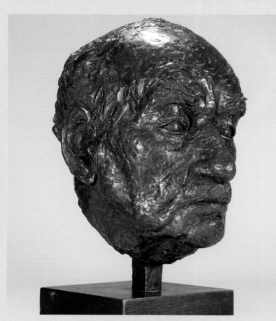

Colonel Graham Mason (resin with bronze)

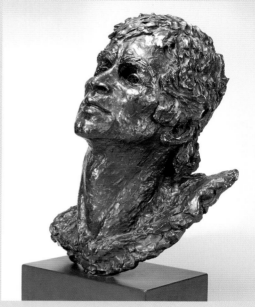

Rudolph Nureyev (bronze)

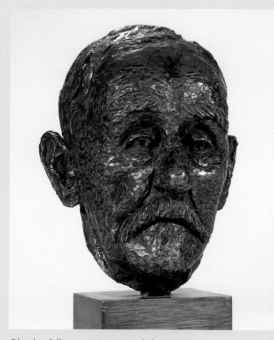

Charlie Pilkington (resin with bronze)

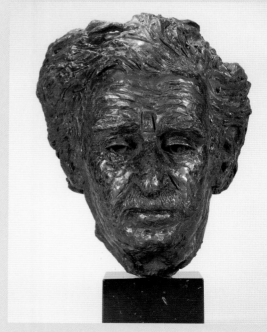

Miron Grindea (resin with bronze)

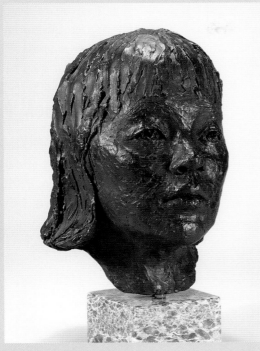

Alexi Stuart (*ciment fondu*)

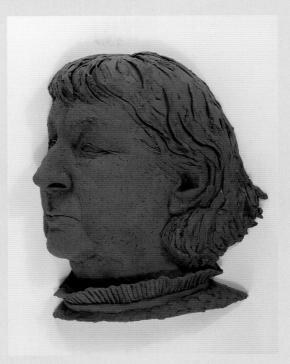

Denne Gilkes (relief portrait – Plasticine for bronze)

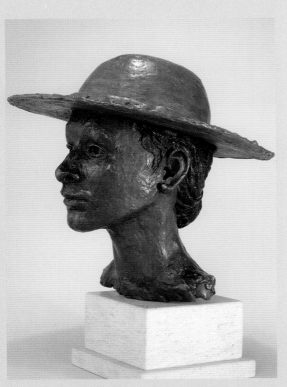

Marie-Odile Trabichet (bronze)

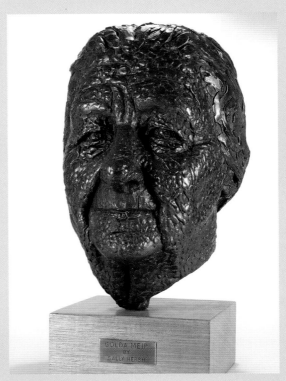

Golda Meir (resin with bronze)

Directory

Stone

Albion Stone plc
www.albionstone.co.uk
Independent Offices, Easton Street, Portland, Dorset DT5 1BW
email: *production@albionstone.com* Tel: +44(0)1305 860369
Portland stones

Blockstone Ltd
www.blockstone.co.uk
Bolehill Lane, Wingerworth, Chesterfield, Deryshire S42 6RG
email *blockstone@realstone.co.uk* Tel: +44(0)1246 554450
Ancaster and other limestones. Sandstones

Clipsham Quarry Company
www.clipshamstone.co.uk
Clipsham Hill, Clipsham, Oakham, Rutland LE15 7SE
e.mail: *thomas@clipshamstone.co.uk Tel:* +44(0)1780 410085
Clipsham stone. Visitors welcome, contact first

Francis Lowe Ltd
www.lowesmarble.com
The Marble Works, New Road, Matlock, Derbyshire DE4 4NA
email: *info@lowesmarble.com* Tel: +44(0)1629 822216
Hopton Wood stone. Visitors welcome, contact first

Haysom (Purbeck Stone) Ltd
www.purbeckstone.co.uk
Landers Quarries, Kingston Road, Langton Matravers, Swanage, Dorset BH19 3JP
e.mail: *info@purbeckstone.co.uk* Tel: +44(0)1929 439205
Purbeck stone. Visitors welcome, contact first

McMarmilloyd Ltd
www.mcmarmilloyd.co.uk
Brail Farm, Great Bedwyn, Marlborough, Wilts SN8 3LY
email: *info@mcmarmilloyd.co.uk* Tel. +44(0)1672 870227
Alabaster, soapstone, onyx, marble, others. Some tools. Visitors welcome, contact first

Nigel Owen Stone
www.nigelowenstone.co.uk
42 High Street, Crick, Northampton NN6 7LQ
email: nigelowenstone@aol.com Tel: +44(0)1788 822281
Alabaster, soapstone, limestones, others. Visitors welcome, contact first.

The Rare Stone Group Ltd
184 Nottingham Road, Mansfield, Nottingham NG18 5AP
email: *enquiries@rarestonegroup.co.uk* Tel: +44(0)1623 623092
Ancaster and others

Cathedral Works: There are various Cathedrals Works around the UK and elsewhere that are constantly restoring their building and doing new and restoration work. They are often pleased to supply offcuts of stone to interested carvers, as otherwise this stone will be dumped, so it is worth seeking out the cathedral works manager to see if stone might be available. Telephone numbers in local directories or Chambers of Trade.

Journal:
Natural Stone Specialist and Natural Stone Directory
7 Regent Street,
Nottingham, NG1 5BS
e.mail: *nss@qmj.co.uk* Tel: +44(0)1159 411315

Stone Sculpture Tools and Equipment

Arco Ltd
www.arco.co.uk
Waverley Street, Hull HU1 2SH
email: *sales@arco.co.uk* Tel: +44(0)1482 611611
Respiratory protection (Dustmaster and Sundström), tools and equipment, diamond hand pads, visors

Avery Knight & Bowlers Ltd
www.averyknight.co.uk
James Street West, Bath, Somerset BA1 2BT
email: *sales@averyknight.co.uk* Tel: +44(0) 1225 425984

Buck & Hickman Ltd
www.buckandhickman.com
Unit 3, City Industrial Park, Southern Road, Southampton, SO15 1HG (see internet for other branches throughout UK)
email: southampton@buckandhickman.com Tel: +44(0)2380 715300
Respiratory protection, abrasives, etc.

Clayman
Morells Barn, Park Lane, Lower Bognor Road, Lagness, Chichester, West Sussex PO20 1LR
Tel: +44(0)1243 265845 Fax: +44(0)1243 267582
Clays of various kinds

Crawshaws Ltd
www.crawshaws.co.uk
3 Silverwing Industrial Park, Horatius Way, Croydon CR0 4RU
email: *info@crawshaws.co.uk* Tel: +44(0)20 8686 7997
Sculpture tools, diamond pads, respiratory protection, equipment, resins, abrasives

Cromwell Co. Ltd
www.cromwell.co.uk
Millbrook Trading Estate, Second Avenue, Southampton SO15 0BS
email: *southamptonhazelaar.nl@cromwell.co.uk* Tel: +44(0)2380 704705
Dustmaster respiratory protection, filters, facemasks, visors

De Hazelaar Art Supplies
www.hazelaar.nl
Pimpelmees 1, 3766 AX Soest, Netherlands
email: *info@hazelaar.nl* Tel: +00 31(0)35-6012825
Specialist sculpture suppliers. All tools, equipment, stone, books etc. Soft white wax.
Small tins of stone resin

Harbro Supplies Ltd
www.harbrosupplies.com
Morland Street, Bishop Aukland, Co. Durham DL14 6JG
email: *enquiries@harbrosupplies.com* Tel: +44(0)1388 605363
Mallets, stone resin, respirators, masks, visors, diamond hand pads

Northern Tools Ltd
www.northerntools.co.uk
Industry Road, Newcastle upon Tyne NE6 5TP
email: *northern.tools@crossling.co.uk* Tel: +44(0)191 2652821
Face masks and safety gear, tools

Prime Tools Co. UK
www.primetools.co.uk
Ferncourt, Broadway, Chilcompton, Bath, Somerset BA3 4JW
email: *support@primetools.co.uk* Tel: +44(0)8456 444989
Steel tool boxes and tools

H.C. Slingsby plc
www.slingsby.com
Otley Road, Baildon, Shipley, Yorks BD17 7LW
email: *sales@slingsby.com* Tel: +44(0)1274 535030
Lifting gear, stackers, winch operators

Tabvlarasa srl
www.tabvlarasa.com
Viale Scalo San Lorenzo 40, 00185 Rome, Italy
email: *info@tabularasa.it* Tel: +39 (0)6 45420272
Stone sculpture tools and equipment, Italian handmade rifflers, diamond pads

Tiranti Ltd

www.tiranti.co.uk

3 Pipers Court, Berkshire Drive, Thatcham, Berks RG19 4ER (mail order and showroom)

27 Warren St, London W1T 5NB (London shop)

email: *enquiries@tiranti.co.uk* Tel: +44(0)845 1232100 (mail order and showroom)

Tel: +44(0)20 7380 0808 (London shop)

All sculpture carving tools and equipment. Benches and bankers, wood chops, steel and tungsten rasps, wet and dry emery paper, visors, face masks, stone resin etc.

Portrait Modelling and Casting Materials

Potclays Ltd

www.potclays.co.uk

Brickkiln Lane, Etruria, Stoke-on-Trent ST4 7BP

email: *sales@potclays.co.uk* Tel: +44(0)1782 219816

Clays, pottery materials and Portland sculpture and tools and books

Tiranti Ltd

www.tiranti.co.uk

3 Pipers Court, Berkshire Drive, Thatcham, Berks RG19 4ER (mail order and showroom)

27 Warren St, London W1T 5NB (London shop)

email: *enquiries@tiranti.co.uk* Tel: +44(0)845 1232100 (mail order and showroom)

Tel: +44(0)20 7380 0808 (London shop)

All beechwood modelling tools, clay, plaster, *ciment fondu*, armature wire, prepared modelling stands, fibreglass matting

Sculpture Courses

There are art colleges and short courses being offered widely in the UK as well as in Europe and elsewhere. Those mentioned below are just a start.

Central St Martins College of Art and Design

www.csm.arts.ac.uk

2 Elthorne Road, London N19 4AG

Tel: +44(0)20 7281 4111

Chelsea College of Art and Design

www.chelsea.arts.ac.uk

16 John Islip Street, London SW1P 4JU

Tel: +44(0)20 7514 7751

City and Guilds of London Art School

www.cityandguildsartschool.ac.uk

124 Kennington Park Road, London SE11 4DJ

Tel: +44(0)20 7735 2306

Heatherley School of Fine Art

www.heatherleys.org

80 Upcerne Road, London SW10 0SH

Tel: +44(0)20 7351 4190

Kingston University

www.kingston.ac.uk

Cooper House, 40–46 Surbiton Road, Kingston–upon–Thames KT1 2HX

Tel +44(0)20 8547 2000

Portland Sculpture and Quarry Trust

www.learninghamptonstone.org

The Drill Hall, Easton Lane, Isle of Portland, Dorset DT5 1BW

Tel: +44(0)1305 826736

Wimbledon School of Art

www.wimbledon.ac.uk

Main Building, Merton Hall Road, London SW19 3QA

Tel +44(0)20 8408 5000

West Dean College

www.westdean.org.uk

West Dean, Nr Chichester, West Sussex PO18 0QZ

email: *enquiries@westdeancollege.org.uk* Tel: +44(0)1243 811301

Other short courses in the UK and worldwide can be found on the internet.

Sculpture Parks

Check opening times and exhibitions before visiting

Barbara Hepworth Museum and Sculpture Garden
www.tate.org.uk/stives/hepworth
Barnoon Hill, St. Ives, Cornwall TR26 1TG

Bergh Apton Sculpture Trail
www.berghapton.org.uk/index.php/sculpturetrail
Bergh Apton, Norwich NR15 1DD

Cass Sculpture Foundation at Goodwood
www.sculpture.org.uk
Goodwood, West Sussex, PO18 0PQ
email: *info@sculpture.org.uk* Tel:+44(0)1243 538449

Grizedale Forest Sculpture Trail
www.forestry.gov.uk/grizedale
Hawkshed, Ambleside, Cumbria LA22 0QJ
Tel: 0845 3673787

The Henry Moore Foundation
www.henry-moore-fdn.co.uk
Perry Green, Much Hadham, Herts SG10 6EE

Little Sparta Trust
www.littlesparta.co.uk
Dunsyre, South Lanarkshire ML11 8NG Scotland

New Art Centre Sculpture Park and Gallery
www.sculpture.uk.com.
Roche Court, East Winterslow, Salisbury SP5 1BG
Tel: +44(0)1980 862244

Yorkshire Sculpture Park
www.ysp.co.uk
Bretton Hall College, West Bretton, Wakefield WF4 4LG
Tel: +44(0)1924 832631

Index